Doris McCarthy
My Life

DORIS

McCARTHY
MY LIFE

written with Charis Wahl

Second Story Press

Library and Archives Canada Cataloguing in Publication

McCarthy, Doris, 1910-
Doris McCarthy : my life / by Doris McCarthy ; with Charis Wahl.

Memoirs previously published in A fool in paradise, and The good wine.

ISBN 1-897187-16-5
ISBN 978-1-897187-16-6

1. McCarthy, Doris, 1910- 2. Painters—Canada—Biography. I. Wahl,
Charis II. McCarthy, Doris, 1910—. Fool in paradise. III. McCarthy,
Doris, 1910—. Good wine. IV. Title.

ND249.M23A2 2006 759.11 C2006-904423-6

Printed and bound in Canada
First published in the USA in 2007

*Very special thanks to Lynne Atkinson, Wendy Wacko, Madeleine Moir, Steve
Smart, David Tuck, Judy Finch, Betsy Jones, Margaret Schatzky, and all who
helped with providing photographs.*

*Second Story Press gratefully acknowledges the support of the Ontario Arts Council
and the Canada Council for the Arts for our publishing program. We acknowledge
the financial support of the Government of Canada through the Book Publishing
Industry Development Program.*

Canada Council Conseil des Arts
for the Arts du Canada

ONTARIO ARTS COUNCIL
CONSEIL DES ARTS DE L'ONTARIO

Published by
Second Story Press
20 Maud Street, Suite 401
Toronto, Ontario, Canada
M5V 2M5
www.secondstorypress.ca

Contents

Look to this day
For it is life, the very life of life.
In its brief course
Lie all the verities and realities of your existence.
The bliss of growth,
The glory of action,
The splendor of beauty.
For yesterday is but a dream
and tomorrow is only a vision,
But today well lived
Makes every yesterday a dream of happiness
And every tomorrow a vision of hope.
Look well therefore to this day.
Such is the salutation of the dawn.

Translated from the Sanskrit

To the natural world,
which has given me such joy and riches

Introduction

DURING THE 1980s, when any sensible person of my age would admit they were far too old to start a university degree, I decided I'd like a BA, and began my studies at the Scarborough College campus of the University of Toronto. In 1986, I chose creative writing as one of my courses.

During the Fall term, about fifteen of us, men and women, young and not so young, gathered in the classroom with the yellow swivel chairs to take turns reading an original poem for the rest to receive critically or appreciatively or both. We learned a bit about one another and perhaps more about ourselves.

In the Spring term we tackled fiction. The only piece I submitted that met with much enthusiasm was a sketch of a day in the Arctic, which was biographical rather than fictional. Russell Brown, the professor, recommended that I concentrate on autobiography. So much for fiction!

With that settled, I decided that I should move into the twentieth century and buy myself a word processor. Nothing in my whole life was as frustrating, humiliating, and difficult as learning to master that servant. The instructions came in a strange, repellent language, such as, "Error, Doris, change the default drive and try again." To be reproached by name added to my embarrassment. Some of my self-confidence returned when I discovered that my machine had factory flaws and the confusion was not all my fault. I have since learned to love it dearly.

As I can't bear waste, it was inevitable that I should sign up for a second year of creative writing to use what I had learned with so much travail. Advanced creative writing was one-on-one, which meant that I had to find a professor willing to work with me. The two English courses that I had taken with Alan Thomas had taught me that he was hard to please, and a tough marker. I asked him if he would take me on to develop autobiographical sketches.

Every other Tuesday I would meet Alan in his office, hand him two chapters diffidently, and sit in tense silence while he read them. I was lucky if there were only two mistakes in spelling, and delighted if he gave a snort here and there over an anecdote. His criticisms were perceptive and helpful, and I would drive home exhilarated and eager to get on with it.

Autobiography drove me back to the diaries that have sat idle on my shelves for years and made me relive the passions, the heartbreak, and the raptures. It gave me back my girlhood and the years when I was discovering my artist's eye and the heady joy of creation. I suffered again through

my thirties, when I was desperate with frustrated love and when, too briefly, I knew fulfilment. Writing gave me a second chance — not to change things, but to savor them. That is a great gift.

❧

PART ONE

The Bliss of Growth

Chapter I

I WAS BROUGHT UP on the nursery rhyme about Monday's child and Tuesday's child; as I was Thursday's child, I took it for received truth that I would have "far to go" and do a lot of traveling. The family had moved about a great deal even before I was born, because my father, George Arnold McCarthy, was a civil engineer. He married Mary Jane Colson Moffatt — Jennie for short — in Montreal in 1901, and they went to live in Niagara Falls, where he was assistant chief engineer for the building of its first big hydroelectric plant. My eldest brother, Kenneth, was born there.

Five years later they were in North Bay, where Dad was in charge of the extension of the railroad north to Timmins, and there my brother Douglas was born. By the time I arrived, in 1910, the family was living in Calgary, and Florrie — Florence Hicks — a wonderful young Cornish woman, had been taken on as domestic help. I was blessed in being a girl after two boys and in having three adults to love

me. At her first sight of me — my head covered with dark hair, which the nurses had put into little braids tied with colored ribbons — Mother wondered if they had given her an Indian baby by mistake.

My earliest memory is of fluffy yellow chicks running about behind wire netting. Mother said they were at Mr. Cousins's farm outside Vancouver, where we were living the summer I turned two. From that same summer I remember gulls, clean white shapes against the blue sky. My first memories are full of sunshine.

My father was transferred to Idaho, so it was in a Boise apartment-hotel that we spent the Christmas of 1912. There I had my first remembered experience of sorrow, when the little girl in the next suite broke the doll that Santa Claus had brought me.

During the next summer, after we had moved once again, to a construction project in California, my father's employers went bankrupt. Out of a job, Dad took us east to the old family home in Moncton, New Brunswick, to see Grandfather McCarthy, who was gravely ill. Grandfather was a patriarch in fact and in appearance, erect and handsome, with a flowing beard. Great-grandfather McCarthy, a wheelwright, had come out from Ireland early in the nineteenth century. Although a Roman Catholic, he apprenticed his son to a Protestant; and Grandfather became a Presbyterian and, eventually, a naval blacksmith. I was too young to realize the implications of the Moncton visit. Dad's mother had been an invalid after his birth and had died many years earlier. His strongest bonds were with his father and his eldest sister, Molly, who had brought him up.

I suspect that we lived not at the old King Street home but at Aunt Adelaide's much larger house on the hill. Her husband, Uncle Matthew Lodge, was a stout, bluff, expansive man, whose later visits to us were notable for the new doll he always brought for me and the smell of cigar smoke that lingered after he left.

Faced with how best to provide for his wife and three children, Dad decided to forgo the tempting fees offered a freelance engineer, choosing instead the security and stability of a government job. By the fall of 1913, he was an engineer with the works department in Toronto, in charge of railways and bridges, and we were living in a rented red brick house on Sherbourne Street, from which he could walk to his office in the City Hall.

Toronto was a small city in those days, conservative, sedate, known as a city of churches, and very British. Eaton's and Simpson's were institutions central to the lives of its citizens, two big department stores facing each other across the busiest intersection in the city. Eaton's was the larger and more popular; Simpson's was directed more to the carriage trade. The McCarthys didn't think of themselves as carriage trade. (Mother and Dad were interested in a house in Rosedale until someone warned them that in Rosedale you couldn't be seen on a ladder washing your own windows.) We were an Eaton's family.

The morning parade of Eaton's delivery wagons was one of the sights of Toronto, each red and blue wagon pulled by a matched pair of dappled gray-and-white horses. The delivery man on our route became a friend, calling two or three times a week, knowing everyone's name. One cold dark morning in November, he brought a shiny scarlet doll's sleigh. I accepted

Mother's hasty explanation that it had come to our address by mistake until it reappeared on Christmas morning.

My father was not really a city man. He loved the outdoors and wanted to be closer to the lake. The summer of 1914 saw us about ten miles (sixteen kilometers) west of Toronto in a cottage at Long Branch, then a summer resort on Lake Ontario.

Now the memories crowd. Early in the morning Dad would be in the dew-wet grass of the bowling green, picking mushrooms, which Florrie cooked with bacon for breakfast. The whole family went swimming together on Sunday morning, when Dad was home. (Saturday morning was work as usual back then.) I was a fairy at the summer residents' masquerade, dressed in a stiff tutu of pink tarlatan with wings held in shape by a wire frame. Mother and Florrie sewed sequins all over me to make me sparkle.

It was Florrie who filled the round galvanized-iron tub for the Saturday-night bath that I shared with Dougie. She read us Uncle Wiggley stories that appeared every night in the *Evening Telegram*, which Dad carried home from work on the train. Was it Dad or Uncle Wiggley that I was waiting for the day I disappeared from the house and was found sitting on the railway track?

That summer, too, I found Mother in the sitting room having tea with other ladies when I needed her to pull my panties up after I had successfully gone to the toilet all by myself.

I remember especially a spectacular thunderstorm one night, with lightning snaking down over the lake and cracks of thunder shaking the cottage. My father took me out to the veranda to watch it, holding me tight. I have not been

afraid of storms since that day. Mother did all the talking, but Dad was the rock, the strength, the refuge.

It was while we were in Long Branch that war was declared. It was not long before grown-ups talked of very little else and every family had someone, or had neighbors with someone, who had joined up. I have a vivid picture of breakfast at Balsam Avenue, a few years later. Dad would shake out his morning paper and look up the casualty lists. "There's a Jarvis here, Jenny, killed in action: Donald Bruce. Could that be Bert's youngest?" "Missing" was a separate heading. "Wounded" seemed almost like good news.

In 1913 the Beach, a summer resort on Lake Ontario just east of Toronto, was taken into the city and became a permissible place for a civic employee to live. R.C. Harris, commissioner of works and Dad's boss, built himself a fine new house close to the lake. By the time the Long Branch summer was over, Dad had found a house to rent on Maclean Avenue just above Queen Street, the one paved road parallel to the lake right across the city. From Queen Street to the lake, Maclean bordered the woods of Scarborough Beach Park, which lay between it and the city. The park was a wonderful place with picnic tables beside the long sandy beach, and an amusement park. There was a miniature train, a real steam engine pulling a string of cars behind it, each an open carriage with seats for four.

Up the street lived Freddie Hood. Together we explored the woods behind his house, finding mossy stumps that were obviously fairy palaces. Freddie's father was good with children. Easter morning brought ashy rabbit tracks to the living-room carpet, and following them led to hidden treasures of jelly beans and chocolate Easter eggs. Mr. Hood had

made a long bobsleigh, able to take ten of us at once, and many a winter Saturday afternoon was spent dragging it up the steep path through the woods and careening down the long S curve and up the sharp slope at the bottom with Mr. Hood at the helm.

My birthday came in July, allowing me to start kindergarten as soon as I had turned five. Freddie was too young to go with me; but his sister, Barbara, made a dependable escort. However, kindergarten children were dismissed earlier than the big girls, and some wretched little boy discovered the fun of chasing me. For a few afternoons he terrorized me, until Mother found out and arranged for me to be given a five-minute head start. I ran all the way home to protect my lead. I wonder if, as Mother predicted, he came to a Bad End.

Dad's major project for the city at this time was building the Bloor Street Viaduct to take traffic across the Don Valley and allow Toronto to grow to the northeast; but a minor project, which he designed as well as built, was a pretty little bridge that spanned a waterway at Centre Island, close to where the ferry docked. Perhaps that is why we began to celebrate family birthdays at the Island. On one such day, a small boy who had run away from his mother tripped and fell into the lagoon near our picnic table. He couldn't swim, and Kenneth jumped in to the rescue. Mother was alarmed, and then proud as everyone declared Kenneth a hero; but his reward was traveling home by ferry and streetcar wearing only Mother's ankle-length sweater. Mother had her own embarrassing moment on that streetcar, when my clear childish treble asked her if the Holy Ghost wore a white sheet.

We children went to Sunday school at St. Aidan's Anglican Church on Queen Street at the Beach. On an important

festival morning at St. Aidan's the Sunday-school children were taken up into the church for part of their program. Lacking a hat, I was turned away at the door and sent home. Mother's response was to take me over to the nearest competition, Kew Beach Presbyterian Church, where, she assumed, the standards would be less ridiculous. However, the time came when the janitor at Kew Beach caught me stealing a sweet from the big tub of hard candies to be put into Christmas stockings for the poor. I was ashamed to face him again, and rejoined my brothers at St. Aidan's. This is my first public confession of the crime.

Even during the war the Beach was growing at a great pace. New houses were springing up, and Mother and Dad found theirs on Balsam Avenue, one street east of Maclean. Our new house looked down the steep hill and commanded a view right to the lake. The backyard was deep enough for a lawn with a family garden swing, and a vegetable plot so that we could do our bit for the war effort. There was a central hall with the stairs going up to a landing with a triple casement window. The living room, twice the size of the one at Maclean Avenue and with a real wood-burning fireplace, was Mother's territory. Above it was the den with another fireplace, which was all ours. We children were free to play in it and entertain our friends there. The neighbors' lot on the north ran through the woods down into the ravine. In the tall oaks behind their house, their boys had a tree-loft, and those boys' ages matched ours. What more could anyone want?

Mother was a capable woman, well able to run a home smoothly with Florrie's help, and with energy left over to

fling herself into all kinds of outside war work. She was organizing tag days, singing with the Mendelssohn Choir in benefit concerts, knitting "comforts for the boys," and moving steadily up in the hierarchy of the IODE, the Imperial Order of the Daughters of the Empire. She was a handsome woman, straight, somewhat heavy ("Am I as fat as that woman, George?"), with presence, like a ship in full sail. She had a strong sense of drama. Mother had been a professional singer before she married, soprano soloist at St. Andrew's Presbyterian Church in Montreal. Dad fell in love with her voice when he was a student at McGill, too poor to afford concert tickets but able to walk to the big church on Ste. Catherine Street and hear music for nothing. Mother was as attractive as her voice, beautiful and full of fun, but nursing a bitter disappointment. She had won a scholarship to study opera in England, but her parents wouldn't or couldn't let her use it. A pity. (I'm sure that was one of the reasons she supported me in every effort I made to become an artist.) Her voice was glorious, clear, true, and strong.

She made a stage of wherever she was. Perhaps she came by it honestly. Her great-grandmother had landed, alone and terrified, from Ireland, eighteen years old, a "ward in Chancery." At the door of a Quebec City lawyer's office, she fainted into the arms of the lawyer's clerk, John Hunter, the man who would become her husband.

The winter I was seven, Florrie had to leave us. She had "taken service" to help her sister and brother tide over the years while they waited for the apple orchard they had planted in the Okanagan Valley to start bearing. That time had come and she was needed. Every Christmas after that she sent us a loving letter full of news and a box of her own

homemade chocolates. On my bedroom wall I had her photograph. When I visited her twenty years later on my first trip west, I got off the bus looking for the tall woman I remembered; and there she was, just like her photograph, but a little person who came hardly above my shoulder.

In the fall of 1918, there was the Sunday of the false alarm, when all the bells in Toronto rang out the end of the war, and then we found that it was not yet true. But the armistice came soon after, and I was taken uptown to the front porch of a house on University Avenue, just north of Queen Street, to see the victory parade, with broad ranks of men in khaki marching down the wide street, and everyone on the sidewalk waving flags and shouting and crying.

Jubilation about the end of the war changed quickly to anxiety when the flu epidemic hit that autumn, causing more deaths than the war had. The streets seemed to be full of funerals. When I went with Dad on his Sunday-afternoon long walk we crossed to the south side of Kingston Road to stay farther from the cemetery at St. John's Norway. Even the air was suspect.

The incident that underlined for me the return of peace happened on the Sunday morning that I went into the kitchen, where Mother was getting dinner. There was a pot on the stove, tightly covered.

"Can you keep a secret?" Mother asked, and she lifted the lid. Potatoes! The first for two years! I can smell them still.

Chapter 2

ONE SATURDAY IN AUGUST of 1918 a new family moved into the house next door. But it was not until Sunday afternoon that I met them. A Salvation Army band was playing in front of their house. A fair, pretty girl, who seemed to be about Doug's age, came out on the lawn and stood watching; but some rowdy boys were jeering and yelling rudely.

"Aren't they awful?" I ventured.

"They're terrible," she agreed, and told me her name was Eleanor Beer. While we were exchanging tentative introductions, her younger sister joined us rather shyly, and so I met Marjorie.

She was smaller than Eleanor, slight, with short mousy hair cut in a straight bang. She was nine, a year older than I and taller, but I was the sturdier in build, with a thick blonde pigtail down my broad back. We liked each other at once. In the weeks before school opened we became friends, comfortable together, pleased to discover that we were both

in love with Anne of Green Gables and secretly loyal to our outgrown dolls. Alas, Marjorie was enrolled at Balmy Beach School just across the road, while I was half a mile away at Williamson Road School, where I had been since kindergarten.

This made weekends all the more precious. Saturdays we shared picnics on the side porch of the Beers' house. Marjorie's bedroom window faced mine, and we contrived a private wake-up signal to give us time together before breakfast. We had a string long enough to stretch from window to window and each of us tied an end to her big toe. The first to waken after daylight gave a tug. We went to the window to acknowledge the signal, and the morning was ours.

Marjorie's father had been an army doctor in England and France during the war and was still in active service, stationed in Toronto. He was called for every morning by a uniformed driver in an automobile. This was a matter of some pride, for motor cars were still uncommon enough to turn heads. On rare occasions when he was needed uptown on a Saturday morning, he would take Marjorie and me for the ride.

Marjorie's parents were literary in their interests, active members of the Dickens Fellowship. Mine were practical — Mother a born organizer, Dad able to make things and always working on some project. (All these years later, my books stand on the shelves Dad made for my bedroom on Balsam Avenue.) Marjorie and I haunted the Beaches Library and explored a wide range of books and authors; but I smile when I recall the summer evenings in the garden swing when Mother and Dad took turns reading *The Old Curiosity Shop* aloud in emulation of the Beers.

Marjorie and I discovered an entrance to the crawl space under the veranda that ran on two sides of the Beer house, and we used to creep in there on our hands and knees and sit in the dark corner nearest my house, smoking dry oak leaves in acorn pipes, playing characters called Jake and Bill, ruffians who lived in the mountains. It was from that refuge that we overheard our mothers agreeing that we would benefit from ballet lessons and that we should be enrolled in a Saturday-morning session. Our mirth at the idea was matched by our delight at the prospect of traveling to town together every week.

The classes were held in an imposing imitation-Greek temple on Sherbourne Street, but we were ill equipped to serve in the sanctuary, and never did become the graceful little girls our mothers had hoped for.

Summer brought separation, eased by letters. Marjorie was taken out West by her grandmother; I spent July at a table under the trees, making a book as a birthday present for Mother. Writing the story and painting illustrations seemed a natural thing to do. I don't suppose I thought that Mother would be particularly interested in the tale of a princess and a giant, but I was confident that she would be pleased I had made it for her.

Balmy Beach School went only to Grade Six, so in September Marjorie transferred to Williamson Road and we were together — same room, same teacher, and only two seats apart. In March, Dad and Mother were called into conference with the school principal and my teacher. Doris was "idling, not being sufficiently challenged." It was recommended that I be advanced to Senior Fourth, the high school entrance class. Once again we were separated during school

hours, but together so happily at all other times that Marjorie-and-Doris became almost one word.

It was wonderful that two children who were so different could grow to be so close. Marjorie was almost delicate; Doris was stocky and strong, with her mother's emotional energy, and the confidence to take the lead in physical skills. Doris was a good student, intellectual, with high marks in everything. Marjorie was top student in the humanities but had no head for mathematics; her genius was with people. She met everyone with a warmth and interest that took her right through their reserve and into their hearts. Marjorie was a poet with a magical imagination and a delicious sense of fun. We both intended to become great authors, and each of us had in the works several short stories and at least one full-length novel. In discussing our literary ambitions, we agreed, probably on her suggestion, to ask to be given diaries for Christmas, in order to practice Improving Our Style. On New Year's Day 1922, each of us began a journal.

A few weeks later we wrote a verse play together, a one-act drama about a fairy kingdom suffering under persecution by mischievous elves. I suspect that its plot owed much to Lamb's *Tales from Shakespeare*. It contained some slight variety of character, a modicum of conflict, and a happy ending. Our elders were impressed and, thanks no doubt to Mother's influence, it was produced as part of a concert to raise money for the building of the St. Aidan's church Memorial Hall. As the curtain closed, the rector, Dr. Cotton, called us up to the stage to be presented with flowers. My diary's detailed description of the event concludes with the declaration, "This day is an epoch in my life."

Art at that time was more mysterious and distant than writing; I drew constantly, but for my own amusement. There were two other girls at who could draw ladies better than I could, which kept me modest about my ability. Although I chose the art option at high school, nothing at Malvern nourished my talent or my interest. On the other hand, the courses in English and the teachers were inspiring, and my marks in literature and composition were high. Marjorie was already writing and being published on the "Young Canada" page of the *Globe*. She and I were confident that we would be Canada's next L.M. Montgomerys, and we amused ourselves by playing at being "future us," writing notes about our latest bestsellers.

Chapter 3

ONE SUNDAY AFTERNOON IN JUNE, 1921, just before I turned eleven, Dad invited me for a paddle on Lake Ontario and a packed supper so that we needn't be home for tea. We paddled east, with the sun behind us, past the Balmy Beach Canoe Club and Toronto Hunt Club. Beyond, the Scarborough bluffs became bare and sculptural, eroded into sharp peaks and cut with ravines with only a narrow strip of beach. For an hour or so, Dad and I paddled close to the shore, watching for birds. We came at last to the remains of the old lake freighter *Alexandra*, which had foundered during the war in a violent autumn storm. (Rumor had it that she was worn out and heavily insured.) All that was visible of the old ship was the round top of the boiler and part of a funnel. Gulls flew from it, screaming, as we approached. We circled it curiously, then landed on the beach nearby where a deep ravine came down to the shore.

We had our picnic there, building a small fire just for the fun of it. When the sun had dropped behind the top of the bluffs and the air grew cooler, we took to the water again, far enough from shore to feel the sun's warmth as we paddled home. It was the first time I had known my father as a friend, and unknowingly had first set foot on the place that would become my true home.

The next summer, I found Eden: a ten-acre island in Lake Muskoka with the cottage that we rented for the first time. It had a safe, sandy beach and good drinking water. Best of all, Marjorie was coming too. Dr. Beer wanted to take Mrs. Beer to see the places he had been to in the war, and Mother agreed to have Marjorie as a second daughter for the whole summer. We could hardly believe our good fortune. The two mothers employed Mrs. Bennett, the enormously stout dressmaker who lived down on Spruce Hill Road, to make us black sateen "play-suits," knee-length bloomers and short tunics — a pink cretonne border for Marjorie, blue for me — as shapeless as the two little girls wearing them.

When the great day came, Dr. Beer drove Mother and Marjorie and me to the train. Dad and Doug were already on the platform, standing guard over the luggage and Dad's canoe. When we arrived at Bala Park station, we found there, among the luggage and freight piled up along the dock, ten big cartons addressed to George McCarthy. Our summer's supply of groceries had arrived from Eaton's.

An open launch rounded the point. I was used to a canoe and a rowboat, but this was my first time in a motor-boat. The engine was started with a crank, just like a car, and suddenly we were moving, faster and faster. Marjorie and I

sat side by side, squeezing each other's hand, speechless with excitement.

Our cottage was wooden, painted brown with white trim. Behind the living room was the kitchen with a wood-stove, and off that a back porch big enough for the table that soon became the focus of cottage life, when we were not in the lake or exploring the island. A path through dense undergrowth up a hill led to the "little house," a two-holer, much to Marjorie's and my delight. A second path ran through more open woods with boulders half covered with pine needles, and led to the big pine that we had seen from the launch. We named it "Spyglass" and buried at its foot a bottle containing a letter to be opened by the finder in 1937, an unimaginably distant fifteen years thence.

That summer we learned to dive, spending hours in and out of the lake, groping along the sandy bottom after the metal ring we used as a lure, dumping the canoe and climbing back into it. We felt like fish. At the beginning of the summer we rowed to the mainland for milk and the mail; but, by August, if the evening was calm, we were allowed to go by canoe. We came home as the sun was low, paddling towards the great early star in the southwest that I still think of as "Goldie."

Marjorie and I were used to slipping into many character roles with each other. One of us would assume a voice, and the other would pick up the cue. Sometimes we were Bill and Jake; often she was Teddy — Edward, Prince of Wales — and I was a lady of the court. (We were avid collectors of photographs and clippings about royalty.) We played our future selves, the famous authors, and we read together. Marjorie had been given *Anne's House of Dreams* for her birthday,

and we read *David Copperfield* that summer, not aloud but keeping up with each other so that we could discuss each incident and character.

All summer long at Silver Island there were family games — cribbage, all the pencil games we knew, and hearts, that poor relation of bridge. Mother once offered a chocolate bar as a prize for the winner, but quickly withdrew the offer as it might teach us to gamble. The cottage rocked with such laughter that there were evenings when Mother feared our hilarity might be disturbing the neighbors. Silver Island was in a Methodist enclave, but as the one church in the district was Anglican, every Sunday evening one of the cottages became the gathering point for a song service. Families came dressed almost as if for church. Most left their boats at the dock and carried cushions up to the veranda; but some young people stayed on the water, adding what Marjorie and I considered a romantic dimension to the scene.

Before we left at the end of August, Dad had arranged to rent the cottage for the next year. Marjorie's parents were so delighted with the brown, healthy girl that Mother had returned to them that she was included in our planning; but the Beers surprised us (and Marjorie) by renting a cottage on nearby Dunbarton Island for July.

Seen from Silver Island, Dunbarton was a charming composition of trees, cottage, and rock, set against a distant shore. I had no theories of art and no technique of watercolor, but I had an accurate eye and some experience in mixing paints. I carefully copied what I saw, with predictably pedestrian and muddy results. Two of my paintings have survived. It is interesting to me to see that I did observe the gradation

of tone in the sky from the horizon up to the zenith, and that I invented a convention to describe the stonework on which the cottage stood.

After the Beers had left Dunbarton, Marjorie was allowed to tell me the secret she had nursed since June: Mrs. Beer was going to have another baby. Marjorie was thrilled.

When I told Mother, she said she thought it was "disgusting."

"But Mother," I protested, "you said you couldn't help it if you were married."

"You can help it if you want to," said Mother stiffly.

Marjorie and I spent many hours that autumn wondering how it all happened, and how the baby got out. Eventually her father put into her hands *Men, Women and God*, a book that told us the facts at long last, explaining sex and marriage and babies in the context of human love, and convincing us that life was even more wonderful and beautiful than we could have imagined. Poor Mother. It is a great pity that she didn't have such a book when she was young. Poor Dad. It must have been rough being married to a beautiful, spirited girl with twisted, Victorian ideas about sex.

We had four summers at Silver Island. Then, the summer I turned sixteen, we went to our own cottage for the first time. During the previous winter, Dad had bought an old one-story farmhouse overlooking a bay on Lake Muskoka, accessible by boat from Beaumaris, which in turn was accessible by steamer from Gravenhurst. Our arrival was traumatic. Mother climbed up the slope to the house, walked through the cottage, and announced, "I'm not staying here, George."

Poor Dad! He knew that it needed a lot of work, but he could visualize the delightful haven it could become. Mother

could see only the newspapers pasted over the cracks in the walls and the shabby paint on the floor. Fortunately there was no way she could leave, and by the time the new cots and mattresses were out of their crates and the beds made up, the food unpacked, and the first meal under way, she noticed the big bay window in the kitchen with its view down through trees to the lake she had loved so well at Silver Island. She had also discovered the good cook stove, and was soon beguiled by the smell of wood smoke.

Before doing the cosmetic work, Dad and I reshingled the roof. We rowed across Lake Muskoka to the saw mill at Milford Bay, loaded the whole supply of cedar shingles into the rowboat, leaving hardly an inch of freeboard, and so home. The fortnight spent working with Dad on the roof is one of the best memories of my teens. He was a good crafts-man, knowing all the professional ways of making the roof weather tight and keeping the rows uniform and true. We were up on the steep side of the roof by nine in the morning. Mother would come out into the sunshine to hang up the wash with a word of praise for our progress and consultation about lunch.

By four in the afternoon I climbed down for a swim and a leisurely removal of slivers from my legs and seat. Dad hammered steadily on until he was called for supper, and sometimes he put in another hour or two before dark. We promised ourselves a holiday together when we had finished making the cottage habitable — a week's canoe trip, perhaps down the Moon River to Georgian Bay. I think it is the only promise that Dad ever broke.

26

Chapter 4

EVEN NOW, so many years later, I am not sure how objectively I can look back on my teens. Rapture was commonplace and, although I seldom experience the same intensity of joy now, nothing in my life since then denies the emotions of those days or the truth of the insights I was led to.

We sincerely believed that the 1914-1918 horror had been a war to end war and that the League of Nations was the way the world would settle disputes. Universal suffrage was taken for granted, and poverty meant leaving school to work, not hunger. Dad believed in public ownership of important utilities like hydro and the railway, and always traveled Canadian National, but he considered himself a Conservative. I grew up during Prohibition: alcohol was unknown, bootlegging was merely a word. The Twenties in my experience did not roar, and the loving atmosphere of my childhood home was normal among my neighbors and school friends. I equated

evil with thoughtlessness, selfishness, complacency, and laziness. I prayed sincerely to be delivered from them.

In 1925, my last year at Silver Lake, Marjorie was not with me. She was out West, in the Okanagan Valley, experiencing for the first time the joys of a girls' camp. She came back with stars in her eyes and a vision of girls around the world joining in a fellowship of unity and understanding. She was in love with Mary Allison, the leader who had shown her this dream, and with the teenagers who had shared it with her. As a result, she became part of the Canadian Girls in Training movement.

CGIT was an interdenominational Canada-wide experiment in religious education, sponsored by the major Protestant churches. Teenaged girls were organized into small groups, with an adult to lead them in Bible study on Sunday and in a midweek program of projects "purposed, planned, carried out, and evaluated" by the girls themselves. It was hoped that by studying, working, and playing together in this way they could discover what Christianity really was and learn to live it. Mary Allison was the national secretary, coordinating the program across Canada, and acting as liaison with the YWCA, the Girl Guides, and other youth organizations. Jessie Macpherson did the same work for Ontario.

Marjorie's home church was Beech Avenue Methodist, and she became deeply involved in its CGIT group. Her leader was Louise Boothe, a young librarian at the Beaches Library, who pioneered the concept of making a neighborhood library into a focus of community activity in music, drama, and art. (I got to know the group by painting scenery for the Christmas play they were producing.) Marjorie

was soon on the council that linked all the Toronto groups, making new friends among the girls and the leaders she met there, and full of plans to go to an Ontario CGIT camp the following summer. Mother said that if I got enough money from the sale of my bike, I could go as well. My concern was that Marjorie would resent my going, but she laughed my misgivings away, and convinced me that I was welcome in every area of her life.

Jealousy, which I recognized as a sin, was probably my greatest temptation. Marjorie's expanding world was bringing her close to national and provincial leaders, young women of god-like glamour; and, at times, I felt that she had left me far behind. (To give us needed time together we planned an adventure after camp, a week in the country, reading, walking, catching up.) The camp, Normandale, on a cliff above Lake Erie not far from Port Dover, was a big field rising to a long hill that held the wooden dining pavilion, known as the "shack." Round Top was a treed knoll where we sat on the grass for worship services and study groups. A tall flagpole had space around it for all sixty of us to stand in a circle for the morning ceremonial flag-raising and recitation of the Salutation of the Dawn.

After flag-raising, each of us went alone to some special spot she had chosen for Morning Watch, twenty minutes of solitude with a little book that was to help us find ways to think about God and give thanks for the love and beauty surrounding us. I found myself a nest in long grass on the very edge of the cliff, where I could watch the waves making patterns as they followed one another in to the edge of foam along the shore. I felt breathless with the beauty of the world

and the joy of being at Normandale with Marjorie and Jessie Macpherson.

We sang through breakfast (and every other meal), which was followed by morning worship on Round Top. Next came Bible study and informal discussion in small groups. After lunch and rest hour in the afternoon there were optional interest groups such as camp craft, handicrafts, or nature study. I chose what I hoped was sex education, but was of no use. The leader advised us never to "do anything that we wouldn't want our husbands to know," but I was none the wiser about what you could do! Evenings were for campfires, stories, games, and skits, ending when we stood in a circle, arms around one another, and sang taps.

Through all the fun, the meals punctuated by song, the shared interests and delights — even the irritations — we knew that we were united in loyalty to the best and highest that we could imagine. For ten days we tasted the sweetness of the presence of God.

Marjorie was elected chief camper, and Jessie Macpherson invited her to go in August to represent Ontario at a camp in Wisconsin. Goodbye to our week in the country.

Marjorie went off to Wisconsin, and I suffered from camp-sickness, the inevitable let-down after the high experience. I thought constantly about Normandale, and began plans to introduce CGIT at St. Aidan's. After my second summer as a camper, I received Dr. Cotton's permission. There were about ten girls in the group, boisterous, giggling, irresponsible, mostly twelve-year-olds.

I look back on the first three years of our group life as a hectic time in which it was always Tuesday evening: a dash

through dinner, a hasty gathering-up of equipment, a fast walk down to the church, an hour of shrieking and playing basketball in the gym, and eventually a discussion of whatever was on the agenda. It was a washed-out dishrag that trailed back up the hill after those meetings.

We called ourselves Shawnees, an Indian word for silver birch, in complement to Silverbirch Avenue where the church was situated. We put on plays, ran mother-and-daughter banquets, sold hyacinths to raise money for the church, went carolling at Christmas, and hiked along the beach of a Sunday morning to cook a shore breakfast.

One evening in the spring of our third year, someone who may have been sick of hearing me talk about Normandale, suggested that we have a camp of our own on the May 24th holiday. Decades later we still laughed over the discovery that the bundle big Doris Amson was sitting on in the truck was the bread, now well compacted. We sang all the way up, most of the time there, and on the long bumpy drive home. And when we met again on Tuesday next, we hugged one another and laughed, and we discovered that camp had done in a weekend what three years of my hard work had never quite accomplished.

Group leadership taught me some truths that I have lived by ever since. Because I had known what I wanted — to pass on the inspiration and happiness I had found for myself in CGIT — I had accepted the drudgery and the discipline necessary to achieve it. I never asked myself on Tuesday morning if I wanted to go down to the church that night. I just went. I believe now that if the goal is worthwhile it is never fully reached, but working with dedication towards its end is abundant life, happiness enough for any-

one. My talent or lack of it is not my responsibility. What is my responsibility is to use what I have to the full.

Once we had become campers, I knew the joys of leadership and had few of the headaches. The girls were eager for Tuesday night, and attendance was steady. As the years went by, the older girls became leaders themselves. The annual weekend camp in May grew to include more than fifty girls and four or five leaders. We did our share in interchurch activities, and many of us went on to provincial leadership camps. What a pleasure to wake up in a bedding roll under the trees, to sit up and see across the grass the tousled heads of Elie and Madeline, two of my own "children," emerging from their bedding rolls, ready for another day of the shared heights.

When Jessie Macpherson, CGIT coordinator for Ontario and later the innovative and adventurous dean of women at Victoria College of the University of Toronto, was a student at U of T, she had come into contact with the leaders and most creative thinkers in the Student Christian Movement. Dr. Salem Bland (whose portrait by Lawren Harris is one of the treasures of the Art Gallery of Ontario), minister of Bond Street Church, was inspiring or scandalizing the city with his radical Christianity. Professor James Hooke at Victoria College was challenging his classes and was condemned in the press for poisoning students' minds.

Every summer Dr. Henry Burton Sharman from the University of Chicago gathered about him a group of students from across Canada at Minnesing Lodge in Algonquin Park to give the New Testament the kind of close textual examination that was becoming common in literary criticism. He asked the young people to leave their theological

ideas at the door and read the Gospel stories with an open mind. Sharman's books and methods were used in the camp study groups. For the first time in my life I understood how the disciples and the early church had struggled to find words to say what they had come to feel about Jesus.

After meeting Jesus the man, even the theological words of the Creed made sense (especially with some judicious personal reinterpretation). I remember the liberation I experienced the day that Jessie, discussing the feeding of the five thousand, suggested that, perhaps after the young lad offered his loaves of bread and five small fishes, everyone dug into his pocket and pulled out the bit of cheese, the fruit, the chicken leg, or whatever, and the real miracle was the joyful sharing that Jesus inspired. This was the new light that I wanted for the CGIT girls at St. Aidan's. Weekly Bible study offered the opportunity, but camp released us from the distractions and pressures of normal family living, concentrated focus, and provided a way both to express the emotion that developed and to ritualize the love and security that we felt in the camp circle.

The drop into real life after camp was harsh; but I carried the experience as a strength to help meet all the less loving encounters, the untidy frustrations, the irritations of daily living. Every camper who had shared the exaltation was a friend. As soon as we were singing together we were recapturing the fellowship and renewing the dedication. I think the greatest poverty of my life today is that the people I love and enjoy do not sing with me.

Chapter 5

High school at Malvern was a rich experience for me in most ways. The academic work was stimulating and my consistent high marks were gratifying. Outside class, Marjorie and I were very much together, active in drama and the literary society and in producing the school magazine.

School dances are among the few nightmares of my youth, but outdoor parties were better. Marjorie and I were included in some memorable winter hikes, long sunny days spent skiing, snowshoeing, tobogganing on the hills along the creek valley of Taylor's Bush. Lunch was made over a fire, with bacon hanging from a sharp stick spitting into the flame and eaten rubbery or charred, in cold bread. There was a tinned camp coffee syrup, stirred sweet and strong into hot water, very good. Afterwards, we straggled back to somebody's home, shed our wet wools in the front hall, and danced to a gramophone record. You might be offered an

escort home. If not, it didn't matter. I had no fear of the dark or of walking alone anywhere at the Beach.

Dad had conditioned me to the importance of nature and the out-of-doors. He was one of the early conservationists who formed Men of the Trees, dedicated to planting rather than cutting. The McCarthys never had a Christmas tree, taught by him to prefer a row of stockings hanging from the mantelpiece. He took me one night to hear the great Jack Miner and see slides of the bird sanctuary for Canada geese that Miner had established at his home near Kingsville.

(More surprising, in retrospect, was the night that Dad invited me at the last minute to the Royal Alexandra to see Walter Hampden in *Hamlet*. Hampden was a big name in theater in the Twenties. We were given the last two seats in the house at the end of the last row in the gods. What a performance! The audience was spellbound, and I had discovered a new side of my father.)

Other interests were broadening my horizons. During my last winter at Malvern, I traveled by streetcar two nights a week to Central Technical School to qualify for my bronze and silver medallions in swimming and lifesaving, studying Latin en route. And I went every Saturday morning to the "Junior Course" at the Ontario College of Art, an introductory experience for high-school students. At Malvern, art had proved to be a total loss, and I hoped at last to learn something about it.

The college was beside the old Grange House behind the Art Gallery of Toronto. Both college and gallery were founded by the artists who had organized the Ontario Society of Artists, but were autonomous. Fred Haines, whom I

remember as a genial man and a good traditional landscape painter, was president of the society and director of the gallery. George Reid, another fine organizer and a genre painter of great reputation, was principal of the college.

The main thing I learned on those Saturday mornings was that there were painters who were pioneering a new style of Canadian landscape painting: the Group of Seven. We spent hours at the gallery becoming familiar with the names and works of the artists in the annual exhibitions of the Ontario Society of Artists, the Royal Canadian Academy, and the recently formed watercolor society.

Arthur Lismer was the tall, untidy, tweedy figure in charge of my course. He gave us a short talk at the beginning of every class, setting a project for the day, teasing us and irritating me very much. I wanted him to be serious and teach. However, we were merely encouraged, which I found disappointing. The only light I gained from those sessions was an understanding of the difference between warm and cool colors. Grace Coombs, who was in charge of the class after Arthur Lismer had given us the pep talk of the day, suggested that the gray I had used in an illustration of the Pied Piper of Hamlin was "too cool," and explained that red, orange, and yellow were called "warm," while the blues and greens on the other side of the spectrum were "cool." To warm up a gray I should mix in a little orange. Welcome my first fragment of professional vocabulary!

At the end of the term, early in May, the college held an assembly for all the Saturday students and their parents and friends, at which time the walls were hung with the best work of the year, and the results announced. I was hoping to be one of the Juniors chosen to take a second year of

Saturday-morning classes. Mother and Dad came with me, gratified that two of my paintings had been chosen to go up on the wall. I was proud to be showing my new world to my parents.

Principal Reid welcomed the guests with a rather prosy speech. Then Arthur Lismer talked about the Saturday-morning classes and went on to announce that the one full-time day scholarship had been won by Miss Doris McCarthy. I don't know what was done or said for the rest of the evening.

Mother and Dad were pleased but somewhat taken aback. We had all expected that I would go on to university and teach English in a high school, perhaps writing eventually. However, at fifteen I was still too young to enter that stream, so my next year had been a big question mark. By the end of the long streetcar ride home I was to go to the art college.

My diary captures the excitement of that Fall:

"October 8, 1926: We are actually started. I seem to be getting along quite famously so far. I love my teachers. Mr. Lismer is just the same — perhaps a little less odious in his jokes, but he hasn't lost his baffling attitude of being amused at the whole world and at us in particular.

"October 23: M and I went for a walk. I was telling her all about the students' supper last night when I sat beside Mr. Lismer and suffered horribly from nerves at having him help me to butter and potatoes. But it was quite thrilling watching him draw Mr. [Emanuel] Hahn, who was right opposite me, on the tablecloth. It was so jolly and informal. Mr. Lismer has a remarkable brain for seizing puns and can

never resist them. But he fascinates me. I love to watch and listen to him talk.

"November 19: I have never been so happy in my life — every minute is just another beautiful deep gratitude. Surely nobody in all the world has as much, so full a life as I. I love Monday — because Mr. Lismer usually gives us a criticism and sometimes a lecture. I love Tuesday — because it's modeling with Mr. Hahn. I'm wild about Wednesday because Mr. Lismer gives us such wonderful lectures, and Museum study is opening a new world of ideas and ecstasy to me.

"I love Thursdays — because we have modeling again. Friday is the climax of the week because we have our happiest drawing classes and then Composition — the finale — the most looked-forward-to period of the week, when we have wonderful lectures, and both Miss Coombs and Miss Patterson! Then, best of all, the students' suppers."

There was an older woman in the first year with us, Edna Breithaupt, from Kitchener. She offered her cottage on the Grand River for a sketching house party at the end of term. About twelve of us were able to go, and we engaged Yvonne McKague to be our resident teacher. She was Arthur Lismer's assistant at the college, and one of those rare people whose presence turns the lights on.

Before the trip we were shocked by the news of Lismer's resignation from the college. The tension between him and George Reid had become intolerable. The Kitchener gang, encouraged by Edna Breithaupt, decided that they would rather have his teaching than everything else the school offered. They formed the Toronto Art Students' League, rented a small house in Grange Park, and planned for the following year a regime of self-run classes. Lismer agreed to

provide some supervision; Lawren Harris and A.Y. Jackson promised them an occasional criticism.

I longed to be with them, but I had won complete tuition at the College of Art for the following year. Dad left me to make the decision, but helped me to realize that if I ever wanted to teach art in the school system, my degree from the college would be important. I grudgingly went back to carry on with my course, but felt that the life had gone out of my world.

I would have been less gloomy had I known that Ethel Curry would be appearing at the college and entering the second year. She was a dark wisp of a girl from Haliburton, eight years older than I, quiet, self-contained, beautiful. She had interrupted her art course to teach school in Haliburton for a few years in order to earn some money. Now she was living in an upstairs front room of an old house on St. George Street, a ten-minute walk from the college; it became a favorite gathering place for the serious students.

I don't know whom to blame for the fact that I survived four years of instruction in sculpture and was given high marks without learning to think structurally. When modeling a head from life, I kept turning the clay round and round on the stand to compare its silhouette with the corresponding view of the model. I thought two-dimensionally, confusing two-dimensional copying with truth to life.

J.W. Beatty's Saturday-morning classes in composition were good, although he was so steeped in the nineteenth century that the subjects he gave us were usually Biblical stories with masses of figures in them. At least we were challenged to think about arrangement, focus, center of interest, and relationships of scale.

This was the year that Charles Goldhamer, a recent graduate, was hired back as an instructor in still life and costume painting in watercolor. He had been well grounded by Arthur Lismer, and he taught us to use a full brush and put the paint on with courage and decision.

The next year, Curry — to my mind the name Curry suited her better than Ethel, and increasingly we all called her that — invited me to spend the Christmas holidays painting with her at Haliburton, and I took the train up the day after Christmas.

I emerged from the smelly coach with its dim oil lamps into a world of sharp cold snow and brilliant stars. Waiting for me was a horse and sleigh, with Curry's mother, a round bundle of shabby fur coat below a woolen bonnet, perched on the driver's seat.

It was like stepping back fifty years. The Curry house had electric light, but water was gravity-fed from a cistern upstairs, filled by a hand pump in the kitchen. Too enthusiastic an attack at the pump brought water pouring down the kitchen wall. Hung up in the back shed was the frozen carcass of a buck, shot in hunting season, ready for butchering piece by piece as needed. In the cellar was the wood-burning furnace, and a long wall of cut wood to keep it fed. Curry and I made a work space there, with our backs warmed by the furnace, and a strong blue bulb hung from the ceiling to give us "daylight" for finishing the oil panels that we brought home every morning and afternoon.

Curry gave me her world, the winter woods full of animal tracks, the snow fanning from the stump fences in drifts of sculptural purity, the log homes and the tar-paper shacks with blue wood smoke in curls above them. She taught me

to lay out my palette before I went out, squeezing my colors onto the floor of the box, white at the corner, the warm colors in spectrum order across the top, the cool colors down the left side (for us right-handed artists). Besides the practical advantage of avoiding accidental mixes, it was pleasant to see the hues in logical sequence. The narrow partition across the front kept my brushes and turps cup separated from the palette part of the box.

In those days I was still using hog's-hair brushes, stiff-bristled and square-ended, from a quarter of an inch to a full inch in width. Having heard Mr. Lismer jeer about people who used one-haired brushes, I avoided very small ones. I was painting on wood, usually panels of poplar because it was a wood without an aggressive grain. I shellacked them to prevent the wood from leeching the oil out of the paint, and the shellac gave me a warm light color to paint over. I placed my opened sketch box between my legs at arm's length so that it was necessary to hold the brush by the end of the handle and draw with wrist movement, not with my fingers. I watched Curry and learned from her.

We found our subjects in the village itself, along the river, down at the saw mill, or out on the frozen lake looking back at the hills. I was composing as I had been taught, choosing a focus of interest, a building or a part of a building, the pattern made by the open water in a snow-bordered stream, a hillside broken up by contrasting areas of evergreen trees and the gray purple-pink of bare maple woods. After I had drawn my composition in a thin turps wash, I would begin to paint it, as directly as possible, putting down a firm stroke of color and not messing it around afterwards, letting distance blend the brush strokes and clarify the story.

We painted every day all day, usually within walking distance of home. But not always.

"December 29: The end of a perfect day. Curry and I dressed and ate hastily, and then packed into the cutter. I loved the motion of the horses, the crispness and tingle of the air, and the sideways skidding of the sleigh, up slowly, along smartly, bells.

"We saw some striking bits of color — a blue door, and a pink-and-gray one, and some gay washings hung out to dry. The last few miles were through a wild bit of wood — rough uneven trail, hardly a road — twining black birches and elms tangled up in saplings and underbrush. There were three patches where the road was sunk in black bog and the horses would hardly take the jump across. But the climax, more thrilling even than the cutter part, was the walk over the lake, dazzling in sunlight.

"January 2, 1929: Our walk to the rink was indescribably lovely ... street-lights made circles of cold yellow light, accented by the tenderly blue-purple shadows between them. The blacksmith's shop was a perfect composition — dark against a still darker sky, roof and snow gleaming dimly, and a lovely pattern of light, fan-shaped on the snow from the two windows in the front."

And so back to school in Toronto to start 1929. J.W. Beatty, the instructor in "life," both drawing and painting, was a stocky, middle-aged man with thinning gray hair, a chain smoker with a wheeze that sometimes made talking difficult. His fingers were yellow-brown from nicotine and shook so that you wondered if he could aim at the page when he sat beside you to give a criticism. But once on the paper, his

hand was in control, and his line confident and true. He was a competent academic painter, fairly well respected in the community, but bitter towards those artists who received more recognition than he had; and he hated — it is not too strong a word — those who were challenging the academic standards of the nineteenth century, especially the Group of Seven.

Lismer was no longer at the college, but gentle J.E.H. MacDonald was head of design, Franz Johnston was on the staff, and the students were full of admiration for Lawren Harris and A.Y. Jackson. The members of the Group whom I met at the college, at the Art Students' League, or in their own studios, seemed to be warm, generous-minded men, critical of artists who were still painting Canada as if it were England, but without personal rancor and full of encouragement for the students. I was unwilling for that satisfying third year to end, although we looked forward to the final dinner and announcement of results.

The real gladness came afterwards. We grabbed hands and went leaping along Dundas — laughing and shrieking (such letting loose was a new experience for me!), going home with Curry, and falling asleep with scarcely a 'good night.' "Thank God for our fourth year still to come," I wrote, "and may there be other times together after it."

Chapter 6

WHILE PART OF ME was an art student, learning to see and to draw, another part was a teenager exploring the meaning of life and what it meant to be a Christian. After my first year at the college, I went again to Normandale, for the first Camp Council of elected delegates from all parts of Ontario. (I was invited as a thank you for the drawings I had been making for camp folders and other CGIT literature.) Camp Council was everything that camp had been before, multiplied and intensified. That summer Jessie Macpherson lent me her university notes on religious knowledge, and I learned about textual sources of both the Old and New Testaments.

In the late summer of that year, 1927, I went to a student conference at Elgin House, a gracious place, not luxurious but comfortable, surrounded by wide lawns on beautiful Lake Joseph, the most northerly of the Muskoka lakes. This was the year of Church Union and ecumenism was in the air, a good enough reason for the hotel's being

made available for the annual conferences of the Student Christian Movement.

There, for ten days or so, I was plunged into a more adult version of camp, with university students from across Canada, and leaders from around the world. I felt very young, but I watched and I listened, forced to face difficult problems of international suspicion, racism, and economic injustice. Art students seldom talked of such things or seemed to care.

Back in Toronto I was invited to Sunday-evening study groups with some of the leaders I had met at Elgin House. I was flattered to be admitted to such sophisticated company. We were studying Alfred North Whitehead's writings, from which I memorized a definition of God, hoping that by brooding over it long enough I would understand what it meant: "God is the actual but non-temporal entity by which the indeterminateness of mere creativity is transmuted to a determinate freedom." Of more value to me than the metaphysical talk of the great ones was a phrase that stuck with me from one of the Gospels: "Sirs, I would see Jesus." Increasingly, I did.

Both Marjorie and I were involved in youth conferences that were bringing together teenage girls and boys. My own CGIT group at St. Aidan's was in full swing. And there were camp reunions, vesper services, shore breakfasts, and conferences out of town, at which I sometimes had to make speeches or lead in singing and games. I was being pulled in two directions. I loved school and was happy with Curry and the gang there, but their friendship was without the spiritual dimension that gave richness to my love for Marjorie and Jessie and our widening circle of camp friends.

My diary is full of the tensions among my three worlds: college, home, and CGIT. Mother was having a wretched menopause, labeled "nerves" by the doctors, enduring backaches, nausea, and insomnia. All the fun had gone out of her. I had never been able to discuss ideas with her and had long since stopped trying, but now there was no pleasing her on any level, and I felt both helpless and guilty. Mother's religious convictions were summed up in "Honor thy father and thy mother." She resented my new loyalties.

The Ontario Girls' Work Board was the interdenominational committee with responsibility for CGIT, and Jessie was its provincial secretary. Her office was in the Methodist Bookroom, a handsome pale-gray stone building at the corner of Queen and John streets that I passed every morning as I walked from the streetcar to the college. When I was lucky, Jessie would be walking down through Grange Park as I was walking up, and there would be time for a greeting. The Girls' Work Board used me increasingly as an artist to create graphics for camp folders, leaders' magazines, and other promotional material.

One afternoon, walking through Queen's Park with Jessie, she said, "I wish you were two years older. Oh, I guess I don't either — but if you were two years older I could leave you my job." I laughed. "I'm not being funny," she said. "I mean it. I'd be quite willing to trust you with it." She asked me if I would consider Girls' Work as a profession. I didn't know the answer.

But I did know to say yes to a job offer that came my way for the summer. A county camp was a ten-day CGIT camp with the site, leaders, cook, and so on provided by the local organization; the director was sent in by the provincial Girls'

Work Board to ensure that the camp met CGIT standards. As director I would receive transportation, my keep, and a ten-dollar honorarium per camp. I would be responsible for the program, discipline, security, and smooth operation of everything except the finances. It would be my camp. I was thrilled!

The first county camp took me to New Liskeard, farther north than I had ever been, eighty miles (130 kilometers) or so up the railway line that Dad had built when the family lived in North Bay and about 300 miles (480 kilometers) north of Toronto. Considering that I was to be in charge of fifty girls and their ten leaders, it did seem a bit ridiculous that Mother worried about my making the train trip by myself. I was all eagerness.

My tent-mates were a congenial group for the most part, although we were not always in agreement. We had a discipline problem, with three of the girls leading in noisy nonsense after lights out, and there was some thought that the solution was to put a leader in each tent. But this was against my principles. The only discipline I wanted for the camp was self-discipline. I called a council hour. The camp as a whole was presented with the issue, and the girls agreed that there must be rules, and that they would respect them. The campers asked from each of the three rebels a promise to cooperate. The promises were given, and what is more, they were kept. What had threatened to be a disaster turned into a triumph.

October plunged me back into college. "Another year, the last. Incredible. Such a short while ago I was looking forward

to four whole years, marveling, and now I marvel more that they are gone. Will all of life be like this?"

Sometime during the autumn, Curry and I did a survey of our finished paintings and decided that we had the makings of a respectable exhibition. If we were to be serious artists we must show our work in public and start to build our reputations. We eyed the walls of the Royal Conservatory of Music and took courage in hand. Dr. MacMillan [not yet Sir Ernest], made us feel instantly at ease, chatting away about our sketches as if he had nothing on earth to do but entertain us.

We framed up and hung about twenty small oils in the lunchroom and corridors of the conservatory. No sales, of course; but we had the satisfaction of seeing the work properly presented and feeling that it looked professional.

We were working and playing hard. My diary is full of parties in Curry's room, of serious discussions about art and life, about the possibility of getting a job at Northern, the new technical school that was due to open in north Toronto the next year.

Christmas was like most family Christmases: exciting, hectic, and emotional. I fled to Haliburton on January 2, joining Curry and two others of our college gang, for a few treasured days of painting.

My regrets at leaving Haliburton gave way to joy at returning to school. Both Dad and Mother liked my sketches, and even I felt they were better.

By February, life was moving very quickly. Mother made an appointment for me with Mr. Saunders, my future principal if there should be a post for me at Northern Vocational School, and Arthur Lismer offered me a Saturday-morning

teaching job. I never really wanted to teach, of course, but by this time I had accepted teaching as the most practical means for me to be an artist, and I knew that being an artist had to be first with me.

After two years of painting, freelance lecturing, and teaching, Arthur Lismer had been taken on by the Toronto Art Gallery as director of education, with a Carnegie grant to introduce a new concept in art education for children. It was now thought that the purpose of teaching art should be to release and encourage a child's creativity, rather than to develop technical skills. Lismer inspired everyone who worked with him. We made a modest start that first year, but by the next fall we had hundreds of children, picked by their public-school teachers as the most talented and interested, and screened by us.

Curry was taken on staff, along with three or four others. She and I were responsible for the eleven-year-olds — sixty of them! Eleven is the perfect age: children have lost none of their openness and energy and have not yet become self-critical or inhibited. We provided big brushes, generous pots of color, and as much paper as they could use. We encouraged, praised, suggested further development, but made no attempt to impose our ideas on them. Just as well — they were bursting with ideas of their own.

This was a revolutionary change from what I had known as art in public school. We had been set to copy strawberry boxes with hard pencils or paint sprays of red salvia with thin camel's-hair brushes and dry cakes of watercolor.

After the turn of the year all the students in fourth year at the college were working under pressure, with exams looming

and projects to be finished. But at the end of March, Marjorie and I managed to get a weekend together. We went out to the Falcon Inn at West Hill, a charming English-style hotel, which burned down a few years later. Mother had heard dark reports of the goings-on there: drinking, businessmen and their secretaries in illicit liaisons, and who knows what else. In the event, we were the only guests that weekend and, as the silence descended at about eight-thirty, when the kitchen closed up for the night, we were hard put to suppress our giggles. We walked, we read, we talked, and I returned with renewed zest to school.

Drawing and painting from the nude model, life-size, in oil on canvas, was the major work of senior painting students, occupying every morning. Afternoons were given to still life painting, again in oil on large canvases. History of art and anatomy were after-hours lecture courses with demanding written exams. Other examinations were practical tests in which we had several days to carry a project through to completion under supervision. Because I was very interested in sculpture, I had obtained permission to take night classes with Emanuel Hahn and carry a double specialization: painting and sculpture. My sculpture examination was scheduled for every evening during a week in May. For that week I arranged to stay with Curry.

On May 7, the chestnut trees, which in those days lined St. George Street, were in tender curly leaf. Every year since, I have checked the trees on that date to see if we are ahead or behind 1930.

The end of term came too soon. Our graduation dinner was to be held at the Arts and Letters Club, a beautiful former

church, full of association with the great men of our world of art. (The most famous historic photograph of the Group of Seven was taken there at lunch the day they adopted their name.) Of the sixty students who had been in first year, only seven were graduating; each of us was given a yellow rose to distinguish us from the other students and guests.

One of the first features after dinner was the farewell speech by Robert Holmes, who was due for retirement. He had taught us history of art and was a painter notable for his very fine watercolors of Canadian wild flowers. He opened his speech with an affectionate tribute to the school, hesitated, stopped, and suddenly fell behind the table. We stood horror-stricken, Curry's hand in mine, heard the rattle in his throat, and saw his face go gray and then opaque. Through the terrible wait for a doctor, the weight of horror overwhelmed any petty regrets about parties and graduation. We all drifted home to Curry's room and sat on the floor in front of her fire, needing one another for comfort. When the others had gone, Curry and I went to bed, but slept badly.

When I went into the college in the morning to clear my locker, there was a phone call for me. It was Mother. Dad had had a hemorrhage during the night and was in St. Michael's Hospital. Would I please come directly there. Mr. Holmes's gray, dead face leapt to my mind, and I was sick with terror and dread. Yet when I saw Dad, I felt quite relieved: he looked pale, but talked to me quite normally.

Chapter 7

SUMMER SHOULD HAVE BEEN heavenly. Marjorie and I were going to be together at Camp Tanamakoon in Algonquin Park for the whole summer. (She had spent the previous summer there and had enjoyed it immensely.)

As it turned out, we were both there, but not together. She was part of the group of beautiful, assured senior counselors, all old friends from the previous year. I was a new assistant crafts teacher, doing what I was told to do by a woman who knew her basketwork and leathercraft but was no artist.

I was responsible for half a dozen fourteen-year-olds, but I found it hard to relate to them. At our first meal they were discussing the pros and cons of the various ships on which they had crossed the Atlantic, and I resented their criticism of the excellent food and their complaints about what seemed to me luxurious living in the camp. However, things improved with time, as the campers and I began to

appreciate camp more; and Marjorie and I had precious half-days off together, free to leave the camp after lunch and to be out until after breakfast the next morning. That meant a chance to take a canoe across several portages into Canoe Lake, visit the famous Taylor Statten camps there — Wapomeo for girls and Ahmek for boys — and sleep on the home side of the last portage, within easy reach of camp ahead of the deadline.

But the news from home was disturbing. Dad's illness had been diagnosed as a stomach ulcer, and I had left for the summer confident that he was on the mend. But Mother wrote that "spinach and motoring are off Dad's list," and that alarmed me. Should he not be adding foods and activities? By late August, Mother had written that Dad was getting weaker and losing heart. I couldn't bear to think of it, and refused to until it could no longer be avoided. In fact, Mother had known before I went north that it was cancer, but she decided to let me have the summer free of that burden. And Dad was not to be told at all. Mother wanted to leave him hope.

We still had to get through the fall, watching him become paler and more frail. The day he taught me to change the washer on a tap, my throat ached with the effort to keep back the tears and give no sign that I knew why I had to learn to do it. Some time later, Mother had to bring home the papers from the safety deposit box, so he could explain them all to her. Every day Mother helped Dad to dress, and he sat downstairs, not even able to read, but rousing when someone called, and many did. Everyone was doggedly cheerful, but I have often wondered if Dad would have liked to talk with us about what we were all facing.

One November day, Mother couldn't rouse him, and his breathing was harsh. About noon, I took over the vigil, sitting with my hand covering one of his.

He stopped breathing. That was all.

Dad was still in his fifties when he died, an active city engineer until that dreadful night of my graduation, when he was taken ill. I felt a kind of bitter recognition that he had completed his most important responsibilities — seen his three children educated, and made sure that Mother had her home paid for and enough income to live on — and was free to die.

"I'm glad I went to the cemetery. M was with me, and I watched the trees, bare-branched against the pale sky, and wondered about the flowers. I told myself that it really wasn't Dad — and it didn't matter. Mother talks about how happy he must be with his old friends, and I can't feel anything except a fierce pride in him and in our love for each other, and a fierce resentment that in another generation he will be unknown, that his whole fine life will be forgotten even while the things he did are going on, and I loved him so. One of my biggest comforts is that I didn't have to wait for him to go to discover how much I loved him."

Mother retreated into black widowhood, with a heavy crepe veil falling from her hat. It served some purpose. People knew enough not to ask her about her husband, and everyone was kind and considerate in shops and on the streetcar. After her long, faithful ordeal of nursing him, I didn't begrudge her the drama.

My concern now was to start to earn a living. We were a year into the Great Depression and I wanted to be able to

give Mother money for my board. (At that time ten dollars a week seemed a fair price for board, but I discovered later that Mother banked the lot in a special account that she kept in trust for me.) The Saturday-morning classes at the art gallery provided a steady income of five dollars a week. Moulton College, a private school for girls, gave me two half-days teaching a week. Leadership of a CGIT group at an inner-city church meant a small honorarium.

In the back of my diary I kept track of my freelance work and what it brought in. That first year I made twenty-seven different posters, for as little as fifty cents and as much as four dollars. I wrote and illuminated the oath of allegiance for the Ontario Boys' Parliament (fourteen dollars), and I continued to do black-and-white drawings for the United Church and CGIT. My biggest item was Christmas cards. I made and peddled hundreds of dozens of lino blocks of Haliburton winter scenes, printing and coloring them by hand in up to eight colors and making the envelopes to match.

In a different category were sales of paintings, six oil sketches that first year, usually for ten dollars each, which must have included frames. With the balance of what I earned, I was able to clothe myself, pay for streetcar tickets, buy my art supplies, and save a bit, as I was always a firm believer in Mr. Micawber's recipe for happiness.

That year I submitted a painting to the Ontario Society of Artists' annual open exhibition and it was accepted. My excitement at this success was tempered by disappointment that Curry's work was rejected, and at the OSA opening I was rather ashamed of my canvas, but it was a start.

The annual juried shows were an opportunity for young artists to view their work in the company of paintings by the

top professionals. The societies elected each year a different committee of their most experienced and respected members to act as a jury. Anyone could submit work if it was framed ready for exhibition and the modest entry fee was paid. Sometimes there were prizes for "best in the show" or for the best in some special category. Admission to membership in the societies was earned by having one's work regularly accepted for hanging. At that time only candidates who had been successful in the three previous years could be considered for membership in the OSA. One year missed meant starting all over again.

I had put my foot on the first rung of the ladder, but it was to be a few more years before I could go to an opening of a juried show and see my work among the others with any satisfaction. I was overjoyed to be accepted, and sick with disappointment when the mail brought a rejection, but a juried show is a stern test. In a solo show the sum of the exhibition speaks more eloquently than any single work. In a juried show there is a babel of voices, all talking at once, the paintings often so close together that they compete for attention and the one with the most strident voice is the one that is apt to be noticed. Juried shows were good proving grounds where I could assess the strengths and weaknesses of my work in challenging company.

Interlude:
Fool's Paradise

I PAINT MY MAJOR CANVASES after the garden has been put to bed, Christmas is past, and the house has been made tight for the winter. I move into the studio not only physically but emotionally; it becomes the center of my life.

Painting a large canvas is not very different from an on-the-spot sketch, except that I usually do my preliminary designing in thin acrylic, using it almost like watercolor. For my first marks on the blank canvas I use a large brush, about an inch wide, flat-ended, with a long handle. After I have made two or three lines to establish essential movement, I walk to the far end of the studio, and sit and study it. This is the time to change the proportion of sky to earth or the placing of a dominant feature. While I am working out the composition, I spend far more time looking than painting. When I have made the plan in lines, and found that it has enough vitality to give me back some excitement, I begin to define dark areas and build up a balance of tone. Colored

washes give local color — the actual color of the objects — and establish the shadows. (A warm light will cast a cool shadow, and a cool light will make the shadows appear warm. Yellow sunlight turns shadows blue, and a shadow lit by blue light will be warm, usually gray with a touch of brown.)

In the studio I use slides freely. As I look through the viewer, the whole world is the slide. I am able to imagine that I am seeing that view for the first time. I react as I would have done on the spot, looking for a feature to be the focus, observing what can be used, moved, omitted, or changed in size. I may run twenty or thirty slides through the viewer before a color, a form, a movement, a pattern, or a mood will suddenly make me want to paint. Sometimes I work from three different views of the same place. Occasionally, I put two slides into the viewer at once to see if the complexity of the confused images is more exciting than either by itself.

I envy artists who carry their images deep within and can produce them entirely from their imagination or sub-conscious, but there's not much profit in bemoaning the talents I don't have. It seems wiser to accept my own kind of talent and develop it as far as I can. My work has broken new ground within an honorable tradition, and I have learned at last not to feel guilty because it is not revolutionary. I am grateful that other people see my vision as personal and original.

Jennie and George, Doris's parents

Grandfather and Grandmother Moffat, photographed in the
dining room at Balsam Avenue, 1926

On the dock at Silver Island, 1922: Marjorie and Doris in made-to-order playsuits. Doris's mother carried groceries from the supply boat.

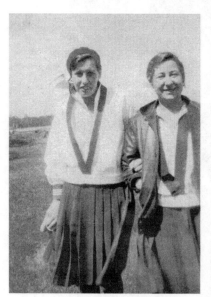

Left: Doris (right) as a CGIT leader, with Doris Amson
Right: The CGIT group

PART TWO

The Glory of
Action

Chapter 8

NORAH MCCULLOUGH, Lismer's assistant at the art gallery, alerted me late in 1931 that her friend Edith Manning, a teacher in the art department of Central Technical School, was to be married at Christmas. As marriage meant dismissal for a woman teacher, her job would become open. I had already tried to be taken on staff at the new Northern Vocational School, but I had been turned down; they considered me too young at twenty. But I was now twenty-one, and Charles Goldhamer was at Central; he had taught me at the college and was very friendly and interested in my progress whenever our paths crossed. I telephoned him to ask how I should go about applying, and he set up an appointment for me with the art director, Peter Haworth.

Mr. Haworth gave an occasional grunt as he looked over the portfolio I had brought, and asked some questions, especially about the outdoor painting I had done, but didn't commit himself. Then he asked if I thought I could teach a

group of librarians how to make posters and, when I assured him that I could, he told me to be at the school before nine o'clock on January 4, prepared to do just that.

Peter Haworth was a young, good-looking, curly-headed autocrat, who was gradually transforming a mediocre secondary-school art department into a dynamic powerhouse. Instead of hiring teachers who had taken summer courses in art, he hired artists and hoped they could teach. Peter's method of teacher training was to fling his novices into the situation and let them fight their way to the surface. He explained nothing, and his manner discouraged questions. When I reported to his office, as instructed, after my class with the librarians, he said only, "You can take PG1GH in EM3 this afternoon."

I found a translator. PG1GH meant Pre-vocational Girls, first year, sections G and H. EM3 turned out to be the classroom in the tower. Every day thereafter I reported to Mr. Haworth's office and received my instructions, in code. For that first nightmare week, I received no timetable and no briefing on what I was expected to teach; but, at its end, I had not been fired, and began to realize that I had inherited Edith Manning's timetable as well as her job. My classes were not art students. In most cases they were "vocationals" or, worse still, "pre-vocationals," girls unable to make it in the academic stream who were given watered-down courses in English and mathematics and concentrated on cooking and sewing, with physical training and art to round out the week.

Nobody in the art department cared about them, and I was free to do anything with them that would keep them out of trouble. If, by using all my native wit and CGIT experience,

I could find projects they liked, and show them how to produce presentable work, we were even allowed a small stretch of wall to exhibit the results. This was how I discovered the magic of cut paper as a medium: easier than drawing, faster than painting, and fun. With sheets of colored paper, chosen for color harmony and tone contrast, they could hardly go wrong.

One afternoon when I was teaching downstairs in an academic classroom, I was startled by a roar from a stout man standing in the open doorway.

"Who is in charge of this class?"

"I am," I responded meekly. "Who are you?"

At last I was meeting my principal, Dr. Kirkland. It was a poor start, but the only bad moment I ever had with him.

At school, I was beginning to enjoy the other young artists on the staff. Closest to me was Noreen Masters, tall, dark, vivid, a magnet for anything male, and a scandal to some of the older academic teachers. Nory had been a student of such brilliance in the Central Tech art department that she had been invited back the year after her graduation to take over the classes in illustration. She had imagination and could stimulate it in her students. Before the annual bazaar she had her classes make huge posters, working where they could find space. Art staff drifted in and out of the rooms, approving, criticizing. We got used to the chaos and found the excitement contagious.

Mr. Haworth asked me to make a poster to advertise the work of the Vocationals, a grim task, as it put my work in competition with that of the talented senior students, which inevitably made me nervous. Feeling rather like a

Pre-vocational, I used cut paper, hid my insecurity, and got away with it.

The annual exhibition in March was the time of reckoning, when you could see the quality of the year's work. The week after it, Mr. Haworth called me in to the office. Did I want to go on teaching? The truthful answer would have been no, but I needed the job, so I said yes. In that case, Mr. Haworth explained, I would be wise to take the teacher-training certificate course. Then I could be taken on staff and paid an annual salary instead of wages by the half day. Some points were stretched to convince the Ontario Training College for Technical Teachers that I had the equivalent of six years' experience in the trade and, as my academic qualifications were high, I was somewhat grudgingly granted permission to enter the school in Hamilton the following September.

That winter I had been painting hard, developing some of my Haliburton sketches into canvases. The previous year Curry and Casey and I had hung a joint exhibition of sketches at Annesley Hall, the women's residence of Victoria College. This year I sent a solo show to Strathcona Hall at McGill University. Later, I was part of a group show in the Memorial Hall of St. Aidan's church, where people said so many nice things about my *Snow Drift* canvas that a perfect fever of excitement and ambition and dreaming laid hold on me. I was both thrilled and embarrassed by all the compliments. I think they were very bad for me, but I discovered that I have a great appetite for appreciation.

I submitted two canvases for the OSA annual juried show; one was accepted.

In the spring of 1932 Grandfather Moffatt lost his job with the income tax department in Montreal, almost without

warning. He felt that they showed very little appreciation of his years of faithful work and the tremendous sums he had tracked down in tax evasions when they turned him out on his eightieth birthday. Grandmother was not well and, after some soul-searching, Mother invited them to come to Toronto and live with us.

Grandma had kept house and bossed Grandpa for more than fifty years, and now she was doomed to live in another woman's home. She was unhappy, and so was Mother. Grandpa had a saving sense of humor and a gentle irony, which I enjoyed, but which neither of his other women shared. Grandmother's face would tighten, and she would look at him reproachfully.

Such humorlessness was offset that spring by the delight and freedom of my first car. Curry's brother, Ronald, was ready to sell his little blue Chev convertible, complete with a rumble seat. He picked me up at the Beach, and took me out to the Exhibition grounds for my first and only driving lesson. What a marvelous feeling! I was surprised, and disappointed, that he wouldn't let me keep the wheel for the drive home through the city.

The Shawnees, my St. Aidan's CGIT group, christened the car Gabriel. It gave us mobility and made our weekend camps easier. It also made possible the mural painting I had been given permission to do on the walls of the children's room at the Earlscourt Library. (The board, having approved my sketch, agreed to pay for the paint that I would use. All that wonderful experience at no expense to me!)

I used fairy tales as my motifs, and the space was generous enough to allow the figures to be life-size, with the giant of Jack and the Beanstalk twice that. The paintings filled

all four walls above the bookcases. The plaster was coarse-textured, agreeable to paint on, and I was comfortable with both the height and all the climbing up and down on the scaffolding. The caretaker considered the weeks I put in on the job excessive — he had seen a man paint a whole billboard in a single day — but he was my only critic. When the work was finished, the board gave me an exhibition in the adult room, a party at the opening, and, best of all, a surprise check for two hundred dollars.

Chapter 9

THE PROSPECT OF TEACHING FULL time at Central Tech made me reluctant to spend the holidays directing camps. I needed time to be an artist, and Curry's father said we could use his hunting shack at North Lake for the summer. It was about eighteen miles (twenty-nine kilometers) from Haliburton, very isolated, hard to reach and a bit rough, but Curry was keen, and I was thrilled at the thought of two whole months to paint with no other responsibilities. Mother almost had a fit and was sure that we would at the very least be attacked by a bear, lost in the bush, stricken with appendicitis, or raped and murdered.

Curry's Uncle Andy and Aunt Jennie helped carry our gear and saw us settled. We had to take enough panels, canvases, and other art supplies for two months, as well as basic food supplies, clothes, and bedding. At the lake, Andy unloaded the outboard motor he had brought and hauled a skiff out of the underbrush where it had been hidden. It was

a five-mile (eight-kilometer) trip along this uninhabited lake — woods and more woods, with only a lily-clogged bay or a bare rocky promontory as a landmark.

At the portage Andy safe-stored the skiff and motor, and we heaved the first load onto our backs and started up the trail — a mile-and-a-half (more than two kilometers) uphill through bush over the height of land to North Lake — and then doubled back for the rest of the gear. At the far end of the portage was a rowboat to take us across the lake to Mr. Curry's hunting shack, which stood on a point of land above some shelving rocks that made a natural dock.

It was a two-room hunting cabin: a kitchen with a wood-stove, a rough plank table, and one bunk; the second room with rows of bunks down each side, enough for a whole hunting party. We left Andy and Jennie the privacy of the kitchen and chose places for ourselves in the other room under the windows that looked out to the lake.

Andy and Jennie stayed for two days, taking us through short portages to show us other lakes in the chain. In every lake or pond Mr. Curry had a canoe or rowboat stowed to serve the hunting parties he guided for in the fall. The next day we rowed Andy and Jennie back to the portage. Now we were alone on our lake. At dinner time we made a birthday party for me: candles and muffins and coffee and a sense of high occasion.

For the first two days on our own, we made sure that we had done all our chores before dark, including our last visit to the extraordinary privy — two slim saplings nailed between trees to make a seat suspended over a natural crevice in the floor of the woods. It was an airy, leafy retreat (in fine weather). Before dark, we were safe indoors, with a lamp

lit. By our third day we felt far too comfortable with our woods, our shore, our sylvan perch out back to be uneasy when night came.

Sometimes we went by boat to the far shore to find a place to paint. (When we went off through the woods, I carried the .22 rifle and some bullets in case we should meet a partridge.) The shores of North Lake were wooded with second growth almost to the water's edge. The challenge was to find a subject among so much sameness. It taught me to see subtle variations in the greens, from the bluer green of the pines to the lighter and yellower green of the birch and poplar. Skies were always changing, and I learned the difference between cumulus and cirrus clouds and how to describe the tones of the night sky, with stars or in moonlight. The movement of the water and the reflections of rock and trees were worth hours of study and endless attempts. We tacked our sketches up on the sun-tanned wooden walls of the cabin and lived with them, discovering weaknesses that we could correct and occasionally virtues that reassured us.

One evening we spent an hour in excited curiosity and trepidation, watching a moose from the canoe and making sketches of him. We stayed until it was too dark to see him, then paddled on to a little island to make camp in the dark and get ourselves a much-needed supper. "Such a falling over, such a spilling, such a losing of knives and dropping of butter and choking on pine smoke, and crying of damns, and intense enjoyment, all in one meal."

When a flock of blue jays came by, Curry said it was a sign that summer was almost over. The calendar was saying the same thing, but the end came abruptly with a letter in Mother's handwriting. Mail had been brought to us by the

rare fishing party that passed through. For me, it was usually painful, as Mother felt it necessary to remind me regularly of her disapproval of my retreat into the wilderness. I tried to forget her in between deliveries. This missive was marked IMPORTANT. I was under orders to get home right away for half a dozen important reasons, including visits from my brothers with their families. Andy and Jennie came to help us break camp.

Looking back on that summer, I think its greatest gift was silence. Curry is a person of few words and, in time, we came to read through meals. We had no radio. If a leaf fell, we heard it and looked to see why. Every sound had meaning.

The return from North Lake was like dropping from paradise into hell. Noise. Confusion. Chaos. There were constant family gatherings and trips to the CNE, and although I loved them all, I couldn't stand to be in the middle of it. Even the return to school was a relief.

Chapter 10

AT THE ONTARIO TRAINING COLLEGE for Technical Teachers — quite a mouthful — were gathered about twenty male aspiring teachers of printing, sheet-metal work, carpentry, motor mechanics, and so on, and half a dozen young women. Four were being trained to teach domestic science, a euphemism for cooking and dressmaking. Two of us were qualifying to teach art. We were a conscientious group, getting along well together, doing our best to support the poor victim whose turn it was to teach a practice lesson, and spending our spare time in riotous games of badminton.

The lectures were elementary to anyone who had done much reading or thinking about education; the real challenge for me came in the practice teaching. Hortense Gordon was my critic-teacher. At the time I didn't know that she was a highly respected pioneer of the abstract art movement in Canada (although it was more than proven in a retrospective of her art that I attended in September of 1993). Her analyses of the

principles of design were far ahead of what little theory I had been offered at the College of Art. Mrs. Gordon taught that the basic principle of rhythm was orderly sequential change: of direction, as by allowing the trunks of trees in a grove to vary subtly in their slope from the vertical; of size, as by making sure that a group of boulders in the foreground of a painting included small, medium, and large, with no two exactly the same size; of form, by using several intermediate shapes between a circle and a long rectangle; of tone, by letting intermediate grays be in even steps between black and white, and so on with color and texture. Any two elements in a design could be brought into harmony by creating a step half-way between them. For me, this was light shining into darkness.

The office secretary at the training school had offered me a blind date for the dance that closed the fall term, and so I met Walter Fraser. He was eight years older than I and serious about finding himself a wife. Although I wanted marriage too, I was in no hurry. But I liked Walt and enjoyed his attentions, even while doubting that he was for me.

Nonetheless, much of my year in Hamilton was spent in an emotional confusion, trying to sort out my feelings about Walt, agonizing if a week went by without a telephone call, in highest heaven when he was in attendance, doubting him, doubting myself, dreading Mother's critical appraisal, trying to see him with Marjorie's eyes — all in all, being very young and inexperienced and, for the first time, very much obsessed with sex.

Marjorie was teaching at the Ontario Ladies' College at Whitby. We saw each other on weekends, and talked long hours about love — what it meant, and what it did not mean.

During that year she realized that she really did care for Roy Wood, who had been pursuing her faithfully for three years. I had always dreaded the idea of a man coming between us; yet, when it finally did happen, it was strangely unthreatening. For the intimacy that Marjorie and I shared was not at all like that of lovers, more like that of twins. We stood on the same ground, secure in the understanding of each other built over the years, sharing the same ideals, the same sense of humor, the same memories. Our love for each other was not possessive; each of us wanted the other to marry and have children. We had a respect for the other's talents, an intense caring for the other's richness of life, and a continuing need of the understanding possible between us because of the years of knowing.

I had had one brief obsessive friendship with a fellow camp leader in which I began to recognize a sexual element in her caresses. I was immediately uncomfortable and made sure that there were no further opportunities for any physical expression of affection. Between Marjorie and me this had never been a factor, and we began to plan a summer of travel that would give Roy and me a chance to get to know each other. I had regretfully parted with Gabriel and bought a full-sized Chev, strong enough to pull a trailer carrying a little punt, which could be packed full of gear. Roy would sleep in the car; Curry, Marjorie and I would share a small tent.

We drove east to Ottawa and then turned north into the Gatineau Hills. Quebec villages were organized differently than our familiar Haliburton, and the architecture of the houses interested us. On the way down from Mont Laurier, our most northerly point, we saw a frame house of such charm that I stopped the car, backed up for a better look, and

then ventured through the gate and up to the door to express our interest and pleasure. We were graciously received. Our French was equal to the occasion, and we were given a tour of the interior of "Ensoleillé." It was that home, with an old church window set in the end wall of the living room, that dominated my house plans from then on.

We traveled as far east as Baie Saint-Paul, camping, exploring, and painting until it was time for Marjorie and Roy to return to Toronto. Mrs. Beer was not willing to let Marjorie travel overnight with Roy on the train unchaperoned, so we drove them back to Montreal to catch a day train. Then Curry and I, after stashing the punt and trailer in my cousin's yard in Saint-Lambert, took off along the south shore towards the Gaspé peninsula. Without its load, the car was winged. We tented wherever we could find a little stream and a good view. Curry was great at spying out fresh vegetables and inspiring small boys to catch brook trout for our breakfast.

The people of the Gaspé were very poor. There was no paint for the shabby little houses; but the fishing boats and dories had to be painted for their very survival, and the odd bits of color left over were used on doors or window frames. Sea-silvered wood, with touches of faded blue and pink and green, in a setting of breathtaking grandeur! No wonder we fell in love with it.

Another accomplishment of the summer was falling out of love with Walt. I was bored at the thought of physical intimacy. All I wanted to do was work and have men around as friends. The following January, when Walt told me he was engaged to be married, I was able to rejoice for him sincerely, and to observe that as soon as Walter was no longer courting me, Mother thought he was a "lovely boy."

During the next school year, I got not one but two rooms of my own. The art department at Central Tech was strung along a fourth-floor corridor, several steps higher than the rest of the floor. That Fall, I no longer had to hold my classes in the life room or down on the ground floor. Finally, some privacy!

After Easter, I got some privacy at home, too. I took over the big cellar room as my new studio, lined it with wallboard, and glorified it by painting the concrete floor turquoise and the brick fireplace a grayed pink. The windows were small and high, but I was used to painting at night and had no complaints.

Marjorie's wedding was set for June, as soon as term was over, and her sister Eleanor and I were to be bridesmaids. Marjorie shocked her mother by insisting on being married on a Monday morning, an impossible time for caterers and florists. It was the first day the licence would be ready and would give Marjorie and Roy the afternoon to drive north to our cabin in Muskoka for their first few days of honeymoon before taking off on a camping trip to the west coast. The service was memorable to me especially for the moment when they exchanged the vows — not by repeating them phrase by phrase after the minister, but clearly, in one unbroken pledge. I was unprepared for that and the tears sprang.

While the bride and groom were driving west with their tent, Curry and Nory and I were off to explore the Maritimes with ours. We had heard so much about Peggy's Cove that we made it our objective. But the area around Peggy's is impossible tenting country. There isn't a bush on the landscape! We drove as far south as Lunenburg looking in vain for

something as good to paint and as hospitable for tenting as the coast of the Gaspé, before we turned around and headed back to the country we had discovered the year before.

We pitched the tent on a ledge of rough red rock above the beach that shelved down past the tide wrack to the Atlantic. Away off to the right we could see Percé Rock jutting out beyond the high cliffs of the headland. Behind us, sloping gently up to the road, a big field was a garden of daisies and slender blue iris. A grove of spruce gave us essential privacy.

The family who owned the field included Maurice, a young man who took one look at Nory and became our host, friend, escort, encyclopedia, and personal lobster-poacher. With his help, we located the owner of the empty house a few hundred yards down the road and succeeded in renting it — five dollars for the season. It took another five dollars to secure a workable woodstove, but that was all we needed. We used the house as studio and kitchen, and slept in the tent.

We did most of our painting at Barachois, a fishing village nearby. A railway bridge across the channel was high enough to let the two-masted fishing boats pass under it into the harbor. Perching on the edge of this bridge gave a perfect view of the little boats tethered in the channel or tied to the stages along the shore. Behind them lay the mud flats of the river mouth, stretching away to blue hills in the distance.

When supper was over, we would hear the slow putt-putt-putt of one-stroke engines and see the fishing boats putting out to sea for a night of drifting for herring. In the morning, far out at sea, the nets would be pulled in, and each herring hooked on a line lowered into the depths where the cod lurked. Sometime in the afternoon, when the cod had been

hauled up and all the bait was gone, the fishermen headed for home under sail. I spent hours drawing the men gutting the cod, watching the rhythmic movement of their mittened hands and the sweep of the knife, and listening to their gentle voices teasing one another about having their portraits painted.

From time to time, when I did paint people — men gutting cod, roller-skaters, participants in the Arctic Games — I used figures as incidents in a landscape, too small to be portraits. (The truth is, I had difficulty being objective about models, uncomfortable if they looked at my work in case I had made them ugly or failed to capture their personality. This was another attraction of landscape painting: nature didn't talk back.)

The social life was almost too active. Tall, dark, and handsome Earl Roberts, who worked at the store, had reacted normally to Nory, and was around a great deal. Astonishingly, he gradually transferred his attentions to me and made my days and evenings sing.

In the car driving back from the Gaspé, Nory and I began to wish that we could go off to study, to learn more about painting. This was the first seed of our dream of a year away from home and teaching, which grew all winter and flowered late in 1935.

Chapter 11

GRANDMOTHER HAD DIED while we were still exploring the Maritimes, and by the time Mother's letter reached me the funeral was over. Grandmother had been increasingly difficult during her last year. Sometimes she went up to the neighbor with stories of the cruelties practised on her by Mother and Grandpa. They were devastated by her inventions. I imagined that her death would be a relief to Grandpa. How naïve and wrong I was!

My Dearest Doris:

Thank you dear for your kind and sympathetic letter of the 22nd. I have been so prostrated with grief that I have been hardly able to concentrate my mind on anything much less write to anyone … It is quite true, dear, that few can realize the strong love that is engendered by a lifetime of close intimacy even if

one's natures are not tuned to perfect harmony. Of recent years she was unhappy due principally to disappointed dreams of a different life and a growing change of mutuality due to high blood pressure and old age. For, Doris dear, I loved her dearly with a love that was the very root of my life and I shall miss her every hour of the day and dream of her at night. She died at 3:30 on Saturday morning and, every night since, I awake from sleep at that hour ... Excuse this rambling letter. I am not myself at all.

God bless you, dear,
Your affectionate Grandfather

He was, indeed, both an affectionate grandfather and a congenial friend, both of us somewhat wary of Mother, but able to laugh together at the things we could not change.

That spring Mother found Grace, a pretty blonde teenager who needed a job and could actually keep house to Mother's standards. Grace and Grandfather took to each other at once, which freed Mother wonderfully. I was grateful to have someone to laugh and sing about the house after the grim years just past.

Grace also made a dream more possible for me.

I wanted to go overseas. France was where all the artists I read about had gone to study, and Paris was supposed to be the center of the modern action. But in spite of two years of extension courses in French conversation, I was afraid of not understanding French well enough to study in it. Peter Haworth, Dawson Kennedy, and Kath Cooley were loud in praise of the Royal College of Art in London, which they

had attended. Nory had more faith in New York for offering the latest and best.

She and I had many discussions of pros and cons, until she suggested an inspired compromise: four months in New York, to England at Christmas for study in London for six months, and then a tour of England in a cheap car. Peter agreed to support our request for leave, without pay of course, and we saved every cent we could scrape together. We anticipated needing about two thousand dollars each. I began painting watercolors of bouquets of flowers and found a ready market among Mother's friends. We gave up all luxuries, even the after-school cup of coffee on Bloor Street.

And so it was that September saw Nory and me off to New York. After a day and a night on the bus, we were landed in the big city in the silent dawn. Three days later, having visited the art schools on our list, we were in the dumps. Our own students at Central Tech were producing work of a much higher standard. We decided to head for England at once.

The *American Farmer* was a freighter that sailed from New York to London with accommodation for about fifty passengers. It was single class, without the lavish luxury of the big liners, but with a much more relaxed and friendly atmosphere. We rode out wild wind, heaving sea, and the shock of the news: Mussolini had bombed some town in Abyssinia. Italian troops were mobilizing. It was a virtual declaration of war.

My diary captured the strange combination of emotional horror and exultation of that time:

"Friday, October 4: Reports this morning confirmed last night's rumor, 1,700 or 1,800 killed in Abyssinia, men,

women, and children, Italy advancing. Baldwin's address expected hourly ... Dear land that I shall love, I'm glad to be British today."

Of course, I have realized since then that England was far from the responsible, altruistic nation that I believed in at that time, and that the League of Nations and its successor, the United Nations, are only as honest and idealistic as their people. My love for England is clearer-eyed now, with a powerful element of irony in it, but it is still strong.

It was raining the first morning after landing, when we set off from our comic little "private hotel" in Bayswater that seemed straight out of an Edwardian novel. We sloshed across Kensington Gardens to Exhibition Road and the Royal College of Art, where we had a tiresome wait at the registrar's office, and very little satisfaction at the end of it. The school was designed for students working towards a degree and short-term applicants were not welcome. We were asked to come back with our portfolios, but given little hope of admission.

We decided at that point to look for lodgings. One of my favourite Dickens novels was *A Tale of Two Cities*, and I had dreamed of living, like the Manettes, in a "quiet square in Soho." After a shocked exploration of the area, by then a noisy concentration of shoddy sex shops and cheap cafés, that dream dissipated, and we turned towards Chelsea. We enjoyed the narrow streets off the main thoroughfare with their workmen's cottages converted into sophisticated townhouses, all polished brass and pastel stucco. In Jubilee Place, a mews behind King's Road, we found what we were looking for: a fine big front room over a chemist's shop, with

a gas fireplace, day beds, good walnut furniture, even ster-ling-silver flatware. On the same floor, also vacant, was a smaller room, with a single day-bed and complete kitchen equipment (our room had only a hot plate), just right for George Keith-Beattie, who was to arrive the next week. The bathroom, on the landing at the end of the hall, served these two rooms and those of the tenant below.

George was one of Nory's students who had ventured into her private life, calling diffidently at the house, escort-ing her where he might, developing into a follower. He was a nice lad, close to her in age, and she was rather glad that he was to be with us in England.

Once George arrived, our housekeeping settled into a routine. Miss Busbridge, soon affectionately shortened to "the Buzz," was a sharp-nosed and sharp-voiced landlady who soon taught us to leave the beds, the cleaning, and the breakfast dishes to her. Nobody else could meet her standard. She also rearranged our groceries and dishes until we gave up trying to maintain our own sense of order, and got along with her famously from then on.

A test of stamina was provided by the bathroom. It had no heat, but, as it did have a gas heater to warm the bath water, it had by law to have a permanently open window, which ensured that the temperature was at least as cold as out-of-doors. When you put your pennies in the slot of the gas heater, you had a choice: a reasonable stream of water that could not quite warm the cold bath or you, or two inches of very hot water. I chose the latter, sitting in the stinging heat as a fog of steam ascended to the ceiling, where it condensed, and dripped onto my back while I scrubbed.

We returned to the Royal College of Art with our port-folios, but were advised that the Central School of Arts and Crafts was the place for us, being geared to advanced students who wanted specialized or short-term study. It was good advice. The Central School was several miles from Chelsea, but buses stopped almost at our door and took us all the way, past endlessly interesting London sights. I asked for a timeta-ble that would concentrate on drawing and painting, and was given four mornings working from the nude model and two afternoons with a costumed model. As well, I studied illus-tration with John Farleigh, lettering with the great Edward Johnson and, best of all, zoo drawing with John Skeaping. The mandate of the school insisted that each student study one craft: I signed up for book binding and Nory chose fash-ion drawing. Until the following week, when classes would begin, we were free to get settled and explore London.

The beginning of classes brought a gnawing ache in the back of my neck, and an amusing sense that the criticisms sounded familiar. Not only had I heard them before, I'd used them with my students. In our first lesson in book illus-tration, Nory heard her own teaching flung back to her in virtually her own words. I liked Mr. Farleigh, enjoyed his presentation of the problem, but we struggled over ideas and all we got for our pains was (a) hysterics, and (b) one Bayer Aspirin advertisement.

"October 16: Zoo all morning, with a fierce pain in the middle but with joy at the end of it. Mr. Skeaping gave us a lesson at the end of the morning that left both of us thrilled. He showed us how to find a single line that would express

the movement of the animal, and then how to develop the form of the animal around the movement line. This afternoon I slogged hard on a Roman alphabet in pencil, and the teacher said that I had done a lot of work in a short time. Even such slight praise made me feel marvelous.

"October 17: Yesterday Mr. Skeaping explained that outline was a vain hope, and solid form the only logical approach to drawing, and we bowed our heads and said 'aye.' Today the attractive-looking young woman in green advised me to spend more time on construction and to ignore shading. 'Let your line suggest the form.' Whom do I believe? No wonder the poor kids at CTS used to tear their hair.

"Monday, October 21: Today was life drawing all day, with a marvelous model, a golden-brown boy who had a beautiful body, well-muscled and yet young and full of form. Memorable also for a criticism from Mr. Farleigh that pepped me all up, simplicity of solid form, selection as the prime task of the artist.

"October 24: I had fun today in costume class, a great splashy watercolor this morning, and a Conté-and-wash this afternoon of the old man in the medieval robe, and I cleaned out my locker this morning and discovered that after two weeks my life drawings don't look nearly so bad as I remembered them being. On such trifles does happiness depend.

"October 25: After being told by every instructor separately, with diagrams, I'm gradually beginning to believe that my life drawings are lousy, over-worked, lacking solidity and construction. Everything was wrong, starting with size, working right through action and proportion and ending up with the modeling and detail. It's the most discouraged I've felt yet, but by gum I'm going to learn or bust.

"Monday, October 28: All day at school I simply slogged, putting heart and soul into trying to simplify my drawing, reduce it to the least common denominator, but keep it right, solid and forceful. I was still sweating over it this afternoon when the old boy gave me a criticism that simply floored me: (a) 'careless,' (b) 'photographic,' and I mustn't expect to draw well after one lesson or even two or three. It took a long time to learn. That was a bad day. We had dinner guests that night, and served steak that blew the budget for the whole week.

"November 9: We spent the afternoon at the exhibition of the London Group, a sufficiently interesting show but, to George at least, deeply distressing. I rather enjoyed it, and I was even thrilled to discover that three of the things at which I exclaimed with genuine enthusiasm were by Mr. Farleigh and Mr. Porter. Porter paints in a way of which I thoroughly approve, and, seeing that he will be teaching me painting, that pleased me.

"November 10: Tonight I did some Conté scribbles of George's room, the window with the washing hanging in front of it, the litter on the table, and the stove corner. They were fun to do, and, like most drawings done for fun, look better than the labored ones.

"November 11: Armistice Day. Nory and I were at White-hall by 9:15 and already the crowd was piled up along the sidewalks. We joined it, and had an amusing hour watching bobbies make walls of themselves, seeing the guardsmen come by in their enormous busbies, with a carriage of such extravagant arrogance that we hugged ourselves in delight. They were beautiful to watch, arms swinging, shoulders high, chests fully out, and their whole march a swagger. The air force lined up right in front of us with a precision that

was alarming but explained by the hatchet face of the officer in charge. They moved as one man, their rifles striking the ground with a single clap, and the perspiration dripping down their callow faces and into their collars. The sun came out palely at first, and then more strongly, and the day was beautiful. Then the music began with the tones as rich and vibrant as a symphony orchestra, the pipers high, shrill, and piercing, yet terribly beautiful. Then Big Ben chimed, the gun fired, and into a deepening silence came the eleven heavy booms of Big Ben. When it had finished, the hush settled like a physical presence over the crowd.

"November 20: We started painting today, and everything looked all right till I began putting body color on. Then, as usual, all the vitality of my turps wash vanished.

"December 5: Farleigh said today that I was almost too slick in my watercolor — I needed to think more of the drawing; but with my gratefulness for crumbs I was able to feel bucked that he said I handled watercolor remarkably well. 'Perhaps it's just instinctive with you.' Yesterday, at the zoo, Mr. Skeaping said to forget technique for a bit and begin to draw your thoughts. I remembered Lismer's 'Think a think and draw a line around it.' I feel as if I hadn't heard it or thought it since first year at OCA. It's the thing I need drilled into me most."

During the term, we contacted Mickey and Kitty Jillings, an English couple who had lived next door to us on Balsam Avenue before returning to England. Mickey was tense and jittery, struggling back from a nervous breakdown that had left him in a deep depression. He was utterly exasperated by what he considered English business conservatism

and stupidity, most of which he blamed on the entrenched class system. Kitty brought Mick and me together, suggesting that I let Mick show me some of the England that he still loved. "It will do him good," she said of the arrangement.

On December 3rd, I met Mickey at the coach station for the first of many dates, off for the day in the English countryside, the trees mossy and ivy-twined, the hayricks top-heavy and thatched, and some marvelous old 'beamy' houses, as Mickey put it. ("And the champagne! And the walk up over the downs with the sherry and beer and sea-mist lending the place a rather dreamy quality. Poor lad. I do ache for him.")

After Christmas, the wireless news was not reassuring: the King was ill. By mid-January his heart was weakening, and on January 20, he died. The bulletins had hardly appeared on the boards before every shop was draped in black and purple. I left school for Temple Bar to see and hear Edward VIII proclaimed king.

"It was difficult to see, but there was much arriving of betasselled coaches with coachmen in silk hats and beautiful men in red uniforms with great cascades of white feathers in the helmet, and the Horse Guards resplendent in shining silver and red and white, and heralds in little gold caps, gold tunics with braid right across their tummies, blowing a flourish of trumpets on long silver horns. I could hear someone calling a loud challenge and, in a few minutes, far away and hard to understand, after another double flourish of trumpets, came the proclamation itself. And then there was cheering and 'God Save the King,' played very slowly, and with people singing softly but in such numbers that it sounded like the moaning of wind, all around, deep and very powerful."

The next day I stayed at an upstairs corner window of the school to watch the cortège on its way from King's Cross station to the lying in state in St. Paul's Cathedral. The procession came in silence, half a dozen mounted men, a line of mounts drawing the gun carriage and the bier, which was covered with the gold flag and its red lion, topped by a small crown and a single cross of flowers. That was all. Behind it came the prince, now King Edward VIII, walking in a distressed sort of way, as if his feet hurt, and beside him Lord Harewood and the Duke of York. After them, the cabinet, bare-headed, dressed in black and very quiet, followed by some more guards.

In February, Mr. Porter explained his way of doing watercolors — leaving all your lights white and modeling the rest in a high key, with a practically dry brush. I plunged into a new pose, full of confidence and determination to use all the things he had taught me. I slapped the paint on and had a grand time. And he said 'good' and, better than that, I said 'good.' That made it worth all the sweating and cursing. If only I can keep the vitality and freshness when I work farther into it. In spring, all of England seemed to share that freshness.

The whole earth seemed to open out and burst into bloom. March came with birdsong and sunshine — and found me capitulating to Mickey's need of me, to the flattery of his attentions, and the sweetness of being in love in London in the spring. Kitty sent us here and there with her blessing, eventually for an idyllic few days on the Isle of Wight and, later, a week to the Isle of Man. My memories of those months are grateful, full of tenderness and pain, knowing always that this was for now, and not for the rest of my life.

Mickey rationalized our affair as good for me, because it enlarged my experience as a woman and therefore as an artist. I rationalized it as good for both Kitty and Mick, because it brought him out of a long period of apathy and depression, which had threatened their marriage far more than I did.

"We sat on the sea-wall tonight and watched the exquisite silver thread of the moon in the sky and the faint glow of warmth at the horizon. A sky like a Japanese print was reflected in the pools left by the tide. Thank God Mickey can see things." I told him that night that I should never see the thread of a new moon without thinking of him, and I never have.

Kitty and Mickey and their two children were all moving back to Canada in the summer, to settle in Vancouver. I joined them for a long weekend before they went, playing with small Robin on the seashore, walking all together on the Downs, picnicking among gorse bushes, and being astonishingly comfortable together. Kitty was warm and relaxed. I admired her and liked her immensely. That made it easier to say goodbye to them, my pain at parting from Mick a small price to pay for what they had given me.

In late June, I sat with Mr. Skeaping in the sunlit garden of the zoo, talking about Life and Art, about the need for emotional and mental self-realization, of the importance of seeing things as if for the first time. I told him I felt a need for greater growth before I would have anything to say. He said that people whose lives had been explosive were more readily able to express their personalities in their work. Later, reviewing the many different ways in which my teachers had given me the same verdict — Miss Dafoe had explained my poor mark in history in Fifth Form by my youth — I felt

then as now, that there was very little I could do about that. Perhaps life would do it for me eventually; but, in any event, my part was to say 'yes' to life.

Chapter 12

WE BOUGHT A CAR, a red Humber, for one hundred dollars and explored England and Scotland for six weeks, using H.V. Morton's *In Search of Britain* as our bible. Our passage home was booked on a ship that left from Manchester and, the day before we embarked, George negotiated the sale of the car for seventy-five dollars.

Our ship was another freighter, but carried only ten passengers and had very little deck space. The tiny lounge doubled as the dining room. One of our fellow passengers was Helen Crichton, head of the domestic-arts department at Central Tech, whom we knew well and liked. Another was Barker Fairley, traveling with his wife and teenaged children on his way to take over the German department at the University of Toronto. Barker was already interested in art, but had not yet begun his second career as a distinguished Canadian painter.

The company was congenial but the voyage monotonous until one memorable morning when a sailor rang the bell, saying, "Iceberg off the port bow." We watched it grow from a light speck to a lovely fairy creation of white and green shadows. We were still at breakfast when someone shouted "Land," and then "Whales!" There, to port, was a whole school of them lazily showing their great dark, slippery bodies and pointed flukes, blowing and spouting.

When we docked in Montreal, Mother was there to meet me with my brother Ken, who had come up from the States especially to drive her down. Mickey was there too, which just seemed to complicate life, as we had no real opportunity to talk. Mother acknowledged him coolly. In a few meaningless minutes we had greeted and parted, with Ken bearing Nory, George, Mother and me off to Uncle Charlie's for dinner.

Toronto brought Marjorie — very pregnant, very happy, and everything that said home. She stayed with me that night, and we slept, as we had so often slept through the years, wrapped in each other's arms.

My CGIT group had set up a camp for the Labor Day weekend, a dramatic demonstration of their maturity. I went, but was too disoriented to feel part of it. When I returned, Mother had changed. She had been fine in Montreal when she had met me, and still all right while Ken was here. Afterwards, she became silent and curt. At first I thought she was tired, then that she was cross at me for having gone to camp. On Christmas Eve I discovered the reason for her behavior. The weekend I had been at camp with my Shawnees, Mother had dipped into my diary and discovered the truth about Mickey and me. She had been devastated, to the point of

taking her prayer book up to Dad's grave in Mount Pleasant Cemetery and reading the burial service for me. For three months her anger had been fermenting; and the explosion was violent, hysterical, and bitter. After Christmas I escaped to Haliburton, but my heartache went with me. Nobody but God has any right to a person's inmost thoughts.

Sometimes I almost hated her for having read it, but mostly I felt sorry for her, and had to admit that she was terribly important to me.

Ken wrote, "I don't know or care what you have done, but you should never write anything down that you are not prepared to hear read out in court." Feeling too late the force of his ironic advice, I mutilated my journal, cutting away whole sections, and erasing every incriminating passage in which I had used Mickey's name.

Unable to help Mother, I told Dr. Cotton the story and asked him to talk to her; but for Mother, Dr. Cotton's visit was the last straw. My guilt was now known — she could never hold up her head in public again!

A week later Grace and Grandfather and I stood at Union Station to see Mother and her friend Mrs. Young off to Florida for a break we all needed. We watched the train disappear down the track and then grinned at one another.

"Let's go to a movie," said Grandpa, and we did.

Afterwards, the three of us sat around the kitchen table after midnight because nobody was sending us to bed, having a festive snack and a leisurely gossip.

Florida and Mrs. Young were good for Mother. She came home refreshed, comparatively civil to me, and wanting to send the three of us off for a holiday as soon as school was over. So Grandfather had the satisfaction of showing off

Montreal and Quebec to the fresh and appreciative delight of Grace, who had never traveled before.

Early in July 1937, I left for my first experience of the West. Depression travel was primitive but cheap. I went "colonist," in a car with black leatherette seats that made up into berths at night, and a stove at one end for food preparation. Usually I bought a good breakfast in the dining car, still gracious with linen tablecloths and finger bowls. My other two meals were sandwiches bought in haste at station counters.

My goal was the YMCA camp on Lake Edith, not far from Jasper Lodge, which I visited once to observe its elegance and luxury. The Y camp lacked these, but had a wooden central dining hall and kitchen, and wooden floors under the canvas sleeping tents, which stood in a picturesque row facing the lake. The first morning I wakened to see a bear looking in the opening of the tent-flap. I froze, but he ambled off and left me free to dress.

A few days after our arrival, six of us went by car, small boat, and a long hike through the woods to Maligne Lake, to stay overnight in the tent hostel there. That evening, Mr. Matheson, the park warden, invited me to his cabin to meet his wife, a painter starved for someone to share art with, and to stay at their house along the shore. I let the others go back without me and had them send up my sketching gear with the next party. What an experience: two weeks learning to know the lake and the mountains with people who belonged in that world and loved it. The Mathesons came out with me when it was time to return to camp. We traveled by horse train, another wonderful first for me.

Marjorie's sister, Eleanor was to meet me in Jasper. She arrived as scheduled and we went off for three weeks' camping on the summit of Mount Revelstoke. We were driven through dense fog, seeing only glimpses of the town, of other mountains — past four-mile cabin, eight-mile cabin, up and up till there was just scrub growth, little Balsam Lake, and then the glass-sided lookout cabin that was to be our headquarters, perched like a red-and-white doll's house on the very top.

The fog gradually thinned, opening up views of other ranges and the valley of the Columbia River, fresh marvels with each gap in the clouds. We pitched a tent on the meadow below to satisfy the technicalities, but we ate, slept, and worked in the main room of the lookout. On weekends, town visitors and tourists moved freely across us and up into the tower. The rest of the time we were left in peace, with a daily visit from the park warden to bring us mail and supplies, and to drink the good coffee we brewed. Our duty was to watch for fires and report them.

One night, just at dusk, we saw one start on the edge of one of the mountains, and even as we watched we could see the orange flame spread and glow. The nearest telephone was at eight-mile cabin, a long way downhill. We ran and were quickly able to get the warden on the telephone. It took us much longer to climb back up, with big grins on our red faces: our forest fire was the rising full moon.

My diary is full of complaints about the bad sketches I was making, but it later reports a quite successful exhibition of them and the canvases based on them. My paintings are always disasters while I am doing them. It isn't until I see

them later, and someone else likes them, that I can see their virtues.

Tragic news from home cut short our summer. My brother Ken's wife, Betty, died very suddenly of heart exhaustion during one of her recurrent attacks of asthma; I decided to reroute my return trip through Toledo to see him.

That was also the year of the terrible epidemic of poliomyelitis in Ontario. Toronto schools remained closed until mid-September; so, after my visit with Ken, Curry and I had a rare opportunity to paint the autumn colors. We lived in one of her brother Ron's summer cottages on Hall's Lake in Haliburton, and painted and painted.

We teachers paid for those September weeks of freedom by a lengthened school day for the rest of the year, to make up the time. I was fed up, except that we received a new course of study that let us try expressive illustration, and for me — marionettes!

Chapter 13

ONE FINE DECEMBER DAY, while in London, I had taken a walk on Hampstead Heath. At the top of the hill, I saw my first ever Punch and Judy show, and it was grand fun. It was the memory of that day that made me keen to try out puppetry with a group of art students. Each of them was to make, dress, and operate one character and share the responsibility for scenery and furnishings. The students were to come to class with penknives for carving the heads out of balsa wood. By the end of the afternoon there were three plays planned and parts decided: a hillbilly melodrama featuring an evil landlord with designs on the virtue of the daughter of the house; Jack and the Beanstalk; and an episode of the Tarzan story.

Making the marionettes involved thinking three dimensionally and functionally — not only establishing proportions of the body, human or animal, but also analyzing the movements necessary for head, torso, legs, and arms,

and designing appropriate joints. Feet had to move up and down at the ankle, but turn only slightly from side to side. Legs must be able to swing forward up to the head, but less freely backward. Knees must not twist sideways. Arms are more complex. The wrist moves at right angles to the action of the elbow, while the shoulder is capable of swinging in a complete circle. Arm, legs, and hands were carved from pine, either with metal pins through the joints or with leather hinges, loose or tight depending on how much flexibility was needed.

I think this was when I really learned the lessons of drawing that the teachers in London had tried so hard to teach me. I came to think structurally and functionally, and to teach the students to think this way. I began to appreciate the human body as a series of simple cylindrical parts of differing proportions, some tapering more than others, all basically dependent on the solid rectangles of shoulders and hips, capable of bending and twisting in relation to one another. We learned to think of the head as a sphere that lengthened in front to a face with the two sides set at a characteristic angle, the features less important than the basic structure.

The naked puppets were already full of personality. Their hands were carved with clumsy fists or delicate fingers, suggesting the character to come. Feet were made with high-heeled pumps or heavy boots, as demanded by the role. By the time they were dressed, they were "in the part." Before we were through that first season of puppetry I had taught (sometimes after having to learn) how to weave a straw hat, the anatomy of a gorilla, pattern drafting for men's and women's clothing, wig-making, stage design, research into period

furniture and dress styles, voice production, diction, stage movement and its relation to character and mood, tailoring, and dressmaking.

We were committed to producing the three plays as a feature of the annual spring bazaar, when the school brought the public in to see what a technical school was all about and made a few dollars by selling baked goods, pottery, and tickets for the auditorium show, which had an enviable reputation for professional finish. Added to all the usual director's nightmares was the mechanical perversity of the actors: joints that came apart, leaving a leg hanging in mid-air; screw-eyes that fell out of the soft balsa wood; strings that tangled. (The other great difficulty was the attraction they had for students wanting to sneak in to watch the rehearsals. My classroom was a madhouse.) Balancing such disasters was the unexpected strength of the personalities of the little creatures. They became people, and we fell in love with them.

Amid all the confusion, the core workers repaired marionettes, revised the design of joints, untangled each actor's nine long lengths of nylon fish line, rehearsed lines, and practised manipulating the control bars to achieve realistic movement.

That first year we were rewarded by ready laughter. Other years, when we did *Romeo and Juliet* and *Uncle Tom's Cabin*, expecting them to be hilariously funny, they turned out to be poetic. Our tour de force, however, was the show that used teachers as the characters, and Heaven as the setting. Peter Haworth, his curly fair hair quite unmistakable, became Saint Peter, in deference to his status as head of the department. He was in charge of the Pearly Gates, which stood

behind him against a blue sky with floating clouds, determining the fate of the other teachers. When the Gates finally opened wide, it was to reveal the back of the school organist, George Graham, with his familiar patent-leather hair, seated at the console of a huge pipe organ, as we saw him in the auditorium every week. He provided the triumphant music that brought the scene to a close. The skit was well received, but it was on the Monday afterwards, when we repeated it for the students who had been unable to see the official performance, that it came into its own. Then, every nuance of voice, every remembered gesture or mannerism was received with a roar of laughter.

The summer after Betty's death, Marjorie and I were able to revisit Silver Island. We paddled back to the familiar landmarks — Mortimer's Point, Eddie Mortimer's farm, and the Kettles, where the water still boiled over the rocks, Dunbarton, and finally Silver Island. On our arrival, we climbed to Spyglass, and scrabbled in the mulch of pine needles and earth at the base of the trunk until we found the screw-top jar holding the note we had written in that golden past — and laughed at its pre-teen solemnity.

That summer, Nory and I were teaching puppetry to the teachers' summer course at Central Tech. Between times I lived a casual life at home, roller-skated with my CTS puppeteers, danced at their parties and gave a couple of notable parties myself, mixing the art students with my Shawnees and some of the student teachers, and finding that they combined well.

In the fall, Dawson Kennedy and I chaperoned a house party of art students for a weekend of sketching on Lake Erie.

At my return to Normandale, I was suddenly swamped with memories. Every little irregularity in the ground was familiar, and I felt all my sixteen- and seventeen-year-old emotions come flooding back. I found myself not in the least amused by my teenage self, rather more appalled by my grown-up one. How earnest and how determined we were, and how gay; yet, we were closer to war than I had ever known. For weeks we had lived with the cold certainty of disaster coming, watching the world moving inexorably towards it.

Around that time, at the end of a Saturday sketching east of Toronto at Rosebank, I saw a vacant cottage. There was a For Sale sign on it. I walked around it, peering in the windows, and called in to see the real-estate agent whose name was on the sign. I told him what interested me about it and what I didn't like. He said that he knew of another that might suit me better, and made a date to show it to me.

The small stucco cottage sat on a steep wooded slope above a long grassy meadow. From the cottage I could see a small woods beside the ravine on the left. "What about that land down there?" I asked. "Is it for sale?"

It was.

"November 2: I'm too excited tonight to bear it alone. Today I went crashing around in the weeds and thorns and burrs and ended up in a heavenly spot, twelve acres on the corner between the bluffs and a great lovely ravine, nature on three sides. It's a perfect spot! And it's mine for $1,500. I have abandoned a new car and a year abroad with scarcely a backward glance, except to assure the year abroad that it's just postponed. Height! Woods! Lake! Please, birds. And, as someone reminded me tonight, probably poison ivy."

I drew house plans and dreamed dreams. Mother labeled

it "that fool's paradise of yours." I put it in capital letters and made it official, and dragged my friends out to see it and pass judgment. Then the blow fell. The owner raised the price, and my dreams crashed to the ground. For the rest of the winter and the following spring I stayed away, viewing it only from the hill across the ravine, feeling that my eagerness had betrayed me. Before the school term ended in spring, 1939, I asked a lawyer friend to get in touch with the realtor again. This time the price was reduced to $1,250, and included a road down the hill and along the flat to reach it.

The deal was done.

In August I returned to Georgian Bay with Nory for some serious painting. On the drive home, we stopped at a little roadside stand to buy cigarettes and heard that war had been declared. Nory wept all the way home.

In the spring of 1940, the German blitzkrieg swept across Europe, France fell, and the war became as terrifying as our nightmares. Nory and George were married that summer, too late to save him from being drafted into the army. Betty Priestly and I were bridesmaids — twice. Nory and George had adopted the Baha'i religion and went through a Baha'i service a couple of days after the conventional one in a church. Nory was dismissed from her job at Tech, as expected, but when night school opened in September, Peter Haworth was able to hire her for a couple of classes a week.

That summer, too, my brother Ken remarried. After Betty's untimely death, he had depended on housekeepers to care for the children, with occasional help from Shirley Caswell, Betty's younger sister. Shirley was a nurse, who had frequently stayed with them to see Betty through her

bouts of asthma. We were all delighted with their decision to marry.

Of me, Mother remarked to my friends gathered for a dinner before an art gallery opening, "Oh, nobody would marry her." And so it seemed. I understood Mother's fear of losing me, but realized that the remark was also a reminder that I was damaged goods, a Bad Girl.

Two nights later, a young medical intern, a photographer who was working with me to produce a poster for CGIT's big anniversary celebration, came to the house for a conference after work. He was on duty at the hospital until ten, so it was almost eleven when he arrived. We had tea in the studio, and worked out the details of the poster satisfactorily. At twelve-thirty, as he was leaving, Mother appeared at the head of the stairs in her dressing-gown — and a fury. "Do you know what time it is?" After I hustled him out, she had much more to say, concluding with "Never ask that man here again."

I didn't argue, but I could find no excuses for her. Lloyd was a gentleman, eminently eligible. I was thirty years old. In the morning I put my case to her. It was her house. She had a right to make the rules, but I was going to move out if she would not let me choose my friends and bring them to the house without having them embarrassed or treated with rudeness. "Think it over."

When I came home that night, I asked for her decision.

"I don't know what you are talking about," said Mother.

"I meant what I said," I replied.

"Don't be ridiculous" was her last word on the matter.

A week later I had found a space with a widow glad of someone in the house. The big rec room in the cellar became

my studio and living room. Her laundry, beside it, was my kitchen, and we shared the bathroom between our bedrooms on the main floor. A side entrance gave me real privacy. For seven years we were comfortable housemates, independent but supportive.

I called often at home, hoping that Mother would modify her implacable silence. She didn't, but Grandfather was always glad to see me. He regretted my moving out and missed me, but never reproached me.

When Charlie Goldhamer and Carl Schaefer left the art department to become war artists, Virginia Luz — slim, dark, pleasant, and a former student — was taken on to handle Nory's classes in illustration. I had more senior drawing and painting classes than before — challenging, but rewarding too. Dawson Kennedy was a tower of strength, more and more appreciated as the pressure mounted. He developed a course in camouflage to make his design and color-theory classes more obviously relevant.

There was a proposal to take over the school for a training center for soldiers, and for several weeks we taught surrounded by the cardboard cartons in which we had hastily packed the contents of all our cupboards and storerooms. Mercifully, that plan was shelved in favor of keeping the school open twenty-four hours a day and running training courses for the armed forces in two shifts, evening and night.

It must have been a year later that Virginia Luz and I were on our way to the teachers' dining room, when we came upon a big white balloon lying on the floor. We rescued it and carried it with us. The art department filled the first

table inside the door. We bopped Peter on the head with the balloon, someone seized it and threw it in the air, and it went from hand to hand around the room and finally disappeared among the shopmen. After lunch, Ginny and I happened to go to Peter's office, in time to hear him answer the telephone and start to laugh. He turned bright red, pulled his face to an exaggerated solemnity, and promised that it would never happen again.

"That was the principal," he said severely, "shocked by the behavior of the two young ladies in the art department." But he couldn't keep a straight face. Our balloon was an inflated safe.

The war years, with the small staff carrying extra loads, were gruelling. The worst of them followed the summer that Peter and his wife had spent out West, flying from airfield to airfield, painting the installations and the life of the RCAF. (During World War I, Peter had been shot down, wounded, and badly shell-shocked.) He returned to school exhausted, edgy, unreasonable, and more demanding than ever. We had all learned long since never to argue with him. It was best to wait for tomorrow, when he would be over his anger and might even laugh at his display of temper. But that year strained our endurance.

To make things worse, one summer afternoon, Roy Wood drove out to Fool's Paradise to tell me that Grandpa had been stricken with a heart attack. The doctor had been called, but Mother was up at a friend's cottage on Lake Simcoe.

The dear old man was already heavily sedated when I got to the house, but he knew me. I sat holding his hand until early evening, when Mother arrived and ordered me out of the house. He died that night.

I was unable to believe that Mother could be so cruel, but there was no relenting; she even refused to tell me the funeral arrangements, although she could not prevent my finding out. I sat through the service, alone, at the back of the chapel.

Chapter 14

WHEN LOVE CAME, it caught me unawares. For many years the two of us had been associated in the education world and, increasingly, friends. We worked well together and enjoyed each other. He was a comfortable, understanding person, intelligent, with a notable sense of humor and enough foibles that one laughed at him as well as with him. I could talk to him about things that were important to me, and he listened. I had often met his wife socially, assumed a good marriage, and had no thought of complications ahead.

One late afternoon, at the end of a meeting that had been taxing, concentrated, and creative, we sat under the trees to talk it over and share a sociable cigarette before we went our separate ways. It was October at its most genial, golden in the warm sun. His kiss was gentle, but its effect was metamorphic. I drove down to Fool's Paradise in a turmoil of surprise and recognition, tenderness and terror.

Living in my own little flat had given me back the free-
dom of my diary, and I wrote out the emotions of those
first tormented up-and-down months. I fought against fall-
ing into such a profitless love, struggling to be content with
companionship, lying awake nights in anger and despair,
weeping on Marjorie's shoulder. By early November we had
agreed to stop seeing each other.

"November 6: I'm glad it's done, and I'm more terrified
of going on than of stopping; but I still feel the way I did
the week war was declared — as if my world had suddenly
fallen apart, and I'm sick with loneliness and fear of my own
weakness."

The renunciation didn't last, of course. Our love grew in
secret, and we came to accept secrecy as the price we had to
pay. It also became a considered decision, after counselling
by a wise woman who was also a doctor: we would welcome
this rare gift. I am forever grateful for that. We knew pas-
sionate mutuality, unfailing understanding, a heightening of
every shared occasion, and continual opportunities to work
together. I had not been an actress all my life for nothing,
and his normally impassive face could be an effective mask.
Everyone loved him, so our friendly companionship was
unremarkable. We were discreet.

So it went for half a year, until a crisis in his family
wrenched us apart. Nightmare weeks followed. I was a shell
going through the motions of living. I can still relive the
winter Saturday when at last he telephoned and I flew to
meet him, to be held in his arms and sob out my desolation.

But I couldn't live on one hour in six months. In despera-
tion I wondered if it was love I needed, rather than him, and
for the first and last time in my life I picked out an eligible

man and made a play for him. He was a sweet young doctor, who rose like a fish to bait, which I found somewhat comforting in my emptiness. He was on the rebound and was as willing to fall in love as I was. Although our affair ambled along for more than six months, neither of us found what we were looking for and we parted by mutual consent.

I have forgotten the slow steps by which my darling and I crept together again. We were even more cautious, more discreet, but neither one of us could sustain the separation. For six years after that, we were together, often, hungrily, our friendship as important as our love. I am a good actress but a poor liar, and it was very hard for me to be less than candid with the friends who were close to me. Marjorie knew about us, of course, and had become sympathetic. But one Saturday morning, two other friends arrived at Fool's Paradise on their bicycles when I was expecting him. I sent them away on some poor excuse. That still shames me.

The time came when I was no longer able to content myself with the half-loaf. I wanted marriage, his children, to walk arm in arm with my head high. Soon it would be time to move permanently into Fool's Paradise, and I was tired of half-truths and evasions. His circumstances at that time made me feel that he could break with his wife without involving me. It seemed to me to be now or never.

When it became apparent that it was not to be now, that he could not take the difficult step, I decided that we must go back to being just friends. I practised saying, "I don't need him, to hell with him," while I weeded the garden. It wasn't very convincing, but it was practice at what I have come to believe — that if you act the way you wish you felt, you will eventually feel that way.

I made the rules: we would be in private as we were in public, with no more lovemaking, no more intimate talk. We both respected the conditions, which left us free to feel however we chose, but bound us to behave by the book. And in all the years of friendship that we enjoyed after that, a friendship that came to include his wife, we continued to know the marvelous comfort of each other's understanding and affection.

I have no regrets, and believe now, as I did then, that a love that cares for the other person more than for oneself is not sin in the eyes of God. I also know that it takes real toughness to defy a social taboo, a toughness that I had but he could not summon.

The other love of my life was born at the same time and has continued to grow. It was the very day of that first kiss that I drove down the track (it could hardly be called a road) to Fool's Paradise and found the skeletal outline of a house, floor joists in place and the framing of the outside walls. Before the snow fell, it was roofed and sheathed, a little white box of a house with a blue roof, looking as if the first strong wind would blow it away.

The well had been dug down fifty-two feet (sixteen meters) before finding water, and beside it was the mountain of clay, sand, and stones that had come out of it. Working by the bucketful, I used the earth to build flowerbeds around the house to hide the foundation posts and, eventually, to give the driveway a crown that would keep it dry. The well-rounded boulders, souvenirs of Lake Iroquois in prehistoric times, made my first rock garden around the blue hand-pump that delivered water from the well — or refused to

deliver it, almost as often. There was no money for plants, but so many friends brought perennial roots and envelopes of seeds that I could hardly keep up with the planting. When the government offered trees for reforestation, my friends and students planted the steep slopes of the bluffs and the ravine with willow twigs to fight erosion.

Forest Telfer was my builder. It was his mother-in-law who had taken me as a boarder when I left home, and he was already a friend. He had such sympathy for my vision of a dream home that he gave me the stone-faced fireplace I could not afford. Although the house was little more than a shell, it satisfied the zoning regulations. The area was restricted to single-family dwellings of a value of at least twenty-five hundred dollars, a respectable sum in those days. Without electricity and running water I couldn't hope to use it except as a cottage, but during the war years I worked away at the inside, insulating, wiring, lining it with knotty pine, and building shelves and cupboards, so that if and when life returned to normal, I could make it my permanent home.

Water had been found in a stratum of very fine sand, which seeped through the brick lining of the well and was drawn up into the pump, clogging it. By the second summer Bill Smith, my well-digger, was in a war-production factory, his assistant gone. Bill was sympathetic, but there was no way he could pour a cement lining for the bottom of that well without help. It was a triumph that he agreed to use me as his assistant.

Bill was an unregenerate old Glaswegian, without formal education, colorful of speech, but a careful workman, establishing the winch firmly above the opening, using good new rope. I was lowered on a sling into the well, with a saucepan

upside down on my head as a hard hat. I received the buckets of cement that Bill mixed and let down to me, and shovelled them into the wooden form he had built inside the brick lining. A touch of comedy was Bill's "Miss McCarthy" when I was up on top, but "Doris" when I was down the hole and he was hollering instructions or asking if I wanted to come up for a cigarette. From that time on, Bill was my friend, keeping an eye on the cottage and available for laboring jobs as need arose.

I can't imagine when I had time for painting, but I did big watercolors of the marionettes in action, and of the garden flowers bursting into bloom around me, as well as snow canvases of Haliburton, which was still my refuge at Christmas and Easter. I even spent part of the summer of 1941 down on the Gaspé coast. Early in the war I had solo shows at the Beaches Library, at Wymilwood (a women's residence at Victoria College), and at Mellor's Gallery, which later became the Roberts Gallery. And I always showed in the juried exhibitions of the societies.

Way back in the Thirties I had achieved the necessary three consecutive acceptances in the annual juried show of the Ontario Society of Artists. I had approached Fred Haines, then the president, suggesting that I was now eligible for membership. He seemed amused at my temerity and sent me away abashed. But in wartime, with many of the men serving as war artists, women were gaining a higher profile. My 1944 solo show at Wymilwood was followed by one at Simpson's, which was given some publicity and well attended.

The next spring I was duly elected to membership, proudly able to sign OSA after my name and to attend the

monthly meetings at the Arts and Letters Club with all the greats. A.J. Casson had succeeded Fred Brigden, L.A.C. Panton, and Frank Carmichael as president, with George Pepper, Jack Bush, and Sid Hallam as vice-presidents in the offing, and York Wilson, Cleeve Horne, Sydney Watson, and Peter Haworth ready to take over the presidency when the time came. They were a strong group, and recognition by my peers meant far more to me than sales, which still hardly covered the cost of frames.

My first venture into modernism was an abstraction of Fool's Paradise and the bluffs, with the angel that had become my logo. (One afternoon up at the Delicious, the Greek restaurant where students and teachers used to gather for a cuppa after school, Bob Ross had scribbled an angel on a paper serviette for me. I carved it in pine to be my weathervane, and it appears later in my rugs, mobiles, and paintings.) It dominated this recklessly modern (for me) canvas, which was accepted for the OSA juried exhibition and earned a press mention. Great excitement!

Carving puppet parts had introduced me to the pleasure of a sharp knife and a block of clean-grained pine. To keep my hands busy while my puppeteers worked, I had carved the figures for a Christmas crèche. Dawson Kennedy taught me the medieval method of polychrome finish over a gesso base, as well as the careful craftsmanship needed to paint miniature gems set in gold filigree on kings' crowns. For Christmas, I made another set for Marjorie, and later, for others.

Basil English, the young rector who had succeeded Dr. Cotton at St. Aidan's, asked me to carve a large set for the church. I agreed, on condition that the church provide the

wood — two-inch slabs of laminated pine, bonded with the grain at right angles. (Mother had withdrawn her promise of a loan to finance Fool's Paradise; and I was in debt to the bank, squeezing pennies.)

For three years I worked away at those figures, graduating to chisels and U-shaped gouges, but too diffident to use power tools. I had to feel my way slowly, and hand-carving suited my pace. It took me a year to finish the Holy Family. I had designed Mary as a young peasant girl, kneeling at the side of the manger, one hand ready to draw her veil across her face. Joseph's hands are together in the gesture of prayer. And by a chance that pleases me still, Joseph looks like my father. The next year I added three shepherds, using my cat as a model for the anatomy of the lamb in the arms of one of them, and a year after that the three Magi were complete. Eventually, I decided to add two kneeling angels, and one was soon ready to paint. As I didn't get back to working on the second one for more than fifty years, I would remind my friends that many people consider Michelangelo's unfinished captives in the Boboli Gardens to be his masterpieces.

Every autumn after that, on a day when the school was given a half-holiday to attend a rugby game, I would call for Basil and take him out to Fool's Paradise for an afternoon of labor. There were some huge oaks in the woods up back of the field. One had fallen in a storm, and we worked away in a steady rhythm, back and forth, back and forth, cutting it into segments that could be drawn on a toboggan back to the house and eventually split. Sometimes Kay, Basil's gorgeous wife, was with us, and she would have supper under way by the time we had finished with the cutting. As soon as

I was able to get furniture into the house I planned a Christmas party, which became an annual institution.

By 1944, gas was strictly rationed. My allowance would take me to Scarborough and back from the Beach, but not to school, and certainly not to the Gaspé to paint. Nonetheless, through the Red Cross nurse whom I had met there in 1941, Virginia Luz and I were able to borrow a house, and we took off by train for a month of hard work. The Kennedys and Curry arrived a week later and settled into cabins not far away.

On our first day out, Ginny and I were arrested by the military police for sketching near the railway bridge. We protested that we had made a proper application to Ottawa to be allowed to paint on the coast, that we were highly respectable citizens, well known in our home town of Toronto, and that we had a telegram at the house granting permission.

But a telegram has no identifiable signature, so we were bundled into a jeep and driven up the coast to the district military headquarters. There we were left to cool our heels for a couple of hours, in Colonel Pineau's office, closeted with all the maps and official papers. It was almost a pity not to be a spy.

I was working in oils that summer, and for the first time tackled some on-the-spot canvases. I had made a train-worthy crate with slots to keep the paintings apart, and I found it exhilarating to move beyond small panels.

It was on the Gaspé coast that I began the analysis of form that has stood me in good stead ever since. Drawing the changing ribs of a boat, both the ones I could see and the ones that were hidden, gave me a trustworthy contour of hull and gunwale. I learned the lesson that I drilled into my

students from then on — that relationships must be under-
stood before they can be drawn, that form follows function,
and that what you don't see is as important as what you do.
Sometimes I used to give students something to hold behind
their backs, and expected them to draw it without seeing it.
A good exercise.

Chapter 15

THE WAR WAS OVER.

After the first heart-leap of relief I realized that with its end also came the end of our sense of common purpose: the relinquishment of self-serving materialism, and the willingness to make routine, if minor, sacrifices for the common good. For me, it also meant the war artists would return, that Charlie Goldhamer would take back all the senior painting classes, and that I would be demoted to teaching the lower grades again.

But the end of the war also meant that I could hope for electric power at Fool's Paradise and everything that could follow: an oil furnace, hot and cold running water, and permanent residence. My original house plans had not included a cellar, but having become a gardener I needed one for storage, and I decided to put a huge cistern in it. The ground-level utility room could become a delightful bedroom if I cut a big window in it looking towards the ravine. Behind the

kitchen I would add a studio-workshop over the cellar, and a garage behind that. I still didn't know whether I was building a dream home to share with some future beloved or a spinster's retreat. I kept my plans open for a wing to accommodate my hopes and in the meantime began working on phase two.

I drew up my plans to scale and managed to get them passed by the Scarborough building department. It was a great moment when I posted my work permit on the cottage. I had decided to be my own builder and to look for local tradesmen to do the difficult technical jobs. The man who agreed to dig the foundation and pour the concrete was either a fool or a crook, I don't know which, but, after he had done his worst, I had honest workmen. I located a good Scottish carpenter who agreed to come on Saturdays.

My right arm was suffering from too many buckets of earth and too much gardening, and could no longer hammer heavy nails; but the carpenter knew a man not long out of hospital, who couldn't lift weight, but could hammer. With a seventh of a carpenter and my half-man, as I labeled Syd Alexander, the addition was framed up on the concrete foundation, sheathed, roofed, and made ready for the plumber and sheet-metal workers. Syd and I worked steadily and amiably all week, and waited eagerly for words of praise when the carpenter came on Saturday. "Mm-hmm" was the most we ever got from him. He cut the first rafter for us to use as a pattern, made sure that our bracing was sound, and hung the doors and windows. I spent an hour or two every night cleaning up the site to ready it for the construction work the next day.

With the hill and winter roads in mind, I bought a war-surplus jeep, ideal for chasing around after the building materials that were increasingly hard to find, and adequate to take me back and forth to school once term started. (Dawson Kennedy once sent me a postcard addressed to "The Girl with the Jeep, Scarborough," and it reached me in better time than many a letter today.) It had no second seat, but a box with a cushion on it served, and I got used to putting out an arm to keep any passenger from falling off when I turned a corner.

I taught Virginia Luz to drive. At her test, the examiner objected to her method of signaling turns. As the side windows of the jeep were fixed pieces of Plexiglas, I had taught her my system of holding a hand up at the back window and gesturing right or left to warn the car behind. The examiner insisted on conventional hand signals, which meant removing the side panels completely, but Ginny always suspected that her success in the test was partly due to the way the wind then caught her full skirt and sent it billowing up around her neck.

My fears about my postwar timetable were justified. Peter Haworth avoided me when making up the complex charts on which he sorted out teachers, classes, and rooms, with Ginny as his assistant. She did her best for me, but I used to lie awake, fighting my resentment and sense of injustice. I was the most active painter on the staff and had been handling senior classes with success; but Peter still gave me the timetable that I had inherited from Edith Manning. Ginny had come on the staff ten years later than I, but had walked into Nory's senior classes at once. I found this hard to bear.

After the lifting of gasoline rationing, I planned a painting trip down to Quebec with a couple of friends. Peter gave me the name of a good pension at Cap-à-l'Aigle, and we booked ourselves in for a few weeks in July. Only afterwards did I discover that our dates there coincided with Peter's, and I was appalled. The last thing I needed! But to change plans would have been too obvious, so we decided to make the best of it.

Those weeks with the Haworths were a turning point in all our lives. Peter and his wife, Bobs made us warmly welcome and took us out in their car to show us the best spots for sketching. The first day as I was laden with my gear, Peter opened the door for me. I was stunned, and began to feel like a woman instead of a bootboy. I relaxed, and we began to enjoy each other. Peter and Bobs seemed to take it for granted that we would all go together to paint and share the picnic lunches that were packed for us. Every day became a party. I could hardly believe that this was the petty tyrant I worked for at school.

One night, shortly after we were all in bed, we discovered a bat flying around the room. True to my newfound role of helpless female, I cried out for Peter. Then I thoroughly enjoyed the mad ten minutes of lamplit noise and confusion as he rushed about in his pyjamas to rout the little creature and rescue us three maidens from peril.

I did not, however, like my work that summer. My sketches were pedestrian, competent but boring. I struggled on, creating my honest, tedious landscapes; but I was yearning for a change of impetus and direction. I found it a year later. Back at school we had an influx of veterans getting the education they had missed by going into the armed forces.

For many it was a valuable second chance at the careers they had been denied by the Depression. Most of the rehabilitation students were men, but there was also Smitty, a stocky CWAC sergeant, who could, and occasionally did, lay a large man on his back.

One gift of the rehabs' program was that they crowded the department to the point that I was needed for advanced classes and at long last had a satisfying timetable. The other was Dino Rigolo. He had come to the department early in the war, a young Italian immigrant, sweet, merry, very talented, with sideburns that made him look like a gigolo. Halfway through his second year, while still technically an enemy alien, he had been drafted into the army. On one of his leaves he had come back to visit us, in khaki shorts, sideburns gone, his hair brush-cut, as sweet and merry as ever, and so attractive that I could hardly keep my hands off him. He returned as a rehab and was outstanding even in that good group. When Dawson Kennedy took a sabbatical leave the next year, Peter took Dino on as his replacement, and every grade nine and ten girl fell madly in love with him. He went on to the National Film Board, and well deserved the Canada Fellowship for overseas study he won there.

After the years of restricted travel, I was hungry for the sea. The Atlantic coast closest to Toronto turned out to be Maine. In Gloucester, a village full of artists and art schools, we called in to see the Romano studio, with its dozen or so students working from a model. I came out somewhat drunk on color and paint, determined to throw caution to the tidal pools.

I began working with primary colors, raw or lightly stirred together rather than mixed, using black paint joyfully

and without regard for realism, letting pure white separate the forms and act as a foil to the color. This was fun!

The next summer Peter and Bobs drove me down to the Gaspé, and I had the satisfaction of introducing them to wonderful Barachois and Bonaventure Island. That July, and off and on for twelve years afterwards, we stayed with Liza and Willie Jean, of Jersey stock like many of the coastal families, English-speaking with a French lilt. Liza's sister, Ceci, came down from Montreal on her holiday to help out with the visitors. Meals were beautiful, served on china that had come over with Liza as a bride. The lunches they packed for us were works of art.

The Kennedys, who had originally discovered the Jeans, joined us that first summer and often afterwards. Virginia usually, other friends from time to time, and family occasionally also came. The Jeans' guest-book has the names of many artists and their friends scattered through its pages. After breakfast the cars were packed and we took off, sometimes in separate directions, sometimes together. Lunch was always social, eaten among the cod-heads and fishing gear on the dock or huddled out of the wind beside a shed or a beached boat. We used huge umbrellas to give us shade for working, guyed three ways with ropes held by stones or driftwood. Twice a day, as the tide changed, the wind shifted and the ropes needed to be adjusted or the umbrellas moved to follow the sun.

The hour we all looked forward to and shared was tot time. We gathered in Willie Jean's tool shed, which he allowed us to use as a studio. The faint smell of fish, old wood, and gasoline was part of the charm. Drinks in hand, we approved, or tried to approve, or questioned the day's

work pinned up or leaning against the wall. By the end of the second drink, candor was apt to overcome tact. I cared more about Bobs' opinion than all the others'. She never flattered, and her silence spoke volumes. When she praised, my spirits soared. I also learned from studying her work. Knowing her subjects, I could appreciate the twists of perception, the puckish humor, the lovely personal color that she used.

Throughout the winter, the monthly meetings of the Ontario Society of Artists continued this experience of being an artist among artists. A feature of the annual juried show was a special section for which twenty or thirty artists each painted a picture based on a theme chosen by the society or constructed a large didactic panel illustrating some principle of color or composition. After the show closed, that section was sent off on tour to galleries, schools, and colleges across the province. As a member, I was committed to producing something for this section each year. Thus, I saw my work in relation to that of the senior artists — L.A.C. Panton, A.J. Casson, and all the others — and was reassured that it stood up well.

I had never stopped trying to see Mother, calling at Balsam Avenue and having the door closed in my face. It was her friend, Mrs. McGill, who told me when Mother sold the house and moved to a bungalow in Birch Cliff just east of the city. I called there, too. She usually opened the door, said, "What do you want? I have nothing to say to you," and closed it. But shortly after the end of the war she said, "Do you want to come in?"

We had a polite formal visit of about ten minutes. I went again soon, and again, and again, the calls getting longer

and easier. But she would never come to Fool's Paradise — until the summer of 1949, when Cousin Florrie and Dotty, Grandfather's niece, were coming out to spend the day with me. They were both of Mother's generation and I urged her to help me entertain them. As she considered herself giving rather than receiving, she graciously consented. I drove the three ladies out to Fool's Paradise, lovely with the garden in its August bloom. Lunch was served on the porch, and we sat afterwards in the shade of the big tree on the lawn, Mother working on one of her cutwork tablecloths while we talked and had afternoon tea.

When I excused myself to start making dinner, Mother asked if she could help. I was so unwilling to say no to anything she suggested, that I asked her to pick me some ripe tomatoes from the garden behind the house. As Mother carried them out of the bright sunshine into the comparative gloom of the studio, she failed to see the cellar stairs just inside the door, stepped back, and tumbled down the steps into the cellar, breaking her back.

The doctor whom I called refused to come. I called an ambulance, called my brother Doug, and left Cousin Florrie and Dotty gossiping on the lawn in comfortable ignorance until help had arrived. Mother was in great pain and had to be lifted out of the cellar on a stretcher, with no room to turn it at the top of the steps.

The ultimate irony was that I was the one who received the most sympathy. To have this happen the first time she was at my home! Perhaps there was also irony in the way that my weeks of daily attendance at the hospital dissolved the barriers between us.

My friends visited her in hospital and then at home. Marjorie lived a couple of blocks away and dropped in often, with homemade bread or cookies. Roy was wonderful, doing the man's chores that Mother found for him. Neighbors enjoyed coming, for she could be entertaining and amusing when she chose. From then on, Mother accepted me as her daughter, her confidante, her support.

Virginia's mother died as school began that fall, ending a two-year, courageous fight with cancer. I suggested to Virginia that we were both due for sabbatical leave, but that her long ordeal with her mother gave her priority. Did she want to take next year off? If not, I did, and would apply to Peter. I would wait for her to decide.

We don't remember who said it first: "Wouldn't it be great if we could go together?"

Peter said, "It would be all right with me, but the principal would never let two people go out of one department."

We put our question to Graham Gore, the principal.

"It would be all right with me, but the director of education wouldn't release two of you at the same time."

Down we went to see the Big Boss. Before he answered us, Archie Morgan filled his pipe, lit it, put his feet up on the desk, and took a great pull.

"I think it's a hell of a good idea," he said. "You'll have a much better time together."

A few weeks later, January introduced 1950, the year I was to turn forty. I was no longer self-conscious about my failure to marry. Most of my close friends were in happy marriages, but I could see the compromises and sacrifices

by which they earned that happiness. They would not have changed places with me for the world, but I was realized that I didn't want to trade places either. In the art community I was at home with both men and women, content with friendship and no longer yearning for romance.

Mother's six years of ostracism had given me six years of independence, in which I had found fulfilment as a woman and some confidence as an artist. I had become a happy teacher, secure in my relationship with my students, giving them riches that I had had to dig deep to find for myself. I was no longer afraid of being outshone by my students; their brilliance was my delight.

I had my own home in a setting that seemed to me close to perfection. The saplings that my friends had helped me plant were becoming trees, the shrubs were spreading to fill the gaps, and the borders were full of blooms. My two cats, Nicky and Tammy, had rabbits to chase, pheasants to flush, a fox to bark improper proposals to them after dark, a life of such freedom that I envied them and longed for the day when I too would be able to enjoy Fool's Paradise even on weekdays.

My salary allowed me to paint, whether or not I made sales. I could pay my taxes, buy my supplies and frames, and live carefully but comfortably. I could afford painting trips, theater tickets, and even feel well-dressed.

What I still wanted badly, and was willing to strive towards with all my dedication and energy, was growth as an artist. Every Thanksgiving or Easter at Haliburton was a new challenge that I approached in fear and hope. I realize now how dependent on others I was for my own judgment about my work, and it would be a few years more before I

was given the public recognition that would build my confidence and let me enjoy the results as well as the process of being a painter.

In the meantime I was heart-free and rich in friends. Marjorie was closest, of course, the one person who had always believed in my work and in me. She would be Mother's daughter while I was away, enabling me to go with an easy mind. And when some well-wishers said, "You'll meet some nice man," my laughter was genuine. I had what I wanted as a woman and the prospect of a whole year to explore as a full-time artist. Was this not happiness?

Chapter 16

TURNING FORTY might have been traumatic. Observation told me that it is the time when women search for gray hairs and men bulge at belt level. Yet, it can be a moment of truth, when youth is gently relinquished, goals are re-evaluated, and changes made while there is still time. So it was for me.

The year that would see me pass that landmark, 1950, promised great things. Since 1932, when I began teaching, I had been struggling up a long tunnel crowded with obstacles that took all my strength and ingenuity to avoid. There must be beautiful light at the far end, but I knew that the tunnel was forty years long, and I had not yet reached the half-way point.

I had been teaching for all those years without a break, slogging my slow way from vocational students with neither talent nor interest in art to painting classes for the senior art students. The work had become richer and more satisfying, but also more demanding. I was determined to earn the

respect the students had for the men I was replacing: Charles Goldhamer, Carl Schaefer, and Cavin Atkins, all well-known exhibiting artists. I had, therefore, since 1930, entered every available juried exhibition and organized solo shows wherever I saw an opportunity. In 1944 I had achieved membership in the Ontario Society of Artists, while carrying a heavy teaching load and managing a tumultuous personal life.

Suddenly the tunnel turned a corner. Ahead I could see a sabbatical leave, a full year free of teaching and hurry, free to paint, to breathe deeply, and to find out what it felt like to be a full-time artist. It was also an opportunity to compare emotional freedom and my commitment to the man who had filled my horizon for most of the previous ten years.

We were told late in December 1949 that our year off was to start the following June, twelve months earlier than we had expected. The veterans' rehabilitation classes were to be terminated at that time; the war artists were back and, until Edna Jutton's retirement the following year, the department would be overstaffed. We could be spared in 1950 better than later. The sudden prospect of freedom raised us to the heights, but a leisurely year-and-a-half of planning had been reduced to a few months. The first question was, could we find the money? Virginia had few savings, and the half-salary she would be drawing while on leave would not go far; but her brother, Edgar, rose to the occasion with a generous loan that made up the difference. I cashed in my war savings, and we both began pinching pennies.

Leaving the responsibilities of homes and families was the next challenge. My mother was still able to manage her own home, but the fall down my cellar stairs had taken its

toll. She was far more dependent on me than she had been before. However, Marjorie, who had known Mother almost as long and almost as well as I did, lived just two streets away from her.

Hardest of all to leave was Fool's Paradise, which was gradually becoming my dream house. It had been enlarged by the addition of a studio and garage, softened with flower-beds and shrubbery, set out with fruit trees, and bordered with pines and maples. I was permanently in love with the place, but I had learned long since that when you choose what you want most, you must not begrudge the price. Two camp friends agreed to live in my house and adopt my cats. I knew they would love it and them.

Our intention was to drive about Britain and Europe, painting as we went. The car was to be delivered to the boat on our arrival in Liverpool, and both Ginny and I were keyed up with the tension of such a major purchase — about nine hundred dollars each, more than two months' salary. We decided on Britain for the summer and fall, northern Europe until Christmas, then south to Italy and France. (I had hopes of getting Ginny as far as Greece, but she hadn't shown any enthusiasm for it.) The very names were magic. In 1935, when I had been studying in England, there had been neither time nor money for such adventure, and for Ginny it was all new.

I am quick to seize on an idea, and ready to adopt it immediately. Ginny says no at once, to slow me up and give herself time to think it over. I let her warm up to an idea until we can talk it through and come to some agreement. We had no problems that could not be resolved by compromise, and we both valued peace more than getting our own way.

One of my nagging worries about going to England was that rationing was still in force, and cigarettes would be scarce. I was not a heavy smoker, but was quite equal to going out in the middle of the night if I found myself out of the weed. On New Year's Day, 1950, I was leafing through a *Reader's Digest* that somebody had left at Christmas. In it was an interim report published by a team of doctors researching the effects of smoking on health. They had made alarming discoveries. I read through the article, stubbed out my cigarette, and promised myself not to have another until my birthday the following July. On birthdays and Christmas I would allow myself one cigarette, that was all.

It was not easy. For a few days not smoking was a full-time job, which I survived by following the cats around the house with a sketch book and a stick of Conté crayon. Ginny stopped smoking at the same time, but weakened, and I found the smell of her cigarettes a consolation. Even second-hand smoke was better than nothing.

The spring was full of goodbye parties, ending with a gala farewell organized by the art department, featuring student skits based on our probable adventures abroad. I seem to remember camels and pyramids as well as a full-sized two-dimensional jeep, which lived in my garage with its prototype for many years afterwards. A few days before the end of term, Peter Haworth, who had been so co-operative about letting us both go at the same time, put Ginny and me side by side against the wall of the stairwell and solemnly traced an outline around each of us. "Just make sure you fit into that when you come back," he said.

Chapter 17

WE WERE A DAY AHEAD of our sailing deadline, unwilling to take any chance of missing the boat at Montreal and horrified by the news that a sister ship, the *Franconia*, had run aground on the Ile d'Orléans the day we left home. But no mishap marred our voyage or made it memorable.

Expecting to be met by our own car, we had organized our clothing and equipment for the year into small units, easy to handle, categorize, and pack in the trunk and back seat. But we were met, instead, by the news that there would be no car until we had completed some more documents and had them notarized. Notarized? In a strange city, on a Friday afternoon? Not a hope! We dropped off our seventeen small pieces of luggage at Left Luggage, and retired to a café for a conference. How could we get out of this big industrial city and salvage the weekend?

We discovered that Chester, a medieval walled town, was just eighteen miles (twenty-nine kilometers) south. What

life was taking with one hand, it was offering back with the other. Our seventeen bags were put on the train with us and, eventually, carried out of the Chester station and across the road to the Queen's Hotel by a procession of porters and bootboys. By this time we were feeling beyond ludicrous.

The notary we located the following Monday was straight out of Dickens. He peered at us through square, steel-rimmed spectacles across a shabby desk surrounded by shelves of books so aged that their leather backs were rotting away. As he read aloud to us, slowly and carefully, every word of both copies of the forms we had brought him, we gave up hope of quick action in getting our car and decided to cross over to Ireland without it. We re-sorted our belongings, and the Queen's Hotel agreed to store the surplus until our return. After a swing south from Dublin in a rented automobile, we settled into a small hotel in Connemara, in country full of thatched crofts and peat bogs ringed by low mountains.

For a frustrating few days I tried to paint with casein, an opaque, latex-based watercolor, but the latex clogged my brushes, necessitating a thorough washing with soap or detergent every few minutes to keep them pliable. I gave up, and went back to familiar watercolor.

The other hazard of painting in Connemara was the weather. Every ten minutes the light changed, the sun hid behind clouds that then spilled on us. Just as we would scramble to the car to protect our wet paintings, the sun would return, flooding the world with such a glory of color that we raced back out and set up easels and chairs once more.

Those days painting in Ireland would have been idyllically happy if I could have relaxed and been content to record the

country and the weather. Instead, I kept demanding that I produce Great Art, failing as usual to appreciate the good qualities of what I was doing. Only later could I see that my sketches did capture the moodiness of the constantly changing light and the unaccustomed brilliance of the wet Irish color.

When we returned to England after a fortnight and found ourselves still without a car, our patience gave out, and we made up our minds to go to the Austin head office and demand action. London had not been on our schedule until late autumn; but we discovered that we could be there in four hours by train from Chester. London — again after all those years! We came out of Victoria Station just as Big Ben began to strike. For Ginny, this was the voice that held the memories and emotion of those terrible years when her brother Edgar was in the army overseas. She stood motionless and speechless, tears running down her face.

Once in our own car, with our reclaimed luggage, we explored and painted as far west as Land's End and up into Scotland, ancestor hunting in MacDonald country for Ginny as we had done in County Cork for me. We fell in love with East Anglia and heard our first nightingale in a back lane near Long Melford. We laughed at the same things, and one of our mutual pleasures was eavesdropping. In hotels or restaurants, we ate in silence, fascinated by the conversations at the tables within earshot. A day of great celebration was the Tuesday after Labor Day, the end of summer holidays at home, when we were not starting another school year.

From time to time, if we felt the tensions mounting, either between us or in frustration over our work, we would

declare a Sunday and take a day of rest. Our favorite way of spending it was cleaning out the car and reorganizing our belongings. Both Ginny and I love order, and were quickly exhausted by confusion. Early on we had agreed that, on calendar Sundays, each of us should feel free to go to church (me) or stay home (Ginny) without guilt for having abandoned the other.

In Stratford-upon-Avon, we saw *Henry VIII*, the first Stratford production without a proscenium stage. Cornwall and Devon offered fishing villages, familiar from our days on the Gaspé, but new because of the distinctive architecture. My diary is full of the cathedrals and churches I attended.

I had been studied many of these buildings from mean little engravings in textbooks; but now I could feel the buildings vibrate to the organ or share the silences, to delight in the cadence of a scholarly sermon and the unique sound of the boy choristers.

Back in London early in October we settled into the Portland Court Hotel, two town houses just south of Hyde Park and Kensington Gardens. It was respectable, a bit shabby after the war but inexpensive, and soon felt like home to us. Many of the guests were permanent residents, most of whom seemed to be gentry in reduced circumstances, some recently home from India, displaced by the British withdrawal.

This was a different London from the one I had known when I was there as a student fifteen years earlier. This time London meant theater. We saw T.S. Eliot's *The Cocktail Party* on its first run, and *Ring around the Moon* with Claire Bloom.

My biggest excitement was a luncheon date with Dorothy L. Sayers. Marjorie and I had read all her detective

stories, falling in love with Lord Peter Whimsey. We had then gone on to read her more recent books, the translations of Dante, and her religious plays. *The Mind of the Maker*, which explored the trinitarian nature of creativity, was already one of my permanent treasures. When things were at their worst during the war, I had written to her; and her acknowledgment came on a lino print, her own work, nothing extraordinary. Perhaps she was only human, with needs like any ordinary person. I sent her some parcels of hard-to-come-by foods, available in Canada. Her letter of thanks had given me the courage to ask to meet her.

She was a hard-working writer, sparing a precious hour from the play she was completing for Colchester's two-thousand-year anniversary celebration. She was also a shy, very private person, probably appalled at the prospect of having to entertain this strange female from the colonies; but the talk was wide-ranging and lively. The following summer, Ginny and I were at the opening night of the Colchester play, heard Sayers speak afterwards, and joined those anxious to congratulate her. It's the only lion hunting I have ever done. I still marvel that I had the temerity, and rejoice that I did it.

When our scheduled time in England was up, the prospect of leaving its dear familiarity for the continent was traumatic, especially for Virginia, who by nature was less adventurous than I. But we were invited to spend time with the Dutch family who had become her brother's friends when he was with the Canadian army of liberation. They told us harrowing stories of the war, still vividly present. One of their younger sons was having a hard time adjusting to peacetime. During the occupation, he had been encouraged to lie and steal from the Germans; now he was confused by the shift in

ethics. To leave Holland, where people had treated us as if we two personally had been their liberators, was hard; but to venture into Germany, land of the enemy, was even harder, and I marvel that we went at all.

The border formalities under the eyes of armed guards were nerve-wracking, but almost as soon as we were in Germany we felt a difference. It was shabbier but more beautiful than Holland, and everywhere there were Christmas trees, complete with candles and angels.

The next day I determined to get on with something I had promised a friend back home. Her son had been shot down in a plane over a little village called Pattern. He was presumed dead, but she was haunted by the fear that he was perhaps wounded and with memory loss, or carried off to Russia. Would I try to find out what had really happened?

In Pattern, Ginny was sick, miserable, and frightened. She burrowed into her rug and declined to get out of the car. Eventually, a handsome, well-built man, probably about thirty, with a dictionary under his arm and a rueful disclaimer about his English, came to the rescue. Yes, the villagers had seen the plane crash, and all the crew were killed. We walked up the hill outside the village to where the plane had fallen.

In the snowy field with bare trees along the fence line, I was shown how it had come down, where it had struck, where the engine had buried itself, here one wing and here the other, and told of the explosion that blew the poor airmen apart and consumed them in fire. We shook hands and I returned to the car, beside myself with the strangeness of the experience.

We had chosen to reach Oberammergau late in December because we judged that it should be able to offer us a real Christmas. And indeed it did. We stayed at a pension with the widow of the man who had played Christ in the passion play for many years. Her nephew was a potter with a kiln out back and, when he heard that we were from Toronto, asked us if we knew the gift shop on Yonge Street to which he sold some of his work. His "gift shop" was Eaton's.

On Christmas Eve we joined the stream of villagers walking through the sparkling cold night to the parish church, its high ceiling vibrant with flying angels and cherubs, the two Christmas trees beside the chancel burning real candles. There was a full orchestra, and the music was traditional, a setting of the mass written by a local musician more than a century earlier. When we came out into the night, the stars were thick and brilliant in the dark sky, and the churchyard was twinkling with candles on small Christmas trees set up on the graves, to include the friends and family who lay buried there.

From Germany we drove through Austria, painting as we went, and to northern Italy to meet Dino Rigolo, the Italian-Canadian art student at Central Tech who had been drafted into the army and had come back after the war to finish his course. Dino was now doing post-graduate study in his native Italy, and had agreed to be our guide on the way to Rome. He was merry, enthusiastic, knowledgeable, and young. He knew how to find us inexpensive hotels and even cheaper rooms for himself, so he could afford to travel with us and show us the marvels that awaited.

We started off in Venice, in fine fettle — over bridges, through streets like alleys to the Piazza San Marco, sun on the domes, pigeons on the pavement.

In Ravenna, we arrived at San Vitale just as the guard came to open the door. And there they were — glory, magnificence — the panels of the Emperor Justinian and Empress Theodora with their attendants, so familiar from reproduction and so new. I stood with tears running hot down my cheeks, grateful that none of us wanted to talk until later, when we were a bit more used to the sight.

In Rome, we tramped for miles, with sudden stops in front of each masterpiece of architecture or sculpture (or to read the posted menu and decide if the restaurant came within our budget). We were predictably enthralled by Florence, and worked our way north and towards the Costa dei Fiori, for carnival time's gaiety. The excitement never materialized, the joke definitely on us; but there was a sense of high occasion, as it was Dino's last night with us. The next day he would return to his studies.

Ginny and I moved on to St. Tropez. From our windows, we could watch the tops of the tall masts of the sailboats bobbing in the harbor. The work I did there is different from any of my work before or since — higher keyed, full of light and lyrical color. At the time, as usual, I was in despair because I didn't know how to get down on paper what I saw and felt; today I am surprised by how much I did manage to say.

The days passed in golden contentment, but I had something nagging at me. We had turned west after Italy — when would I ever get to Greece? While we painted, I brooded and, one day when we sat together with our sandwiches at lunch time, I broached the subject: How would Ginny feel about flying back to Athens for a few days?

"Not me. But you go if you want to. I'll be fine on my own."

I went, for a hideously expensive, uncomfortable, glorious four days.

I spent a wonderful hour on the Acropolis one morning, enjoying new Athens from above, as well as old Athens. It seemed timeless, so that hour went by in a few minutes. I wondered at the time if the placement of the Acropolis colored Greek theology. One could lean over the wall of the Acropolis and watch life going on down below, as their gods might be doing.

Back in St. Tropez, we planned the balance of the year. Of all the places we had been, where would we most like to return to paint?

We decided to split May between Sussex and East Anglia, to spend most of June at Brixham in Devon, and July in the west of Ireland, with a week in London to recover after each bout of work, and a week of history plays — *Richard II* to *Henry V* — in Stratford.

And so we drove north into winter.

In Paris, at an antique shop near our scruffy little hotel, I saw a fifteenth-century oak Madonna and Child, the very subject that I had imagined in the niche in the hall at Fool's Paradise. The price of the statue was moderate, even by my frugal standards, and I could even cover the cost of air express home. Months later the statue came, by sea freight, packed so carelessly that Eaton's wouldn't have sent it across the city that way. The lovely figure suffered more damage on that trip than it had in the five centuries since its creation; but I was able to glue back the hand and arm, repair

the fingers, and see her standing serene at last, the Queen of Heaven and of Fool's Paradise.

Our return to England was homecoming in many ways, but there was a shock waiting for me when we reached the hotel at Rye. I was handed a cablegram: "Don't come home. I am in good hands. Mother." The rest of the day was frantic. Heart attack? Stroke? Paralysis?

Hotel phones did not allow for transatlantic calls, and the police were not willing to tie up their line with a private call. At last I found a good-hearted woman who ran a bed-and-breakfast who let me use her phone. I called Marjorie, who would know where Mother was and what had happened to her; then I sat for an hour, looking at the telephone, at the tiled roofs outside the windows, at my doodles on the brown envelope, waiting for my call to go through. Marjorie's voice was clear, and she sounded reassuring. I suppose a fall and two crushed vertebrae were better than the stroke I was afraid of.

Marjorie, underestimating Mother's ingenuity and instinct for drama, had arranged that I should hear about the accident directly, from a friend who was due in London in a day's time. I met him and had a full report: Mother was already over the worst, although still in hospital. He convinced me that I could go on with my year. I was more than willing to be convinced.

This was when Ginny hit her stride in her work. Her paintings of the Sussex Downs were subtle, exciting, rhythmic. She found a mode between realism and abstraction with a sweeping movement that really said the wind through the grasses, and her color was warm with all the golden light of the early spring.

For me, the month later in Brixham was the best painting of the year. We lived in the attic room of a guest house overlooking the harbor. We could lie in bed in the morning with our early tea and watch the fishing boats bringing in their catch, and we could hear the bell ringing the beginning of the daily fish auction. I found the ideal spot for painting on the flat roof of the Gents, a small cement building at one corner of the quay. It commanded the whole harbor and, when the tide went out, all the boats, large and small, stranded on a stretch of mud ribboned with little streams. Nobody bothered me up there.

We had read about Achill Island, a part of Ireland that had excited us when we were driving north from Connemara. We wrote asking if there was a room with a sea view large enough for two artists to share. The owner's answer assured us that there was one such, but only one, the other rooms being no more than "mousetraps." We booked it at once, convinced that anyone who could be so frank to prospective clients must be a rare and kindred soul. And so she proved to be.

One memorable encounter was with a friend of hers, a young woman recently widowed, who was trying to raise her two small sons by working the pocket-handkerchief fields her husband had left her. We were bid to dinner one night, with the explanation that the roast of lamb wouldn't keep any longer. She and the little boys lived in a two-room croft with an earth floor. She cooked over an open fire on the floor; but her wind-up gramophone wheezed out opera and she had original paintings of quality on her wall, and could talk with assurance about the European masterpieces we had been seeing. Her poverty was not of the spirit.

We were in Ireland when the steamship company wrote to say that our return passage was to be delayed by three days. Our first reaction was dismay — we would get home with hardly a weekend before we were due back teaching. But it gave us three unexpected extra days in England. Halcyon days! The drive north to Glasgow to catch the boat was a funeral procession. Ginny and I could not stop the tears as we felt the ship moving away from the dock down the Clyde towards the sea — and away from adventure and freedom.

The welcoming party when we got off the train in Toronto hardly knew us. Twenty extra pounds — all that wonderful French bread and butter. Ginny would never be slim again, and I had to struggle for years to recover, but that was a small price to pay for such a year.

Chapter 18

WE PLUNGED BACK into the black tunnel of teaching, the years stretching ahead into the dim, distant future; but the way was lightened at first by sharing our memories. Ginny's students discovered to their delight that an apparently innocent question was apt to set her off on a twenty-minute diversion. My history of art classes had new vitality.

Central Tech had weathered the depression of the Thirties, but twenty-four-hour use during the war years had left it tired and shabby, showing its age. The federal government decided to provide the funds to spruce it up after its long and honorable service.

The walls of the art department were all of natural cedar, ideal for pushing in thumbtacks (and pulling them out again), but dark to begin with and darker still after forty years. Peter Haworth ordered them painted in pale gray and sunny yellow, and suddenly our physical surroundings were bright and cheerful. Even more welcome were the new fluorescent lights.

For the first time it was possible to see what you were doing on the side of the room away from the windows. But the greatest boon of all was the reconfiguring of the ventilation system. Through some combination of ducts and fans, my room had received the foul air from the gym. But no more.

I was invited to design the cupboards and stands for still-life subjects. (Previously, we had balanced a wooden drawing-board on a stool, with drapery hanging from another drawing-board, standing on edge and braced to the sides of the first.) The day the carpenters brought in my new long counters with permanently fixed backs, some high, some low enough to let the students look down on their subject, and all with neat cupboards below, I felt as if I had died and gone to heaven. It still irked me to look out on three brick walls, but inside the room the views were charming.

The year I returned to teaching I was more active than ever as an exhibiting artist. Ginny and I had a joint showing of our work at the Eaton's College Street gallery, prestigious in those days and a step up for us. We had a second joint exhibition in Woodsworth House and, later, at Victoria College. I also had six solo shows and was in nine group shows organized by the art societies or by out-of-town galleries; some also traveled.

There were still very few commercial galleries in Toronto, and only the Roberts Gallery showed much Canadian work. Douglas Duncan was operating Picture Loan as an art gallery and rental business, but Av Isaacs was four years away from opening his first gallery on Gerrard Street. Still, there was a growing appetite for Canadian art in the colleges,

universities, and small communities. Every year, I had to choose entries, frame them, then deliver or crate and ship them to more than twenty venues. Sunday afternoons were spent choosing paintings, cutting mats, taking the nails out of frames and fitting in new paintings — not to mention labeling, filling out entry forms, making lists, and keeping records. Sometimes an exhibition would even result in a sale, which would help to pay for frames and the shipping.

I was becoming well known as an artist and teacher, invited to serve on juries and to make speeches at the openings of district exhibitions. I was elected an associate of the Royal Canadian Academy and, shortly afterwards, a member of the Canadian Society of Painters in Water Colour — both coveted honors.

The watercolor society quickly conned me into becoming its secretary, a job that was unpaid but rewarding, in that I got to know the president, Jock Macdonald, a gentle, thoughtful, unselfish man with vision: I wish I had been lucky enough to have him as a teacher. I also came in contact (by mail, if not in person) with a lively, creative group of artists across the country, through whom I saw the broader picture of watercolor painting in Canada.

Most of the staff of the art department were members of the societies. Some were also part of the Canadian Group of Painters, an association of artists who felt themselves to be the new avant-garde, sympathetic to the Group of Seven's pioneering spirit but working in more modern ways. The Canadian Group shows were by invitation and, as a younger artist, I was flattered to be invited to show with them once or twice. Two of their members, Isabel McLaughlin and Yvonne McKague Housser, began to join us for painting

up in Haliburton on weekends and Easter holidays. These were great parties as well as being stimulating, both for our work and for the gatherings to survey the day's achievements. But our most solid work sessions were in the summer, when members of the art staff and friends would stay at Liza Jean's boarding house on the Gaspé.

One day, Anne Cameron, our inspector of art teaching, rounded up Charles Goldhamer, Dawson Kennedy, Ginny, and me and advised us strongly to take the specialists' summer courses at the Ontario College of Education to qualify as assistants or heads of departments. Peter was approaching retirement age, and we were running the risk of having someone from outside put over us. One warning was enough: all four of us signed up, on the assumption that if we were in it together, it might be bearable.

Bearable or not, it was a travesty of education. One of the compulsory subjects was English. The first class was on how to address a business letter. Having been secretary of a national organization for two years, I was not amused, and weaseled out of English class by convincing the professor that I needed the time for library research on the art of the Byzantine empire — I would be happy to write a report on the subject.

For two hot summers we sat through boring and useless lectures and seminars, consoled inadequately by one good course in economics and the fun we had together. We were all given specialist standing, and had the satisfaction of seeing our pay checks jump; but I never did receive an answer to my carefully worded, tactful letter suggesting how such

courses could be made more valuable to the individual and to the system in the future.

One of my constructive suggestions was to give the teachers an experience of Canada's Stratford. From the moment of the first news reports of the plans for a Shakespearean festival in Ontario, Ginny and I were agog with excitement, and were there on the very first night in the tent in 1953. We will never forget it. As the lights went up, there was Alec Guinness as Richard III, perched on the balcony, one leg over the edge, his red cloak hanging almost to the floor. And his voice, that matchless voice: "Now is the winter of our discontent/ Made glorious summer by this sun of York."

(In 1956, when I was newly elected as president of the Canadian Society of Painters in Water Colour, Tom Patterson, who first dreamed the festival and did so much to make the dream come true, opened the exhibition for us at the Art Gallery of Ontario. It was a proud moment to be on the platform with him.)

In the spring of 1957, Peter retired, and Charles Goldhamer, senior among us senior teachers, succeeded him as head of the department. But Peter remained very much a part of our world. He was elected president of the Ontario Society of Artists and chaired our meetings; and both he and his wife, Bobs, were with us at Haliburton and on the Gaspé.

I found Charlie to be a good director, who was willing to listen; and his added responsibilities gave me more senior painting classes. Graham Gore, the new principal, was eager to use the art department to enhance the school's reputation. Yet, despite an exhilarating sense of working together as a team and being appreciated by both students and the

administration, I began to feel unequal to the pressure. I was tired all the time, weak and hollow for no apparent reason, dragging myself about. The doctor told me that it was menopause starting, and gave me a shot of vitamin B to relieve my immediate misery. I was shocked, but comforted to know that there was some reason for my malaise and that I would probably recover in time. That was when I reminded myself that life begins at forty (and was tempted to add bitterly that it lasts about four years).

Marjorie was living in Birch Cliff, a possible route between Central Tech and Fool's Paradise. Two or three times a week I could drop in on the way home for a cup of tea and a few minutes with her among the small children, the toys on the floor, and the chaos in the kitchen. Marjorie conditioned her children to believe that my arrival was a great event and, once in a while, one of them would be sent home with me on Friday to be my company until Sunday afternoon, when the whole family would arrive with a picnic supper. Sometimes I felt that I didn't have time for this extra complication in my hectic life, but Marjorie was making sure that I knew her treasures and that they knew me. Thanks to her they became my children too, and are my treasures still.

Mother was in a small house not far from the Wood ménage. Roy did the chores around her house and occasionally collected her to share in their family dinners. Margaret Doris, Marjorie's second daughter, used to cut Mother's lawn, and told me that she developed her resilience from my mother's criticisms.

Mother spent many Sundays with me. My friends enjoyed her and, providing we were not left too long dependent on our

own conversation, we got along very well. The only mutual enthusiasm we had was for my cats, so when we found ourselves arguing, Mother would say, "How are the cats?" and restore peace.

Tammy was a beautiful Persian tabby, affectionate, but with no sense of humor. Her litter mate was a short-haired black tom, whom I named Nick because he was full of the old. He was the most loving creature I have ever met. My first year at Fool's Paradise was an education in mice, for which the only remedy was a cat. Reluctantly, I had accepted these two kittens. The first thing they did was free me from any uneasiness about mysterious noises in the night. I assumed that any disturbance was made by the kittens, and nothing to be alarmed about.

One day when they were almost full-grown, Nick disappeared. As dusk fell and still no Nick, Tammy and I walked the field together, calling him. When Nick did appear, it was not from the field, but up over the edge of the ravine. He swaggered — there is no other word for it. I could almost see a cigarette hanging from the side of his lip, and his cap on backwards. (Tammy took one good sniff, spat her disgust, and never again had a civil word for him.) In spite of its auspicious beginning, Nick had little satisfaction in his sex life. He never refused a fight, and never won one. Finally, for his own protection, I had him neutered, with no change in his personality. I learned to do housework wearing him on my shoulder, and to sleep with one of the cats on each side of me.

In 1961, dear old Tammy faded away. Kath and Dawson Kennedy, understanding my grief, turned up with a fluffy

tortoiseshell kitten. I appreciated the kind thought, but what would Nick think? I put the little stranger down beside him, nervously. He looked, and gave her a thorough bath, which she accepted with loud purrs. From that moment they were inseparable.

In the 1950s St. Aidan's was a very conservative parish, but Basil English and his successors, Hugh Stiff, who had been the curate, and Reverend Brian Freeland, who was working for the Canadian Broadcasting Corporation, developed a lively church in the months before we were given a permanent rector.

Perhaps it was their openness and energy that started me designing a new look for the chancel. I imagined it hung on either side with an avenue of glorious banners that would lead the eye to the altar. (This was the Henry VII chapel at Westminster speaking to me.) The two front banners would celebrate the current season of the church year and be rotated to the back as the next season's images became appropriate.

I waited until Canon Snell was established as rector in 1956 before broaching the subject to the advisory board. The members had misgivings, but they agreed, after seeing my sketch of the plan and a full-size mock-up of one of the banners, to let me make and hang two on a trial basis.

This labor of love occupied many happy months. I loved shopping for fabrics — the right material for a strong background, colors that would show up well against one another, fine leather-backed gold leaf for touches of brilliance. My ceiling at Fool's Paradise had tie beams high enough to hang the full ten feet (three meters) of banner with the design elements pinned in place for revision and refining. I have

never felt more conviction about a job or understood better Dorothy L. Sayers's words, "You never make a fundamental mistake about the things that really matter." I found patience I did not know I had, and the willingness to change, to prune, to correct, to scrap. I began to understand the terrible ruthlessness of creative love.

Finally, I invented a hanging device for hoisting and moving the banners, and hired a carpenter to mount the necessary hooks in the chancel ceiling. All was ready in time for the sixtieth anniversary of the church; at the big gala service on Anniversary Sunday the pair hung in their glory.

When I came to the early service the next Sunday, they had vanished (and their hooks with them). I was speechless with shock — not to mention my sense of personal injury, indignation, anger at being treated with such contempt and my work not valued — and tempted to leave the church in pique. I finally came to see the humor of the affair when I learned that the pillar whose influence had removed the banners had a front lawn adorned with plaster gnomes. It was some small sop to my pride that the Trinity banner eventually found a home in St. James' Cathedral and that my church now has the panel of St. Aidan hanging high in the narthex.

Chapter 19

IN THE SPRING OF 1959 I began to be homesick for northern Ontario and to yearn again for a summer cottage. It was more than twenty-five years since Ethel Curry and I had lived together in that hunting shack at North Lake. One afternoon, Marjorie reminded me that our friends Marg and Gwen had loved a cottage they had rented on Georgian Bay. Ginny and I booked the cottage for a couple of weeks in August and persuaded friends to rent a second cottage near it. Marjorie's daughter, Margaret Doris, was sixteen that summer; she would come with us, so Marjorie and Roy could go on their first trip together overseas.

It was love at first sight. The track over rock outcroppings and through juniper bushes to the door was high adventure, and promised the privacy that we craved. The cottage itself was a single large room, stone to window level with half-logs set vertically above. One end faced the bay, and windows on

three sides looked across a breast of rock to the water and to a pink granite island that lay like a half-submerged giant.

Marg and Gwen, who followed us as tenants, reported that the two cottages were to be sold: a business magnate from Pittsburgh had been looking them over. None of us could afford them — or even one of them — but we agreed to go into a four-way partnership: Yvonne, Ginny, Doris, and Marg-and-Gwen as one. We gathered at the cottages over Labor Day weekend to celebrate our purchase, and to my wonder saw five bluebirds perched on a wire. I remembered the bluebird on the stake that had marked the site of the house at Fool's Paradise almost twenty years earlier. No omen could have been better.

Mother was too frail that autumn to see the cottage, although she would have loved the place. She had had a heart attack in the spring, so severe that she was not expected to pull through. I have thought since that she should have died from that attack. Although she stayed stubbornly on her own for the next year, with Meals on Wheels and dinners from a local restaurant, she was not really living.

That spring I added to Fool's Paradise the large studio that my work was crying for. Mr. Janes, the carpenter who had made such a beautiful job of the original house, reluctantly agreed to be my builder. At first he was cool; but as the building went on, he became very engaged. Our only unpleasantness was the day I spoke to the roofer and received a proper bawling out. "You speak to me and I'll speak to the roofer," Mr. Janes stormed, quite correctly. He was all over the scaffolding, up at the cathedral ceiling, outside on the roof. He was eighty-nine years old at the time.

At school I was creating an impressive library of slides to use in teaching art history. During my year traveling with Ginny I had bought excellent postcards of architecture and sculpture, and had copied photographs on to slides. But there were gaps, and I decided that I should plan another year of traveling to record the Byzantine art that I had learned about at summer school.

This was the only time I ever approached the Canada Council for help. Ten years' teaching with the Toronto Board of Education entitled me to a sabbatical year on half-salary, but that would not be enough. I was eligible for a senior fellowship, given my record as an exhibiting artist and teacher, and my work in the professional art societies.

While waiting for the council's answer, the night of a Royal Canadian Academy opening at the Art Gallery of Ontario, Mother's neighbor called: Mother had had another heart attack. Mother was in pain when I got to the house, but I helped her to bed and saw her quiet and asleep. My brother Doug shared my vigil — and my incredulity when, after two or three hours of silence, we began to suspect that perhaps she had slipped away. We called the doctor, who confirmed that she was indeed gone. For twenty-five years Mother had been talking about dying, going through dramatic accidents and sustaining serious injuries, and having heart attacks that frightened everyone, but at the last, she went so quietly that we couldn't believe it. I seem to have successfully blocked out the funeral and the reception afterwards, but I do remember one desperate moment when the choir sang something from *Messiah* and I had to fight to keep control.

Cleaning Mother's little house, I felt the contrast between her fussy standards of housekeeping and the dirt and neglect

that spoke of a frail eighty-three-year-old who no longer had good eyesight. Her pride in her home made me unwilling that anyone else should see its shame, although she never tried to imagine how anyone else felt and had no tenderness for their pride.

God knows she was difficult, but I am grateful to have known her. She gave me my strong constitution, physical and emotional energy, organizing capacity, and love of an audience. She has left me good memories and many of them. I think it was the frustrated artist in her that made her love of me so possessive that she tried to direct my life. We had six sad years when she would have nothing to do with me, but many years afterward to become friends and for her to learn that an independent daughter is not a bad thing to have.

Chapter 20

I HAD BEEN DREADING breaking the news to Mother that I was planning another year away. Now it wouldn't be necessary, and my share of Mother's estate would provide the money I needed. With no companion, much of the glamour faded from the prospect; but my reasons for going were still valid, and I doggedly made plans. With a travel agent's help, I worked out an itinerary that would include the sites of the most exciting sculptures and architecture. It would allow me to spend time in Greece, to see the Holy Land, to photograph Saint Sophia in Istanbul and the dramatic monuments of Egypt before friends joined me in England for the summer, to reward me for the year of solitary wandering.

It was a mercy that school was so demanding that June. I was panic-stricken at the prospect of such a long time on my own, without my usual routines — the drive into town, knowing just when to change lanes, my arrival at the staff parking lot, where there was a place for me, the shops on the

way home, Toronto theaters, and the few restaurants that I visited regularly. Moreover, I had to think ahead, carry everything with me I might need, yet keep my needs so simple that I could still travel light.

Marjorie and Roy, with two of their daughters, dropped me and my bags at the airport departure door and took off on their summer trip to New England. I checked in, only to be told that my flight to San Francisco had been delayed six hours: rerouting was necessary or all my connections would be lost. Then came the discovery, in mid-flight that I had no ticket. With the route change I should have received a whole new set of documents, but I hadn't. I shamelessly became a helpless female, apologetic, innocent. The flight officer gave up fighting, patted my shoulder, and coped.

Tokyo was when the strangeness really began. I flew into heat such as I had never before experienced or imagined. The international students' hostel had no air conditioning; and both temperature and humidity were setting records. I would take a cool bath at night and lie on the bed without even a sheet, hoping to get an hour or two of sleep before I had to get up for another bath to cool me down. One day it felt as if ants were crawling down the back of my leg. I hadn't known that the backs of your legs could perspire.

I escaped from Tokyo on an air-conditioned super-train to Kyoto. There I was befriended by Mary McCrimmon, who taught at the university there. She took me to Nara, an ancient holy city, and ensconced me in the guesthouse of a small Buddhist monastery, composed of a long row of small rooms, each open to the narrow deck along the outside wall. Each room had one low table, and cushions to sit on; its inner wall was a sliding cupboard holding the floor pad that

could be spread out for the night. I was left alone for the week, with only sign language to share with the priest and his wife.

I left Japan in love with the people and the gardens, but after the confusion and heat of Tokyo, Hong Kong seemed like heaven — lucid, clean, and colorful after Japan's blacks and browns and ochres. And I could read the road signs!

I was booked to tour China for a few weeks, but there was famine and the Chinese authorities didn't want tourists. Instead, I went ahead of schedule to New Zealand for a month of painting and visiting with friends.

I find it hard to know why my sketches in Japan and New Zealand were so uninspired. Japan was so exotic it should have given me great stimulus, but my paintings were pedestrian, mere illustrations. I destroyed all but four. However, by the end of my third week in New Zealand, things improved and a little magic began to creep in. I can remember saying out loud to myself, "Talk about it, don't imitate it. Tell it, don't show it."

In Singapore I first met the large ceiling fans that make life bearable for foreigners in hot countries. Baths, beer, and the ceiling fan were how I survived the tropics. My world-travel project felt many times like a fourteen-month sentence with no time off for good behavior.

At the Bangkok palace of Anna's King of Siam, there was a scale model of the temple complex of Angkor Wat, the great Khmer ruins of which I had not even heard. The model convinced me that I must see the original, which I did (after an epic wrestle with red tape). To see and photograph the sculptures, I lay on the stone floor, flat out, exhausted but happy. This was a mistake. A severe cold dogged me for weeks.

India a few days later was too rich, too diverse, too crowded, and too difficult for me. My best week there was at Khajuraho, in central India. I spent my days drawing and painting the erotic sculptures that covered every surface of the temples, images of the fertility and creativity of which god Shiva is the source. Those sculptures were gorgeous and the week too short.

Back in New Delhi, I could take the pressure of people no longer. I gave myself a week on a houseboat in Kashmir, surely the most exquisitely beautiful place on earth. I lived on the quiet backwater of a lake ringed with snow-capped mountains, in the solitude I was desperate for, broken by a constant traffic of birds, exotic and colorful.

From India I moved into Afghanistan, a refreshing change from sticky heat, outstretched hands, and cringing poverty. I had seen a photograph of a huge figure of Buddha carved out of the clay cliff in the valley of Bamian. To go there required a special government pass, a licensed guide, and a driver, putting a sizable hole in my budget but worth the expense. The valley lay green about its little river, bordered by golden poplars. I climbed a twisting stairway cut inside the cliff, lit by deep slits in the clay wall, and came out on a broad convex plateau under a domed roof — the head of the great Buddha — from which we could look over the whole valley. No longer.

In Persepolis, I wandered about the remains of the palace taking photographs, and drawing. At the end of the afternoon, I sat against a rock and played the recorder.

From Iran I moved on to Iraq to see the ruins of Babylon; the Baghdad museum full of sculptures from the very first Sumerian civilization; jewelry from Ur, and pictures showing

the tomb where they were found. My old friends Dudu and Gudea, best of the ancient sculptures, were there in stone.

Istanbul, which I reached early in November, became my third-favorite city, trailing only London and Rome. The great Byzantine church of Saint Sophia is an enormous and glorious building. Although photography was strictly forbidden, the director had agreed to let me photograph the interior, that afternoon only and without a tripod.

In Izmir, Turkey, I became drunk — on one half-bottle of red wine and one Turkish archaeologist. I was very attracted to him, and grateful that he said or did nothing to signal that he was also attracted to me, although I knew he was. So, what of the ruins of Ephesus? The museum? The church of St. John? The double church of the Virgin? All seen across a pair of brown eyes and a young but lined face, a strong, fine face.

In Greece I followed the routine that I had gradually established: fly into the capital city, explore the cathedrals or temples and major museums, then escape to a smaller place. Athens was even better than my memories of it, every aspect known and loved, but still leaving me in awe.

When I came down with another heavy cold, I gave in to the most luxurious and spectacularly beautiful stopping-place of my year. Delphi: central heating, a spacious room with a big private bathroom, and hot and cold running water. Expensive for a hotel but cheap for a hospital was how I rationalized it.

I had to drag myself away from Greece, but I was booked to fly to Egypt early in December. In Cairo I went first to the big archaeological museum to browse, to photograph, to savor. The gold artefacts from Tutankhamen's tomb filled

the whole length of one big gallery; other galleries held the astonishing succession of sarcophagi, each richer than the last, that had protected his mummy.

A couple of days later, I took a crowded rush-hour bus to Giza, and found a place to stay with a window that looked towards the largest pyramid. I discovered that the *son et lumière* program the next evening was to be in English. After exploring all day, I was happy to find a seat early, read, and catch up on my journal. A party of men arrived, deep in talk that seemed to have social and political overtones, and a very English voice telling the Egyptians about their own country. I wondered at the respect with which his pronouncements were received until I heard someone address him by name: I was in the presence of the great historian, Arnold Toynbee.

My return to Cairo was darkened by the discovery that I had mistaken the film I had shot in Istanbul for a new roll, and used it again at Karnak. Thirty-six double exposures, all useless. Saint Sophia lost. So much for taking new films out of their cardboard boxes to save space and weight!

My peregrinations were planned so that I could spend Christmas in the Holy Land. I was booked into a former monastery on the Mount of Scandals, across the valley from the old walled city of Jerusalem, its domes, towers, and minarets dominated by the great Dome of the Rock.

It was late afternoon before I reached the hotel, but I couldn't wait until morning to set foot in Jerusalem. I had no particular objective, just the pleasure of the golden ochre stone of the buildings, the archways beckoning, the narrow streets. I was poring over my map of the city under a street lamp, when a young Arab asked, "Can I help you?" in excellent English, and led me to my chosen destination, Herod's

Gate. He was interested that I was a Canadian and, especially, that I was an artist and teacher. He wanted to study art, but there was no night school.

At Herod's Gate, Shukri diffidently invited me to be his guest for a sweet in the little café. We talked for another hour, and he walked me to my hotel, promising to call for me the following evening, to explore Bethany and be a guest in his home for dinner to meet his family. Shukri is still my friend, now settled in Michigan with an art business of his own.

In Rome, Dino was no longer a student on a meagre fellowship but a mature artist working for the Food and Agriculture Organization of the United Nations. We had been in correspondence, and I was invited, for my first weekend in Italy, to stay in his house.

I cannot quite remember by what small steps it happened, but before long I was settled in at Via Modena, taking off to draw once Dino was at work. By the time the light was failing in the afternoon, I did the shopping, and had dinner ready for him when he came home.

Dino took a mischievous delight in taking me around to the parties as "la mia professore" and seeing the suspicion in the eyes of the young women, who, conscious of his eligibility, had been nursing hopes. I only wished their suspicions had been justified, but we both had a rich awareness of the comedy of every day, and we laughed together from morning to night.

Dino was enthralled with my slides, especially of Greece, and realized that, with me in residence, he could leave for a few weeks and see it for himself. I wanted him to go, but I was a bit miffed that he was willing to leave. Then I was

visited by inspiration — maybe Marjorie could join me for a couple of weeks. I spent an exciting hour talking to travel agents, working out dates and details. Then I wrote to Marjorie to see if it would be possible, and enclosed a check to cover her airfare.

While she had been bringing up a lovely family and keeping Roy happy and fed, I had been traveling, pursuing a hectic professional career, and going through the years of emotional turmoil of my one deep attachment. She had sent her love and understanding to accompany me, her shoulder always ready. And now, at last, I could offer her a couple of weeks of my world. We would be together day and night for a full fortnight, in beautiful and beloved Italy. And suddenly there she was, coming through the airport!

After a week in Rome, almost too social, thanks to Dino's friends, we took off in my newly acquired Fiat for places Marjorie wanted to see — Pompeii and the Amalfi Coast — in steady rain. In fact, it rained for most of our two weeks. I was longing to introduce Marjorie to my beloved Forum, but it was our second-to-last day before the sun reappeared. Since our childhood summers at Silver Island, almost forty years earlier, we had not lived together, and now we had had fourteen days of full-time sharing. At the airport I was quite suddenly desolate, and unable to watch the take-off.

A year or two later, at long last, I had Marjorie and Dino together at Fool's Paradise. Each said to me privately during the evening, "Why didn't you tell me what a marvelous person he/she was?" It would have been no use trying — no description could have captured either of them.

Traveling by myself in Spain was predictably lonely after Rome, but offered some consolations. Outside Santander

was Altamira, where the prehistoric cave paintings were — the charging bison so familiar in the art history textbooks. The evening I was there, I heard a rhythmic chant, distant but moving closer. A procession was coming up the hill from the church, singing, stopping now and again while the leader intoned a prayer. Behind them came six men in black robes carrying a litter, on which lay a life-size wooden figure of Christ. Then I realized — it was Good Friday. I had been watching the re-enactment of the Entombment.

On Saturday I made my pilgrimage to the prehistoric cave paintings, then wandered down to explore the village church. It was a desolate sight. The doors gaped. The altar was stripped bare. Behind it a black cloth hung from ceiling to floor. Benches were overturned, lying every which way, and the statues were shrouded in black. God was dead and his house deserted.

But at eleven that night, as we filed into the dark church, each of us was handed a candle. The priest led us up the side aisle. He reconsecrated the baptismal font, lit the candles on either side of it, then sanctified the altar, and dressed it in white linen, setting its cross in the center and lighting candles at both ends.

A taper lit from a candle on the altar was used to light a candle at each pew. The taper was passed along until every candle was flaming, and the church glowed with light and warmth. Then the candles were extinguished, the priest retired into the vestry, and the congregation knelt in silence.

When the priest returned, resplendent in a white robe lavish with gold, he began the mass, still in the familiar Latin. As he consecrated the bread and wine, the acolytes rang their little silver bells, the organ burst into majestic music, the

lights in the church blazed into sudden brilliance, and the black curtain behind the altar fell to the floor, revealing a golden dazzle of saints and cherubim. In my mind, in my emotions, and in my senses, I experienced the miracle of the Resurrection.

If my year of traveling with Virginia was the Wonderful Year, this trip was the Long Year, but I don't regret any part of it. The thousands of slides of sculpture and architecture made it possible to give students a vivid experience of the art of the distant past, and share my enthusiasm for it. One of my satisfactions during the next ten years was receiving postcards from students, off in Europe or Asia, grateful for having been introduced to the masterpieces they were now meeting in person. They were traveling with eyes trained to see.

The hardest discipline for me during the year was to go on painting without the encouragement and stimulus of someone reacting to my work. For that I had to wait until the sketches were unpacked, sorted, finished or revised, and ready for exhibition.

Chapter 21

FOOL'S PARADISE WELCOMED ME with open arms — my house in order, the garden tended, and the cats spoiled. I came home to Marjorie, to the new studio, to Nicky, and to Josephine, the kitten with the coat of many colors. And to a new school term.

Before I had left on my sabbatical, a new art building at Central Tech had been begun. Second thoughts about the budget had eliminated the plant-room that Dawson had wanted for the study of natural forms, and my storage cupboards had been reduced to a frustrating size. But after the Easter break, we moved into our own building, with skylights and windows across the whole north side. (There is always a price to be paid for what you gain, and this had much irony in it. The light-filled rooms were impossible for teaching history of art with slides. I had to build a cupboard on wheels to hold my projector, reference books, and slides for the week, which I could trundle along to the elevator

and down to the basement to a classroom with blackout curtains.) Bach, Vivaldi, and Mozart colored our days and for the first time it became permissible for the girls and even the teachers to wear slacks (although for a few years skirts were compulsory in the parent building for assembly or academic classes).

The Toronto art scene was livelier than it had been when I had gone off on my sabbatical. Catalogues of recent juried exhibitions showed an eclectic mixture of styles and points of view; abstraction and abstract expressionism were increasingly dominating gallery shows. (Montreal and New York seemed to be providing much of the inspiration.) Jack Bush, who had been very middle-of-the-road in my first years in the Ontario Society of Artists, was now producing large color-field canvases, to critical acclaim.

I was given the senior painting classes, and I felt that after the sound grounding the students had received in the fundamentals, I should encourage them to explore some currently fashionable ways of working. One of the tasks I set was to create a painting using only two flat colors; another was to produce "found art," assembled or mounted so that it had unity, dynamism, and excitement. On the playing field south of the art building, the students flung paint around by the big brushful and let the drips run where they would.

Afterward, we judged the works and the students began to appreciate that the difference between good, bad, and indifferent was valid whatever the style or technique. Because I wanted them to learn to evaluate their own work, my criticisms were usually Socratic. I asked them to look at this or that aspect — the composition, the balance of tone and color, perspective if it was relevant — and make a critique. Often

we spread out the work of the whole class and discussed the virtues and weaknesses of each piece, like a jury.

My students became as confident judging the non-objective work as the representational and their enthusiasm hinted that I should take a more appreciative look. To develop my own discrimination I began to work in flat color with hard edges, to eliminate detail and tell my story in the simplest form possible. I found this challenging and exciting.

I was by this time vice-president of the Ontario Society of Artists, ready for election to the presidency at the annual meeting in the spring. I would be the first woman to be so honored. The opening of the annual OSA juried show drew the largest crowds of the year to the art gallery. The president's painting was traditionally hung in a conspicuous position in the long gallery and I began months ahead to plan the big canvas that I would submit.

In 1964, my first year as president, the new powers-that-were at the AGO changed the rules. The society was no longer privileged to hang its own show. Whoever did the hanging put my large vertical canvas in a corner of one of the minor rooms. *Sic transit gloria.*

The board appointed a young art teacher to be its new director. It was widely assumed that the board (or the women's committee, which was possibly the power behind the throne), wanted someone who would do its bidding, and that William Withrow was a man to be led, pushed, or persuaded to get rid of the art societies as regular exhibitors. The powers-that-were wanted an international profile for the gallery and were enamored of the New York avant-garde. In 1965, the Royal Canadian Academy and the OSA lost their

traditional annual exhibitions entirely. Instead, a joint open show was organized and juried by the gallery.

I can never thank Charles Goldhamer enough for his tolerance of the hours I spent on the work of the society. By the time I became president, my classes were almost all seniors, capable of working on their own. Until they were in need of help, they left me at my desk in a welter of letters, notes, and telephone messages, engaged in the administration of the society.

The Ontario Society of Artists had operated for many years on a three-thousand-dollar annual grant from the Ontario Department of Education. With that we had been able to mount the annual exhibition, print an illustrated catalog (which is now a valuable piece of the history of Canadian art), send educational shows across the province, and pay for postage.

In my first year as president, the Ontario Arts Council was set up, and swept away our grant with its new broom. From then on, my life was an eighteen-hour-a-day struggle to keep the society's fiscal head above water. Our difficulties were compounded by the earlier conservatism of some of the members, who had voted down applications for membership from a few young artists. Some of these rejected artists, together with OSA members Tom Hodgson, Oscar Cahén, Jack Bush, Harold Town, Alexandra Luke, Kazuo Nakamura, and Walter Yarwood, formed Painters Eleven, which made a name for itself as the new avant-garde.

Remembering my early experience of being refused membership (because I was too young and a woman), I introduced a point system that enabled artists, however

unknown to us, to earn membership by having their work passed by three juries within a specified time-span.

In my second year as president we enlisted the help of a professional public-relations counselor, Ed Parker. He wisely interpreted public relations not as favorable publicity but as a program of community involvement — we would contribute so much to the art scene that we would be sought out. Once a week I trailed down to Ed's office after school, tired after a full day of classes and the telephone, where he energized my imagination. I would drive home with a long list of things that I could and should be doing to bring art into the lives of more people through the society.

It was as president of the OSA that I volunteered to be a witness at the trial of Dorothy Cameron on a charge of obscenity. Her gallery on Yonge Street had mounted an exhibition titled Eros 65, predictably full of sexual content. The police seized certain of the works, but they offered to drop the charge if Dorothy would remove one painting by Robert Markle. She refused. In spite of my offering an illustrated AGO catalogue of Picasso drawings to demonstrate that community standards had not been violated, Dorothy lost the case. It's hard to believe how much has changed.

Not long after the trial, Ed Parker got me a weekly broadcast, *OSA on the Air*, which began at a Brampton station and eventually moved to Toronto. It was a chance to interview artists, educators, administrators, and anyone else whom I judged to be interesting and interested. I did the research, extended the invitations, made the appointments, did the interviews, and even wrote the thank you letters. No wonder I spent so much time on the telephone!

Yet, during these years of my presidency, I was working

with simplified color-field and hard-edge painting. In the most hectic time of my life, my work had a serenity that was new. Perhaps it became a sanctuary.

At home, my perennial sanctuary, I had a new patio built to fill the angle between the porch and the big studio. I persuaded Bailey Leslie, a very good potter at Central Tech, to make a three-tiered fountain for it. (By this time the township was delivering water and I was no longer wholly dependent on my rain-water cistern.) The fountain fell into a shallow pool that was only three feet (a meter) across, but it brought the sky right down to the patio. If that much reflected sky was that good, I asked myself, what would a whole pond be like?

The next year, I staked out a pond, and now the sky is close to me, often a very different sky from that reflected in the more distant lake. Every spring I am visited by mallards and the big apple tree uses the pond as a mirror. In the fall, a great blue heron, absurdly out of scale, stalks along the edge and sometimes catches a fish, tossing it to get it positioned for swallowing.

In May as soon as it is warm enough to leave the front door open at night, I lie in bed listening to the trilling, shrilling of the fat toads that appear by magic and leap into the pond for mating. For several days and nights their music dominates my life. Then I see the long ribbons of eggs festooned across the water and, later, the tadpoles. Next come the small boys. "Please Missus, have you a jar I could put some tadpoles into?"

The pond had another gift for me. December brought a week of sharp cold that froze the surface to a tempting

smoothness. I borrowed some skates and discovered that I hadn't quite lost the knack. One memorable night, Malcolm Croggon phoned to say that Grenadier Pond, in High Park, was sheer ice, and I must come out. It was a brilliant, very cold night, windless, with stars close enough to touch and street lights too far away to spoil the darkness. We, and perhaps four other people, had the freedom of that great stretch of polished black satin.

I have forgotten whether this was before or after I recognized that I was falling in love with Malcolm. He was a great companion. Everything we did together was doubly enjoyable, and we were together often. But he was fourteen years younger than I, and I had no intention of letting myself go overboard in my emotions if it wasn't mutual. I certainly didn't want to risk losing our friendship by frightening him. One night at Fool's Paradise, listening to a Segovia record, I suggested that we should not see so much of each other unless we were willing to fall in love. Malcolm made it clear that he was not willing. "So where does that leave us?" he asked. "Friends as before," I assured him. It was our last word on the subject, and we were as close friends as it is possible to be. But I have never since been able to enjoy classical guitar.

In the mid-Sixties Virginia was appointed second assistant head of the art department. Ginny and I were only a year apart in age, but I had seven years' seniority. I was devastated. I had been so confident of the solidarity of the team — Charles and Dawson and Doris and Ginny, in that order — that I experienced this as a personal rejection. I was willing to believe that Charles and Dawson had reasons for supporting

Ginny's promotion, and I knew that she would have been consulted before her appointment. I was glad, or tried to be, for Ginny, and I was sure she would be a good administrator, but why could they not have explained to me why they (or the brass above them) had set seniority aside? I didn't hold it against Ginny, but I did hold it against both Charles and Dawson that neither of them had an explanation for me. (I have realized since then what a common and bitter experience it is for middle-aged workers to have a younger person promoted over them.) I was so shaken that I started to think about changing my job.

I was somewhat cheered one Sunday afternoon in the spring of 1968, when the mayor of Scarborough, Albert Campbell, called me. We had mutual friends, had met socially, and were on a first-name basis. Could he bring me a small problem in design? He turned up with some dismal sketches of Scarborough Bluffs, which he wanted if possible to incorporate into a flag for the borough. Fortunately, Ab was an intelligent man. He understood at once the importance of keeping any image that is to be repeated many times simple and perfect in design. I asked for a couple of days to come up with something suitable.

When he saw my sketches, Ab agreed with my own first choice: a repeating abstract shape for the bluffs and conventionalized waves, both blue on a white ground, with a carefully placed red maple leaf. A week later, when I saw how the graphics company had interpreted my sketch, I was dismayed. They had spoiled the proportions and taken all the vitality out of the waves.

Ab could see the difference, and he took the drawing back for correction. Then he gave me a lesson in diplomacy.

He had a couple of small flags with my design on them made up in silk. From time to time, he would invite guests to look at the flag and ask if it might be a good thing for athletes to carry when they represented Scarborough in games away from home. By the time it was to be voted on as the official Scarborough flag, it had been used a few times, everyone had seen it and was used to it — and his proposal sailed smoothly through.

Chapter 22

A FEW MONTHS AFTER Expo 67, Dawson Kennedy died. It was unthinkable: Dawson had been there, every day forever. He was uncle to a generation of students, darling friend and teacher to me. The keystone had fallen out of the art department.

Bloor Street United Church was full for his funeral. Students poured in, parking their portfolios at the door. His widow, Kathy, stood like a queen, greeting each of them by name, beautiful in the dignity of her grief. And there were even apt touches of comedy. As the cortège moved slowly across town, two police officers on motorcycles shot past us in every block, ready to stop cross-traffic at the next intersection. Dawson would have loved that, and laughed.

Flying down to another funeral pressed home to me the value of such rituals, the centuries of experience that lie behind our conventional social patterns. My brother Kenneth had moved from Toledo to Florida shortly after a first

heart attack. The move gave him some good years and gave me a reason for visits. He was my big brother, who could talk more freely to me than to anyone else in the family and to whom I could turn — for advice, for money in an emergency, and for an eye that was perceptive about my work.

When I had phoned to tell him about Mother's death, I said that he need not come up; Doug and I could manage. Afterwards I realized that I may not have needed him for practical reason, but needed him to be with me. When I phoned back to say "Please come," he was already on his way.

His death was sudden and hard to accept, hard even to realize because I was accustomed to not seeing him often. Funerals are important. We need a way of externalizing our grief and sharing it.

That year, 1968, my darling Nicky also left me, at just a month short of twenty-one years of age. Poor little frail old boy, and sweet as ever. The vet, Doctor Graham, had given me a grim diagnosis: the jawbone had perished, was apt to break off, full of infection and possibly painful. No surprise, then, that he wasn't eating. I would have to put him down. That night, Nicky disappeared, as if he loved me enough to spare me his death. Several years later I found his skeleton under the house, and buried it under the big apple tree. For years, every time I saw a black cat my heart turned over.

Our next loss was Jessie Macpherson, in April 1969. To my generation of CGIT she had been our role model, our guru. To thousands of young women (and their male contemporaries) at Victoria College she had been a leader, responsible for the increased presence of art in their university buildings and lives. To Marjorie she had been a rich and constant love,

in the reflection of which I also lived. When a heart attack put Jessie into hospital, Marjorie had been overseas with Roy. She clung to life until Marjorie reached her bedside. Only then was she ready to die, with her hand in Marjorie's.

Arthur Lismer died the same day, in Montreal, but was buried with other members of the Group of Seven on the grounds of the McMichael art gallery, in Kleinberg. A.J. Casson read a eulogy, and a young priest said words that sounded all wrong in the context. A.Y. Jackson's eyes were red-rimmed, which seemed curiously right. Probably Arthur would have been sardonic about it all.

By this time I had completed my three-year term as president of the Ontario Society of Artists and, while still on the executive, was more than ready for the sanctuary of Georgian Bay and the new studio there. I was working on my Wavement series, analyzing the movement of the water under different conditions of wind and light, and translating it into areas of flat color.

The following autumn, I had a telephone call from a stranger, who said that he might be interested in buying some paintings. Could he come to see me? He turned up at the door the next evening, a handsome young Hungarian immigrant, Leslie Reichel. He had seen reproductions of my work in old OSA and RCA catalogues. Did I have any of that old work still around? The big cabinet in my studio was full of the large oil panels that he was interested in, and it was a pleasure to show them. Leslie picked not one, but six, and I was glad to agree on a cut rate for quantity — about thirty dollars each. Cash. I wondered if there might be something shady about the deal, but he sounded all right. He was

working in a framing shop and told me that he intended to frame and sell the work. Good for him, I thought.

Within a few days, he was back for twenty more and, eventually, he had bought almost forty of my best old panels. A few weeks later he had framed them all, beautifully, rented the Gutenberg Gallery on Yonge Street, and was advertising an exhibition of The Work of Doris McCarthy. I was delighted. The gallery was hung with a single row of paintings, not crowded, and by the time I got there in the second week, more than half were sporting red dots. What was more, they were priced at a $185 each, more than I would ever have dared to ask. Leslie's profit pleased me as much as the look of the show.

Three-quarters of the show was sold by the time it closed, but all the remaining paintings were bought by another art dealer, whose business was largely antiques. (A few years later they were on view in his shop, with a price tag of $1,000 each. I considered this both gratifying and amusing. They wouldn't sell at that sum, of course; but I considered it good advertising.)

Leslie was the first art dealer to let me know that my work had quality and was worth promoting. My appreciation of his encouragement was the beginning of a friendship that outlasted any professional involvement.

The autumn of the Gutenberg show, there were rumors that Jacknife Lodge next to us on Georgian Bay was to be sold. Vincent Thomas, who had built and owned it, was an artist and had attracted many painters as guests, including Gordon Webber, Goodridge Roberts, Jacques de Tonnancour and Barker Fairley. Vince had been a good neighbor, and any suggestion of a change worried us.

All the buildings were out of sight; but our view included his long point, which swept from wave-washed bare rock at the far end up to the high granite hill behind us. What if someone built a cottage that would overlook us? Goodbye privacy. For years we had climbed to the high point for our evening walk. A new owner might not be so hospitable.

One wintry Saturday morning, Yvonne Housser and I went to see if we could purchase the point. In conference with Ginny we had worked out what we could manage to pay. We looked suitably shocked when Vince told us the asking price, but it was exactly what we were prepared for and, by the time we left, we had shaken hands on it.

We gathered up there one sparkling January morning and scrambled about through the snow, locating the old boundary markers, drawing new lines. One thrill was discovering that we already owned the high granite hill. The other was the realization that a little cabin was on our new piece. We were tempted to keep the little cottage, but that would give us three buildings to maintain when even two ate into our painting time. Then we cooked up an idea. As we were not allowed to divide the property, why not bring friends into the partnership in the land and give them sole ownership of the cottage. It was the perfect solution!

The next spring, when I was ready for a one-man show, I approached Carl Gutenberg. He was happy to give me the use of his gallery for the usual forty percent commission on sales. (Leslie had paid two hundred dollars' rent instead of a commission, and Carl had learned from the experience.) The *Globe and Mail* review was warm and enthusiastic. After so many years, it was exhilarating to find that my paintings

were worth real money — selling quickly, at $150 or $160 apiece.

A few weeks later I sold forty-three old sketches to the Art Emporium, a gallery in Vancouver, for $1,920 — the most paper money I'd ever seen, stuffed in an envelope. When the Emporium owner, Mr. Kristiansen, was in town some time later, he asked to see more of the small oil panels, and walked away with another bundle, which just about cleaned me out of the sketches of the Thirties and Forties.

By this time, Charlie Goldhamer had retired. Ginny was head of the department, I her senior assistant. We were a comfortable team, working side by side in the office as smoothly as we had at the Gaspé and at the cottage for so many years.

Once freed of my OSA responsibilities I enrolled in the Central Tech weaving class. After I had enough experience to be able to weave on my own and had a loom at home, I moved on to Andrew Fussel's metalwork class. This was a new world. Bliss was to cut a circle out of a flat piece of heavy aluminum, lay it over a chunk of wood with a hollow in it, and bash away with a hard rubber mallet, watching it gradually curl into the very form I had intended.

Having time for such learning was exciting; but even more so was the longer view — the end of the teaching tunnel in 1972.

Interlude:
Georgian Bay

IT WAS A GOOD MORNING when I awoke before the sun came up over the trees on the eastern shore of the bay. Then I could leisurely make the coffee that I took back to bed, sipping it slowly and staring between sips at the sky gradually gaining color above the heat haze that dimmed the far shore and distant islands. The gulls that were laughing and screaming at dawn would have gone fishing, so a sandpiper could land on their favorite rock island, the half-submerged giant lying just off the shore. Then our resident beaver would head off to work in the meadow past the channel, a brown head leaving a silver wake as he glided smoothly past. (He'd come back to his home in Keyhole Bay every evening like a commuter.)

I would take the hint, get out of bed, wrap the big towel around me, and head for the place where the rock goes smoothly off into deep water. I would soap, rinse, and wallow, luxuriating in the sweet cold water. At this hour I had the bay to myself. Virginia was probably awake, but never

admitted it until, after I was dressed, with my bed made, she would hear the wind chimes on the clothesline as I hung up my towel.

At breakfast I would wait for Virginia's daily "I'm not awake yet;" then I'd talk for both of us, reviewing the night, reporting on the heron or other incidents of my coffee hour, commenting on the weather prospects of the day, no reaction needed. I would clear the table and leave her sitting over her second cup of tea just after eight o'clock.

The studio would greet me with its familiar smell of sun-baked cedar and turpentine; but I wouldn't succumb quite yet — any duck families on the bay this morning? Is the mist clearing from the islands and the far shore? Then I'd scold myself and get to work.

I would ponder the painting on the easel. Was the composition right? Does it pull the eye through the landscape, setting up rhythms and movement? Is the tone contrast too strong? What about balance?

My palette would be laid out from the previous day, but inevitably I would grab a tube of white and start to unscrew the top before I'd remember — gloves. Damn! Allergies are a curse. When I'd hear the wheeze of the hand-pump and the ring of a pot lid I'd know that Ginny had finished in the kitchen and put washing to soak in the big pot. Half an hour later, she would be at her own easel beside her own stretch of windows facing the bay. If she commented on my work, it was a good sign and I'd go on with renewed confidence. But if there was silence, I'd look at my work more critically, set my teeth and press doggedly on. (After a bit, I would realize that I had been whistling the same fragment of tune all morning and change it, at least temporarily.)

We would break to split a beer sometime during the morning, up on the rocks in front of the cottage if it was cool enough. (Our cedar chairs would stay out all summer, and I would check how last year's stain was holding up — all part of my job as outside maintenance man.) We'd settle in to enjoy the gulls, the movement of the water against the shore, the launches coming down the channel from Parry Sound, the wind surfers, and any signs of life we could observe around the cottages on the far shore or on the islands.

By the time we would break again for lunch, it was usually too hot on the rocks, so we would sit in the shade of the grove of pin-cherry trees in front of the studio, then back for another couple of hours in the studio. When the sun moved so far around that it was starting to come in the big back door, it was time to stop.

Cleanup would take another half hour. Brushes are precious and need to be kept soft and responsive. Turps, more turps, still more turps, warm water and soap to get out every trace of turps, washing and rewashing.

Our official working day ended at four o'clock, when our friends from the other two "holes" joined us for tea. Everything being held in partnership gave us a sense of being a family, and we cherished the social times. The tea was welcome and the homemade cookies appreciated, but the real attraction was the hour of reading together afterwards.

While Ginny set in motion her well-organized plans for a good dinner I did road-work — pruning dead limbs, clearing brush from the paths, any outside chore that needed doing. After an hour of labor, I'd peel my sticky clothes off my wet back, wrap the big towel about me, and make for the bay.

We took dinner seriously, with the table formally set with the lovely old blue-flowered china that came with the cottage, and our own sparkling glasses. My elderberry wine played a contralto note in the symphony of Ginny's colorful creations. After dinner, Ginny poured herself another glass while I did the washing up and carried the bowl of kitchen scraps to the compost pile.

When the sun was low — sending long shadows across the rocks, catching the brilliant white of the gulls riding in the bay, reflecting back from windows on the far islands — we would set out on our evening walk. Around the point, up through the juniper bushes, up the long spine of glacier-scraped granite that leads to the high place where the three pines guard Marjorie's ashes — monarchs surveying our kingdom (until Ginny slapped the first mosquito). Our return to the cottage was direct, full of purpose, for it was time for the nightly Scrabble game.

Ginny was apt to read in bed longer than I. "Goodnight, dear. Sleep well," I would manage, as I turned out my light. Sometimes I would be aware of when hers went off, sometimes not.

For all such days, and all the gifts that they held, thank God. Amen.

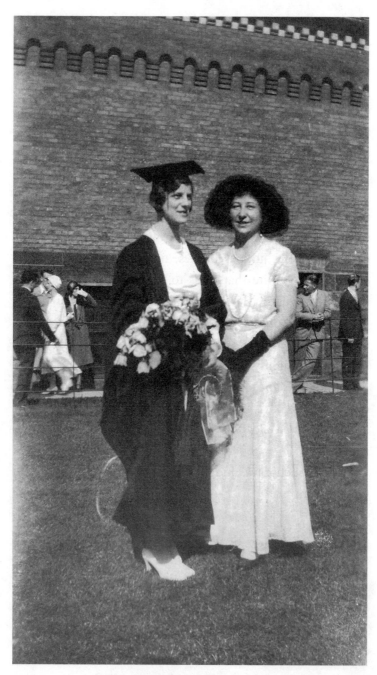

Doris at Marjorie's graduation, 1931

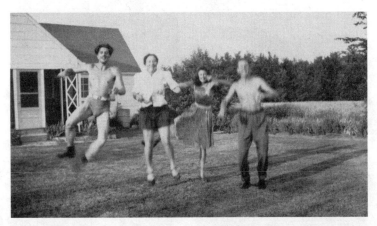

Doris (second from left) and friends playing the fools at
Fool's Paradise

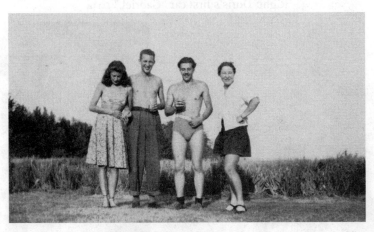

Doris (far right) and the gang

Left: Doris blows her horn, 1932
Right: Doris's first car "Gabriel," 1934

Left: At the cottage
Right: Entering Central Tech, ready to teach, 1936

Doris (left) and Betty Coleman as bridesmaids for
Noreen Masters, 1939

On a painting trip in the Gaspé, 1944

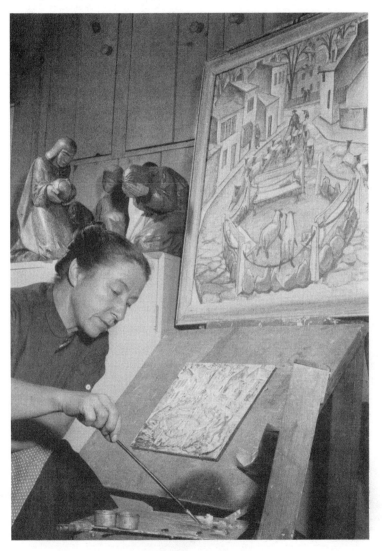

At work on a painting; four of the crèche figures carved by Doris
sit in the background, 1952

London, 1955: (from left) Flo Smedley, Ed Luz, Doris
and Ginny Luz

Doris and Ginny at the Knothole, 1959

Fool's Paradise, April
1942

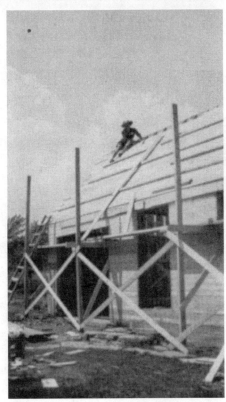

Roofing the garage
addition, 1946

PART THREE

The Splendor
of Beauty

Chapter 23

My LAST FEW YEARS of teaching were so pleasant that the tunnel began to feel more like a glass-roofed arcade. But I had looked forward to retirement for so long — at last, I could be a full-time artist! — that when the time came, I cast few backward glances. After all, Ginny and I were partners at Georgian Bay, with every summer ahead together.

Barbara Greene relieved Ginny of some of her illustration classes and shared still life with me. She was a compulsive gardener, and when I told her about a cottage for rent on the bluffs with a whole acre of orchard, she became my neighbor and good friend. Between us we hatched a plan to paint in the high Arctic in the summer of 1972. We decided to make Pond Inlet our headquarters. It is on the north side of Baffin Island and looks across a forty-mile (sixty-four-kilometer) strait to Bylot Island, which lies like a stage set of mountains and glaciers.

I wrote, asking about accommodation and explaining our needs. John Scullion, the settlement manager, wrote back, asking if we could make do with staying in the kindergarten and using the teachers' living quarters. With pleasure.

One of my adult students remembered reading about a trip organized by the Federation of Ontario Naturalists for seven days' exploration of the Arctic, with Resolute Bay as its base. We booked immediately, thereby ensuring a bird's-eye view of the Arctic before we settled in to paint in one place.

That June the hay field in front of the house had grown high. Wind rippled it into waves and blew the petals from the apple trees like confetti into the pond. Fool's Paradise was at its loveliest. But there was an irony for me in its beauty. At my routine medical check-up early in the month, my doctor had observed a lump in my neck. An operation was advisable, but could wait until I came back from the Arctic. I can still feel the rake in my hand and smell the new hay as I gathered it for garden mulch, wondering if my newly earned freedom was to be over in only a few months. It reminded me that life even at its most idyllic is fragile, and I carry that reminder with me still. I feel vigorous, full of pleasure in today and alluring plans for tomorrow, but as the time ahead grows shorter and shorter, every good hour is doubly precious, and I am less able to tolerate wasting it.

The day I was to leave for the Arctic, I recognized that my strongest emotion was apprehension — not of the lump, but of the trip. I was afraid, as usual, of the painting, afraid of doing tedious sketches, afraid of the opinions of the others, afraid of Barbara (I can't imagine why), afraid of forgetting essential equipment, afraid of the overweight baggage bill,

afraid of too much luggage. But as soon as I had shoved the bags and the unwieldy crate into the lockers at Dorval airport, my spirits soared. I was traveling again.

The Resolute hotel was a series of quonset huts, joined together to provide accommodation for the employees of the oil companies, mines, research teams, and travelers on government business. The food was astonishing, both in quality and quantity, the service simple cafeteria style, the dining-room stark but clean. (For atmosphere you went to the Arctic Club Bar, where there was enough noise and tobacco smoke to give anyone the illusion of having a good time.) The hotel was normally an all-male domain, but one of the washrooms had a temporary "Ladies" sign taped to the door.

On our first night in the Arctic (night by courtesy — it never did get dark) we were given an outline of the group's program for the next day and what turned out to be the best possible advice: "Hang loose." We remembered it often — when the plane was late (again), or couldn't take off because of fog, or when rain cancelled plans to walk to watch the deep-sea divers.

The Twin Otter that had dropped us on Bathurst Island one morning for a day of hiking and birding was due back to pick us up about four o'clock, but it failed to appear. Hang loose. The few men resident at the station gallantly shared their food that evening and managed to find a few cots and mattresses. In the morning, a pair of eider ducks put on a floorshow for us. The aircraft eventually sailed in, with assurances from the pilot that they had tried to get to us the night before but had been turned back by fog. On the way home the pilot spotted a polar bear, and flew low above him as he

lolloped across the ice and slid into the sea, pale green under the surface of the water.

The next day we flew still farther north, to Eureka, a weather station half-way up Ellesmere Island. After the wilderness of glacier-wrapped mountain peaks that we had to pass over to get there, Eureka seemed hospitable, a couple of sheds and some bright tents in a sandy hollow among dark mountains. Flying home over Axel Heiberg Island, we could see only the black jagged tips of the mountains, crooked spines that twisted above the voluptuous billows of snow and glacier.

The challenge that first week was to find subjects to paint wherever we were put down, or while waiting for a summons to the airfield. Hours and hours of our precious week were spent dashing to the airport to catch the early flight to somewhere, then trailing back to the hotel because the weather had closed in; setting out in the other direction to watch the divers at the local research station, only to be told to grab gear and run back to the airport because the fog had suddenly lifted. Hang loose.

At the end of the week we parted with our fellow naturalists with regret, but with a real eagerness to get to Pond Inlet and concentrated work. We were landed on a hill above the settlement on ice-bound Lancaster Sound. Beyond the sound, blue-gray mountains were streaked with snow and separated by glaciers stretching right down to the sea. John Scullion loaded us and our luggage into a sort of van on caterpillar treads and drove us down to our quarters. Because it was already too late for the Hudson's Bay store, Colly, his wife brought us a loaf of homemade bread, butter, and other emergency rations.

We couldn't believe the space in the kindergarten: two big classrooms, one a superb studio, with good light; two bedrooms and a dormitory; three bathrooms; a kitchen; and all the kindergarten furniture to play with. We had a cistern of hot water and every convenience except a flush toilet. (Green garbage bags were used to line the toilets. Every morning a lad came in — without knocking — twisted up the bag and took off with it, leaving a fresh one for us to fit in place.) More disconcerting was having some strange young man walk in with his towel over his arm and disappear into one of the bathrooms to take a bath. Inuit women would drop in, sit at the table in silence, accept a cup of tea and whatever we offered with it, and after ten minutes, half an hour or longer, leave in the same silence.

The Inuit didn't follow our pattern of bed all night and up all day. They slept when tired and ate when hungry; so at any hour children were playing outside, guns were being fired, and skidoos were roaring around on the ice. Best of all was the dog chorus. That wild outcry is the very voice of the Arctic. When one husky starts to keen, a second chimes in, at a different pitch, then a third, and more and more, often with a high soprano doing a comic descant. I spent much of my painting time along the edge of the shore, near the tethered dogs and the storage sheds for the fishing and hunting gear, where I could study the fantastic shapes of ice floes and pressure ice.

Whenever the tide comes in, the sea ice is pushed up. Sometimes it breaks, leaving huge cakes of it on edge, frozen in position. As the tide goes out, some sag against one another and freeze in jagged clusters, with fresh snow drifting about them in scarves — a tumultuous invitation to

creative design. Past this foreground excitement were the pyramidal mountains of Bylot Island, echoing the triangular shapes of the near ice, glaciers garlanding them much as trails of drifted snow draped the shore ice.

One day John Scullion organized for us a trip by dog-sled ten miles (sixteen kilometers) up Navy Board Inlet, which separated us from Bylot Island, to visit the iceberg trapped by the previous year's freeze-up. The heavy wooden runners of the *komatik* could rise and fall over the rough sea ice almost independently. The dogs seemed small to be pulling that heavy sled, but they made quite good progress. One of them, a bitch, ran along one side with her rein usually slack, enjoying the trip but making sure she was not doing much of the work. It was almost mid-July, and cracks were appearing all over the ice. Narrow ones were fun — the sled splashed across; but one was so wide we made a five-mile (eight-kilometer) detour before it narrowed sufficiently to cross.

It was almost noon before we reached the berg. This was the first time I had seen the brilliant turquoise and green of the deep crevasses of glacial ice, fifty feet (fifteen meters) visible and more than ten times that depth below the surface.

After lunch our driver hacked off a good-sized chunk of the berg to take home. Iceberg water made the very best tea, much prized by all the locals. He lashed it to the komatik behind the other passengers; I traveled home backwards, leaning against it. I missed the fun of watching the dogs, but had the full benefit of the glories of the sunlit iceberg as we left it farther and farther behind.

On our last day at Pond we hung an exhibition of our work and invited people to see their world through our eyes.

We offered John and Colly their choice of a thank-you gift from each of us, and John decided that he also had to have my sketch of his boat, the *Lemon*, thereby creating the largest privately owned collection of McCarthy paintings.

The best part of my return home was to rediscover night. After all that sunlight, how beautiful I found the darkness and the stars. It made me yearn to experience the Arctic winter, which is long and cold and, apparently, very beautiful, with spectacular displays of northern lights, moon and stars to dramatize the forms, and the many voices of the wind behind the keening of the dogs.

That fall I made prints of the Arctic icebergs as Christmas cards. I think this was the germ of the iceberg fantasies of my later work.

In November, I had a second show at the Gutenberg — all Arctic sketches and the Arctic canvases completed during the summer at the cottage.

Final score, out of fifty-six paintings? Three kept on consignment, fifteen returned to me, thirty-eight sold.

Then the income-tax boys caught up with me.

When the voice on the phone said, "This is Revenue Canada speaking," I assumed it was a friend being funny; I just laughed and hung up. When the phone rang again, I told the caller to write to me an official letter, which he did. Then I began to take him seriously. I had never declared art income nor claimed art expenses — it had always cost me money to be an artist. But that was before Leslie Reichel discovered me. I had kept careful track of sales, but not of expenses; I found a few big framing bills, but nothing else. The sweet, young Revenue Canada accountant insisted that I

do accrual bookkeeping, which sounded like a life sentence. I paid what was demanded, for as many years back as he asked, and found an accountant to keep track in the future. All of which got me a vendor's permit: I can now buy my paints and canvases without provincial sales tax.

In 1973, the Scullions were transferred from Pond Inlet to Cape Dorset, on the south side of Baffin Island, where the hills are lower and rounder than the mountains near Pond, and invited me to stay with them to paint. They organized an overnight trip to Frobisher Bay, and then to Pangnirtung, on the south side of Baffin Island, part way up a narrow, twisting fiord. There, I was given permission to sleep in the kitchen of the Anglican Sunday school hall and use its stove. (The only proviso was that on Sundays I vacate the hall, as it was needed for the church school.)

The painting was terrific. Twice a day, the tide sent a flotilla of ice floes sailing up the fiord. As the tide ebbed, they went back to the sea. I came home with enough work for an exhibition of watercolors and small acrylics. (This new medium was as good as oils, and its quicker drying made it convenient for packing. But a year later, I tried acrylics in the Rockies in warm weather. They were a disaster, drying on the palette before I could use them, clogging the brushes, and darkening as they dried, making it impossible to patch.)

By mid-September 1973, I missed the stimulus of the craft classes I had taken at Central Tech, and decided to enroll in a course Father Bellyea of St. Michael's College gave, called Religious Concepts. I then discovered that university began weeks earlier than it had in my youth and I was late in applying: I would have to obtain special permission to submit a late application. To my astonishment I was refused,

on the grounds that a person of my age would not be able to catch up on two weeks' missed classes.

Father Bellyea let me audit the lectures and I did the assignments for fun, but one important lesson I learned was to register in plenty of time for Northrop Frye's class the next year. Through the rest of the Seventies and into the Eighties the university was my delight, my tonic. I moved to Scarborough College for convenience and stayed because I found community and good teaching there.

In the early Seventies I felt that it was time to exhibit beyond Toronto. I knew the Robertson Gallery in Ottawa by reputation, but I did not know that the Arctic was John Robertson's specialty. He replied enthusiastically, and I had my first solo show there in February 1974. It was a beautiful gallery, and the work was well hung, with none of the posters and miscellany that had cluttered the Gutenberg Gallery. My loved ones gathered in force for the opening.

It was at that opening that Margaret Pickersgill asked me why I had never painted in Newfoundland — she and her husband, Jack, had a cottage where I could stay. I took her up on that offer. In 1975, I made the first of many painting trips to our newest province and fell in love with it.

My spring painting trip to Arctic Bay was in April. After the equinox the light was lovely and the days long, but everything was snow, even the tops of the hills. The world was white and cold, usually fifteen or twenty degrees below zero, the lowest temperature I had ever tried to paint in.

I would go out in the morning into bright sunshine, in loose moccasins with thick newspaper insoles over two pair of socks, wearing long underwear and indoor slacks

under a pair of thick warm-up pants; a sweater under my hooded T-shirt under a thick down parka; and a wool toque and brimmed cotton sun-hat tied on with a silk kerchief. It was essential that, before I dressed for outdoors, I set up my sketch-box, laid out the colors on the palette, and packed my knapsack with turps, lucite medium, blow-up pillow, paint rags (and a litter bag for them), and my beat-up old yellow plastic slicker in case of wind. Once I had my clothes on, with a tube of white paint lodged in my bra to keep warm, I leapt out the front door so as not to steam up.

The village is built around the sloping shore of a bay. Behind it are high hills. Laden as I was, every step saw me skidding down the well-polished slope of the village. My giggles added to the difficulty. It was a great relief to find a place against a house or kennel that would shelter me from the wind and let the sun reach me. I would blow up the cushion, find a piece of wood or a lump of snow thick enough to level the slope, lower myself on to it gingerly, spread my legs wide enough to position the sketch-box, stick the handles of my brushes into the snow beside me, open my box, pour out an inch or so of medium into one of the two cups and turps into the other, pull out a panel from the slotted lid of the box, lean it against the lid as an easel, and, at last, look about me.

This was the moment of truth: I must find a focus for my painting. I might choose the distant hills, where the first clouds to appear are throwing delicate shadows across the pink distance and offering pattern. Or the hill on my left, noble King George, whose sides are so sheer that there are stripes of pink rock showing above the snow. I might concentrate on the fantastic forms of the pressure ice and let

the mountains be background, center on two small houses and the upturned boats between them down close to the shore. I must decide quickly, before the cold penetrates, but tomorrow is a chance to make a different choice. Today I settle for the pressure ice, and choose one angular cluster to dominate the composition.

With thin color, turps with just a hint of blue, I make three quick lines, to place the mass off center, low enough to leave room for the far hills, high enough to allow some less eccentric snow shapes to take the eye upward and inward to the center of interest. With bold light lines I establish the shoreline and the swinging movement of the distant mountains, and plot two or three shapes of foreground snow forms. I may change the lines later, but shaky uncertain lines are death to a sketch. I move arm and wrist confidently, holding my long-handled brush at the end, still in gloves. Then I sit back and evaluate. Unless the shapes are well balanced, rhythmic in their relationships, and interesting, I should not go on. From the very first strokes the painting must have enough life to give some of its energy back to me, sustaining me through the development.

Next, I work out the tone scheme, establishing the dark areas and seeing how well the pattern of dark and light tells the story. For this I use a turps wash, not yet concerned with subtleties of color. Sometimes I get to my feet and judge the composition from farther off. This is my last chance to revise it.

Once back on my cushion, I fish out my warm white paint and squeeze some onto my palette. Usually I start with the most challenging and complex forms, probably my center of interest, looking for the color in the light and shadows,

and the more complex color of the side of the form away from the light. Every brushstroke must describe the form by its direction and texture as well as by its tone and color. I am always drawing in paint. Most often I start my painting in the sky and work down towards the foreground so the near forms lie on top of those farther off.

In less time than it has taken to describe the process either I have all the critical bits fully painted or I have at least established the exact color and tone. It's time to struggle home. My hands are so stiff that I can hardly open the bottles to pour back the unused lucite and turps. I wipe the brushes and put them in the box in the opposite direction to the others, so that I will know which ones need washing. Used paint rags are gathered into my litter bag. I slide the painting into its slot, wet side away from me, and close the box. I get up painfully on my stiff legs, squeeze the air out of my cushion, and pack it with slicker, litter bag, and camera into the knapsack. It goes over one shoulder, the box over the other, a strap collar keeping them from falling down my arms, and I am ready to slide and slip my way uphill.

In Arctic Bay, I found a magnificent carving of a hunter thrusting a harpoon at a narwhal. It is carved from the biggest single piece of whalebone I have ever seen, an epic sculpture. The young sculptor lived in the village, shy but pleased that I had bought his work. When it had been shipped home, I put it outside the big living-room window; but by the end of the summer I realized that, being bone, it was vulnerable to attack from insects and birds. It came indoors to a less dramatic setting, but it is still my joy and a constant reminder of Arctic Bay.

Chapter 24

My diary for the spring of 1974 is full of details about sales of paintings, fresh delight in the garden, and the newfound pleasures of retirement. In the early days of teaching I had discovered that branches of mountain ash in their September glory of red berries were good for beginners to draw or paint, and for several years I brought in a supply at the beginning of term. After a few years of this, I dreaded the berries turning red. They signaled that my prison doors were about to slam shut behind me. When retirement was imminent, I bought a young tree and planted it near the patio, where every September it would remind me that I had served out my sentence.

One Monday morning in late May, the phone rang. Roy's voice was desperate. "Doris, come quickly. Marjorie's terribly sick."

I jumped in the car, allowing myself to feel nothing but hurry, hurry. She and Roy had spent Sunday with the family.

Monday morning after breakfast, she had felt a little unwell and gone back to bed. (This pattern of tiredness, nausea, and headache was familiar to me since school days, when I used to help her home on a Friday afternoon after a week of too much excitement.) Roy had gone up just before noon to see if she wanted some lunch and called me when he couldn't rouse her. She was still warm but already dead. The doctor confirmed that she had died in her sleep.

My normal response to emergency is to go numb inside, while doing whatever is needed. During the next few hours, I organized the phone calls, admitted the coroner and the undertakers, made tea as the family members gathered. Only when I was no longer needed for practical help did I remember the small dinner party at my house that evening.

I decided not to tell my guests about Marjorie. The shell of me produced food and drink, kept the fire bright, and let the old friends enjoy being together. It was no worse for me to be serving a dinner and listening to them talk than it would have been to be alone. Only Marjorie could have shared this sea change, as she had shared everything else of great importance in my life. I knew that this night was the beginning of the rest of my life; nothing would ever be the same.

I can find no words adequate to say what Marjorie meant to my life. Our friendship taught me how to love. Her steadiness taught me that new love did not cast out old, that hearts grow an infinite capacity for love. After she married, my life grew wider as hers was deepening, but she was always with me, part of the very fabric of my being.

Even in the first realization of having lost her, I could not be sorry for myself. I had known and loved Marjorie for

fifty-six years, and had been loved by her, sharing tears and laughter, rich beyond deserving. My prayer was thanksgiving. In all the years of our friendship, to think of her was to rejoice, and it still is. Our friendship became the model and the standard for my other friendships, in which I offered and expected in return the same acceptance, trust and loyalty. Marjorie was the definition of friendship.

The summer after Marjorie's death, Roy came up to Georgian Bay for a few days. He showed me where he had buried Marjorie's ashes in a shallow depression on the crown of the bald granite hill back of the cottages. We trundled barrowful after barrowful of rich composted earth up the hill to deepen the soil in the hollow, and planted three young pines there. Then Roy hauled a hundred pails of water up the hill to saturate the soil. Today three beautiful white pines crown the hill, surviving wind, drought, and winter storms.

Marjorie and Roy were members of Metropolitan United Church in downtown Toronto, where she had been at the heart of the group that developed Dayspring, a weekend festival of the arts held every May. Marjorie's friends at the church wanted to do a special memorial to her. It had to say something about her genius for people, for loving them, and for working happily with them. It had to be beautiful and it had to be fun. Sitting at the back of the church, looking towards the Gothic arch that frames the chancel, I could see that the blank white spaces on either side of the arch were crying out for color and I visualized a magnificent banner hanging down on either side. I then realized that everyone who had known Marjorie could share in the making of the banners.

Clifford Elliott, the minister, invited all those interested to come to the parish hall one Saturday morning in the autumn of 1974 for a day-long work session. I explained the general plan to this mixed bag of more than thirty men, women, and children. One banner would tell the story of the life of Jesus, the other show the Holy Spirit as we had seen it in Marjorie's life. Each of them was asked to make a picture out of cut paper for each banner. By limiting them to black, white, and half-tone, no one would bog down in subtleties that would be lost at a distance.

There were a few slow starters, afraid of their own lack of experience. But scissors free the hands (shades of my pre-Vocational students!), and images appeared. I went around encouraging, showing how to enlarge and simplify, delighted by the originality of the ideas emerging. Seven-year-old Paul decided to make Grandma's garden, and to put in it the rabbit and the skunk he had once seen there. His nine-year-old sister thought that Marjorie's kitchen had been full of the Holy Spirit, and there it was, half-way up the right-hand banner — a white electric stove on a green background, with loaves of bread fresh from the oven and shelves stocked with pots and pans. The other banner was more predictable, thanks, I suppose, to everyone having been brought up with stained-glass windows and reproductions of old masters. Fortunately, these are impossible to reproduce in appliqué. Facial expressions were replaced by gesture and body language, and symbols were found for ideas too difficult for literal representation. I carried off their designs to make them workable.

After that we met on week-night evenings, in groups small enough for individual attention. They made tracings of

each part of their pictures and cut them out in fabric, leaving extra so that the edges could be turned under to avoid fraying. We tested the composition — if we could still read it clearly and understand its story from the far end of the corridor, it was ready for stitching. By midwinter, thirty-one panels were finished.

Each was a rectangle, but of every color and size — some vertical, some horizontal — against a white sheeting background. I began at the bottom of the banner of The Life of Jesus with the Incarnation, and worked on up to the dramatic events of the Passion, and to the Resurrection at the top.

To unify the banner of the Holy Spirit I used a verse by ee cummings, which Marjorie had hung in her front hall:

i thank You God for most this amazing
day: for the leaping greenly spirits of trees
and a blue true dream of sky; and for everything
which is natural which is infinite which is yes

The triumphant affirmation in those lines was right for her. She embraced life. And the poem allowed me to carry the eye up from the "i thank You God" across the bottom to an enormous flaming scarlet "YES" at the top.

Once more I gathered the faithful on a Saturday morning. We laid out the fabric on long trellis tables and worked at stitching the panels into position. When we left that day, only hemming and inspection remained to be done.

Except for the hanging — except for the hanging.

The Met ceiling rose to the heavens. No ladder could reach it, but Roy and I had to find some way of raising the banners into position and lowering them again. A hundred

or so steps up the spiral staircase in the tower we found a narrow catwalk running the length of the nave. Roy crept out on a rafter and bored holes for the wire hangers. He fed the wires down through the holes over pulleys in the attic. I was down below, fastening the ends of the lines to the rods, and directing the leveling. Then the great moment came. We stood together at the back of the nave, and saw that it was good. If only Marjorie had been there to share our pleasure.

What comes after death? As I get older death is more often in my mind; yet I always conclude that it is none of my business. My concern is with here and now, how to live every day to the full, with love. If there is more to come, good. If not, I have not wasted what I was given.

"So how can an intelligent woman like you go to church?" one of my neighbors asked me some years ago. The question challenges and teases me. Sometimes I suspected that I went to church because Nan Wright's breakfast parties were too good to miss. But, of course, the quality of those parties depended on the unspoken commitments we all shared.

Jesus might be goodness incarnate — another way of saying God — but Christianity is not all good. The sects that make up the Church are just people, full of folly, blindness, mixed motives, self-deceit, vanity, and sloth. So why belong to an organization that I see as imperfect?

Because it keeps before my eyes the perfection that it misses so tragically. Because my values get a salutary shake-up that distances me from my petty triumphs and petty miseries. I believe in the validity of what we are trying to do. And that to do it better, churches need bodies in the pews, money on the plate, and people smiling at their neighbors and greeting them by name.

This is a long way from the ecstatic mood of CGIT camp, where I first was seized by the vision; but then, even the Transfiguration was only a brief moment of insight.

The temperature of my spiritual life varies from day to day and year to year. I don't believe that Christianity is the only road to God. Love, first in my family and then with Marjorie, opened me to spiritual values. Christianity — in the church, at CGIT camp, in the Student Christian Movement — is the context in which I first met Him-Her-Them, and is therefore my community of faith.

Marjorie's banners were the beginning for me of a series of liturgical wall-hangings, among them a memorial to Dr. English, door panels to offer a colorful welcome at St. Aidan's, and a hanging at Cana Place, a residence for the elderly in Scarborough run by the Anglican Sisters of St. John the Divine. But a building, for all its beauty or its ugliness, is not what the Church is about. Its essence is the Holy Spirit that filled Marjorie and spilled over to all who knew her. It is love, St. John's definition of God, and the best I have found in my long life.

Chapter 25

THE SEVENTIES WERE YEARS of great change. Marjorie's death in 1974 was the most devastating; but there were some good changes as well. I showed in Ottawa every other year and was having regular exhibitions in Calgary. (Usually I was able to combine travel to Calgary openings with a painting trip in the mountains.)

About this time Jack Firestone bought a number of sketches, canvases, and watercolors. He had been collecting Canadian art for some time, and was deeding his home and collection to the city of Ottawa as a permanent gallery. Among his acquisitions were a great many works by the Group of Seven. He asked me for an example of what I had done in each year since I had begun to paint. (He had already assembled a similar record of the work of A.J. Casson and I was flattered to be in such distinguished company.) As his was to be a public collection — some paintings and

sketches always on view and the others available for research — I sent off many of my favorite works.

Financially free at last to travel when and where I would, I made periodic trips to Newfoundland and to the Rockies, and was invited to Grise Fiord, in 1976. The most northerly of all the Arctic villages, Grise was established to maintain Canadian sovereignty. Inuit families from Baker Lake and Pond Inlet were settled in this area of good hunting on the south shore of Ellesmere Island, on a long beach under towering cliffs of rock. In the bay in front of the village were a dozen captive icebergs, riches for me as a painter and for the community as a water supply. The bergs were wonderful. One had a wide band of brilliant cobalt-blue ice running vertically its whole height. Others were green, pure nile, and the snow on them made white patterns that I had not seen before.

I found a very different kind of beauty in Fort McMurray in northern Alberta. At first I looked about with some dismay at pipes, chimneys, trucks, and earth-movers of a size I had never even imagined. Eventually, though, I found tremendous interest and excitement in painting them and the tailings ponds. I especially liked the enormous purple-black and dark-brown trenches, as deep as a skyscraper, where huge long-necked back-hoes scoop out the oily sands. It was like painting a mountain upside down. One of the buckets lay on the surface where I could get close to it. The man working alongside was a third its height.

After my second Gutenberg Gallery exhibition, I began to covet a gallery that was not also a shop. At that time, Jack Pollock had acquired a beautiful space across the road from

the Art Gallery of Ontario. I had known Jack for many years, but I approached him diffidently. Jack came to the house, saw what I was doing, and agreed to a show, but he said he was tired of paintings geared to the space above a Rosedale mantel. "I'll paint large if you will sell them," I assured him.

This was for me an exciting challenge and the show would have new impact. I had produced my president's picture for the OSA show and a few other large panels during my hard-edge period. They had been stored in the garage for more than ten years, too good to burn or throw out, but in no demand. Now I could work on the same scale using my new material from the Arctic. Jack sounded confident of being able to sell them, so that they would not be compounding my storage problem.

Two of the five-by-seven-foot (one-and-a-half by two-meter) canvases I developed were iceberg fantasies, abstractions and interwoven forms intended to capture the experience of an iceberg, without being literal. Other large paintings were of villages and mountains and ice floes. But by the time my studio ceiling hangers were full, Jack's gallery had closed.

Being without a Toronto gallery is the artist's nightmare. We are not salesmen, being too committed to our work to be objective and too vulnerable to criticism or indifference to sustain it without great pain. But I packed a box of slides and called in at the Merton Gallery. At least my name was known there. I can still feel the relief I knew when I heard, "We are very excited about them."

The Merton Gallery proved to be an excellent location, thoroughly professional in appearance and spacious enough for my new large canvases. During my first show there the CBC filmed an interview. From Newfoundland to the

Yukon I met people who recognized me from seeing me on *Take Thirty*.

That spring saw my elevation to full member of the Royal Canadian Academy: one of my iceberg fantasies was my diploma piece.

In June 1997, Barbara Greene and I flew out to the Western Arctic. That flight saw a chance meeting that appreciably changed the rest of my life.

On the plane to Edmonton was Wendy Laughlin, one of our former students in the art department at Central Tech. Wendy was on her way back home to Jasper. She had recently married Dwain Wacko, whom she had met while working as a ski instructor. Dwain was a skier, a mountain climber, and manager of the movie house in Jasper, which was owned by his mother.

Wendy urged us to come to Jasper to paint. We warned her not to press her invitation too warmly unless she meant it, but this only encouraged her. So, when, after two weeks we felt that we had exhausted our interest in the flat Western Arctic, we phoned Wendy and moved on to Jasper.

When Merton Gallery closed, I had approached the Aggregation Gallery. (I had worked with David Tuck of that gallery when I was chairing the art committee at the Ontario Institute for Studies in Education. David was one of the acquisition advisers.) David introduced his partner, Lynne Wynick, and together they chose a few paintings to "try out" on their clientele.

In the midst of the silence that followed, Wendy and Dwain came to Toronto on a visit and to Fool's Paradise for dinner. They wanted to make a film to show tourists

in Jasper on rainy afternoons, so they could see the park as the climbers and skiers know it. A few months later, while Dwain was off on a canoe trip, Wendy rounded up half a dozen businessmen who were willing to put up some money for the venture. She was exploited and robbed by her first director and crew, told the facts of life in the film industry by a stranger with whom she chanced to share a taxi, met a world-champion whitewater kayak team who provided the climax of her story on a mountain stream never before navigated, and ended up in debt (what else?), but with an award-winning, hour-long documentary.

Wendy had tasted blood. She had learned so much. Would I let her make a film of my life and work? By this time she was convinced that I was a great artist, and under-recognized. I couldn't help but agree with the "under-recognized" and be flattered by the "great." Besides, I love to act. So yes, I would be. This was as far as we had come when the City of Scarborough presented me with its civic Award of Merit at a very pleasant ceremony at which I made a short speech of acceptance. On faith that there would be a film in which to use the footage, Wendy sent a cameraman and sound-man to record the moment.

The next filming was at the opening of my first solo show at the Aggregation Gallery. Lynne and David considered me to have expanded the tradition of Canadian landscape painting by my use of abstraction to interpret my strongly personal response to nature. It was the first time a gallery had taken framing and pricing off my hands, and had looked after designing the invitation and hanging the show.

The morning of the opening, Richard Leiterman, whom

Wendy had secured as director, was at the gallery, making careful records of the canvases on the wall and, later, mingling with the crowd that came, picking up bits of conversation with former students, friends, and collectors. The shots are a comfort to me. I look relaxed and comparatively young; a year later, when the film was being completed, I had aged twenty-five years.

A month after that opening, I was due to meet Wendy and her film crew at Brooks, Alberta, not too far from Dinosaur Provincial Park, so my arrival and first reaction to the park's challenge could be caught on camera, but the park superintendent flatly refused to let the film crew do its work. Not long before, a commercial film outfit had driven horses up and down his beautiful fragile hills and done irreparable damage. He could not, however, keep Wendy from using his telephone to get in touch with his boss in Ottawa. A couple of hours later, Wendy and Ottawa had convinced him to give his permission, which became less and less grudging as he observed our meticulous respect for the landscape, the palaeontological finds, and the exhibits.

The following month, Wendy, Richard, and I flew to England, courtesy of British Airways. What's more, we flew first class. I wallow in that memory sometimes, savoring again the champagne, the roast lamb, the exquisite attentions. It is pleasant to have experienced such luxury once.

It was thrilling for me to return to the Central School of Arts and Crafts, where Nory and George and I had studied more than forty-five years earlier, to the very studio where I had drawn from the nude model and agonized over teachers' criticisms. For Wendy, the high spot was our filming morning at Stonehenge, which by then had become an

endangered species. She had been assured that it would take at least six months to get through the protective red tape. Wendy just smiled gently, and had written permission in a day. So there we were, inside the sacred ruins, ready with the camera as the sun opened a red eye above the far slope, to get a leisurely sequence of me strolling among the megaliths. No one could guess I was chilled to the marrow, and would need twenty minutes in a hot bath up to my neck before I stopped shaking.

Before we were due for filming in the Arctic, one of Wendy's major investors backed out, so we settled instead for a few days in the studio at the Knothole on Georgian Bay. The real meat of the finished film, to my mind, is the record of the hour-by-hour work of painting a badlands canvas, which I did that week, thinking aloud as I worked. It was one of the most gruelling experiences of my life. I was amazed at my own vulnerability. The silence of the film crew was respectful, but nobody said that the painting was coming along well or that he liked it. The haggard lines in my face reveal my tension. The afternoon I finished the painting I was not satisfied with the form in the lower right-hand corner, but I was utterly exhausted.

When, finally, the crew had disappeared over the rocks, I had myself a quiet nervous breakdown. I think I lay down and read a whodunnit; Ginny and I played Scrabble in the afternoon, a sinful dissipation. It was a full week before I could bear to look at my badlands canvas again and revise the passage that I had known was wrong.

While Wendy struggled to find the money to go on, Richard had to accept other work. I had begun to be very uneasy about the person emerging in Richard's film. Was I

really a contemplative? Did I drift dreamily, brooding about the nature of art? Peter Shatalow, the new, young director, listened to my misgivings, and I thank him for his skilful editing that used Richard's rushes to build a much more plausible me.

There was one large segment of the photography still to come: a dinner party at Fool's Paradise, the umbrella under which everything else was to shelter. The conversation that occurred spontaneously would tie the sequences together. Peter wanted to use the daylight for photographing the paintings and archival snapshots in the attic and storage cupboards at Fool's Paradise; but there was no way I could have a dinner party at night if the house was crawling with cameramen and technicians, lights, cables, and confusion during the day.

I still laugh at the memory of that day. Wendy and Peter had agreed to film an early exterior sequence — the first construction at Fool's Paradise — so instead of the film crew and my paintings all over the house, I had the actress playing me as a young woman, a truck driver, and the film crew, whenever they needed to warm up out of the raw December wind. My one bathroom was in constant use. I spent much of the day fitting the actress with clothes I had actually worn or might have worn, and hauling camping gear up from the cellar or down from the attic. The studio and the hallways were knee-deep in cables and equipment. My kitchen was the film crew's canteen. The miracle was that, by the time the actors had gone and I had wriggled into evening dress, the guests had arrived, and the good food and wine stimulated some real talk at the dinner table. I could even forget the cameraman beside me and ignore the floodlights.

The little fragment of film that Wendy and Peter chose to use at the end and to freeze behind the credits was of me skating on the pond. The sequence was filmed on the far side beyond the hole in the ice made when the cameraman went through. I was torn between relief that the ice held me and feeling that a shot of me falling in would add a touch of hilarity.

Wendy and I shared three exciting previews of the film, which was finally titled *Doris McCarthy — Heart of a Painter*. At the first, in Toronto, everyone was there, from every corner of my life. A few weeks later the Alberta Department of Culture sponsored a showing in New York at the Institute of the Americas and mounted a solo show of my paintings, with a reception that did us proud. Finally it was screened at Canada House in London and, again, the film was very well received. Both the CBC and TV Ontario have broadcast it in prime time.

It is a good film, which stands up even after repeated viewings, and I can still enjoy it. It is not perfect, but it has good pace, never loses its audience, says most of the things I would like to say, and says them well. Bless Wendy for it. Bless her anyhow.

Chapter 26

AFTER MY RETIREMENT from teaching I scheduled my major painting trips for early spring or fall; the summer months were sacred to the cottage at Georgian Bay with Ginny. It offered us the best uninterrupted painting time in the whole year. No two years were ever identical — perhaps no two weeks — but life there had a consistency that was precious.

The deep bay that isolates our peninsula from the adjoining mainland is known as the Keyhole from its shape, and the largest of the cottages, which is closest to it, we called the Keyhole. The cottage that is mine is known as the Knothole, because it is *not* the Keyhole, and it is more rustic. The third and smallest cottage, out of sight beyond the big point, is the Cubby Hole. Ginny's brother named the high place that overlooks us Ben Hole, and the arm of rock that stretches out into the bay is Holy Point. As soon as Christmas was over, the thought of the cottage was a secret warmth inside, and settling in there a sharp joy.

One of the constant pleasures of life at the cottage was the pine-carpeted path to the privy. Overnight the spiders stretched webs across it, and the sun caught them just before they hit me in the face. No matter how thorough my sweep-out of the privy, I never got rid of the spiders. (One year, I did regretfully take down the heap of dried leaves and grasses from the shelf inside the door. For two years a red squirrel lived in that nest and, when surprised at night, would scurry along the top of the door and up over the roof.) Through the screen of pines and cedar undergrowth I could see the color of the dawn sky and if it would be a fair day.

Of course there was the year that Ginny broke her ankle and lay helpless on the path behind the Knothole until she could be helped to crawl to the car on hands and one knee. (The surgeon said that putting the fragments of bone together was like sorting cornflakes.) But she enjoyed the rest of the summer on crutches. And then there were two summers when her brother Ed was with us in a wheelchair, after the stroke that had left him paralyzed on one side. Those were good days, but we would not want them back.

Only summers at the Keyhole seem to exist in a world of unchanging rock blessed by sun and rain and winds, where growth was slow and change gradual.

The rest of my world was in a state of flux.

After my two exhibitions with John Robertson in Ottawa, he sold his establishment and I moved to the Wells Gallery, a fine small business near the Château Laurier. A few years later soaring rents forced it to close, and I took my work to the Welch Gallery. Malcolm Welch had been John Robertson's accountant, and had become addicted to art after prolonged

exposure. He built himself a home on the Ottawa River and attached a small gallery to it. This was the beginning of a very happy association.

Malcolm had adventurous, eclectic tastes and was particularly interested in giving artists their first chance. Fortunately, he forgave me for not being young or avant-garde, and built a good following for my small watercolors, quickies and fun sketches.

The Aggregation Gallery in Toronto was another casualty of rising rent. Twice Lynne Wynick and David Tuck had found inexpensive space in an unfashionable district, opened a gallery, created an ambiance that attracted others to the district, and then had the rent jacked up past the point at which the gallery could support it. In 1982, they renamed the gallery Wynick/Tuck and moved to a former garment factory on Spadina Avenue. Not only did Lynne and David create a beautiful gallery; they started a movement that gradually filled the whole warehouse with art galleries. (They have since moved into another beautiful space to the east.)

Of all my solo exhibitions, the one that gave me the most personal aesthetic satisfaction was the first there, a show of the Alberta badlands, almost all oils: several huge panels done on the spot, and the rest large or very large canvases painted at the Knothole or Fool's Paradise. The paintings were warm in color, full of ochres, siennas, and warm whites, and the western sun streaming in on the freshly sanded gallery floor enhanced the golden tones of the work. Sales were nothing to boast about compared to previous shows, as Toronto patrons didn't easily relate to the bizarre forms of the hoodoos and eroded hills of the badlands, but I knew, and David and Lynne knew, that the paintings would sell eventually.

One winter afternoon in 1986, a meteorite landed on my head (by registered mail). "I am pleased to inform you, in confidence, that the Governor General has received a recommendation for your appointment as a Member of the Order of Canada ... You will, I am sure, understand that this matter should be held in strict confidence until the official announcement is made."

The secret was safe with me for the long month or so to New Year's, when the list was to be published. After the announcement did appear, the phone calls became a flood. Letters and cards began to arrive; there were press calls and photographers' appointments.

My brother, Doug, came with me to the investiture in Ottawa. (After his wife's death in 1978, I saw far more of him, finding him a good companion, with a sharp mind and a quiet wit.) It was a gracious, dignified ceremony, meticulously organized. An added pleasure was that Madame Jeanne Sauvé, the Governor General, was the patron of the Canadian Society of Painters in Water Color, and had attended our sixtieth anniversary dinner in 1986. (That was the year the queen accepted sixty watercolors by members of the society to be in the permanent collection of the library of Windsor Castle.) I had found her charming and easy to be with. At the investiture, it was like receiving the medal from a friend.

Chapter 27

THE ROAD TO FOOL'S PARADISE plunges down a steep wooded hill to a narrow plateau that runs along the top of Scarborough Bluffs. The shore below it is the very beach on which my father and I landed for our picnic together when I was eleven years old. A few yards out in the lake the landmark wreck still breaks the surface of the water and reminds me of Dad. In the early days, before the trees had grown and the vacant land had been built on, we named it Meadowcliff Drive, an accurate description. (I continue stubbornly to spell 'cliff' the way the dictionary does, although even the street signs have added an e.) The plateau is bounded by two ravines, both now parkland. On the east side of my house is the Bellamy Ravine, which used to be partly wooded and partly raw clay and sand bluffs. When I first moved here I estimated that the trickle of water that ran down the center had been creating the ravine all through the ten thousand years since the last ice age. The ravine had grown wider at

the rate of about six inches (fifteen centimeters) a century. Deer visited it sometimes, and came up into the little woods at the lake end of my land. A red fox raises a family in those woods. I suspect she is the reason that all the pheasants have disappeared. They used to be common. Rabbits, squirrels, skunks, and coons are dependable regulars, although the groundhogs far outnumber them. I sit on the patio in summer and watch their heads popping up and down in the field, and see the bold little beast that lives under the house scampering past, or gnawing away at the chrysanthemum plants in the garden.

The original, very deep ravine began getting dramatically deeper and wider after the war. All the farmland that used to lie for miles around us was subdivided during the Forties, covered with houses, and the roads and driveways paved. The rain that used to seep harmlessly into the ground began to run off the roofs and pavements and rush through culverts into the head of Bellamy Ravine, coursing down the center of the gully, gouging out the bottom, undermining the cliffs on each side, and churning over the trees that fell from the slopes. Between Fran Dalziel's house and mine, both on the ravine, a gulch began to form.

Originally, wells and septic tanks balanced each other. After the war, wells were replaced by city water, all of which went eventually into the septic tanks and had to find its way out through the soil. It flowed underground until it could find a hard layer to take it to the face of the bluffs or the ravine. A steady stream of underground water emptied between Fran's house and mine. Every winter the face of the ravine froze hard, and the seepage water was held back and built up pressure. Come spring, it thawed, and the outrush

of water carried away a whole layer of the face with it. Our flat land had been falling into the ravine so quickly that we feared for our houses.

We watched each tree collapse and each foot of land crumble away. I dismantled the fence section by section as the edge crept closer. We hired a consultant engineer, who did soil tests and took photographs but offered little hope that anything we could do would be effective. One of my friends suggested that I should pray about it, and made me realize how little right I had to ask God to work a miracle to stop the erosion in Bellamy Ravine.

Perhaps even thinking about this, as Fran and I did together, gave us the will to do something ourselves. We financed her youngest son, Gordon, who was a student at Ryerson Polytechnical College, to get a team of lads to help him line the stream-bed where it passed below our lands, using gabions to contain the water. The Metro Conservation Authority gave us permission to do the work and kept a concerned eye on its progress.

A gabion, as I learned, is a coffin-sized wire basket, which comes flat but is pulled out into shape and then filled with stones too big to spill out of the mesh. Gabions are used like huge blocks, put side by side or piled one on top of another and then wired together for extra stability. After trying many unsuccessful ways to deliver the stones into the ravine, the boys finally rigged up a two-bucket pulley, with an empty bucket zooming up as a full one swung down. The ravine was so deep and steep that the boys themselves needed a rope to help them up and down.

But what a beautiful sight it was to see the stone-lined watercourse, and the stream contained within it. We enjoyed

it until the spring floods rolled the gabions out of position as if they had been made of wicker and left them this-way-that-way half-covered with fresh mud. The second year saw the team back on the job, doubling the number of gabions in the walls and adding buttress gabions at right angles every few feet for further strength.

Even before the gabion work, Fran had held an annual tree-planting, when her young people, their friends, and their in-laws had spent a Saturday in May setting out a thousand seedlings in the hope of getting growth reestablished along the slopes. The gray-haired worked with the grandchildren on the steep clay bank, with the rope to help climb up over the verge. Every year a few of the trees survived and even flourished, so even if the planting did little permanent for the ravine, it built clan solidarity and was a good party.

All this was just to buy time in hopes that some action would be taken by government at some level to undo the damage that had been done by putting this extra water into the ravine. And, finally, something was done. Two bulldozers worked five days a week for three years, and a great blue and yellow monster with a long flexible neck and a bucket of a mouth gnawed here and spit back there to shape the the hundred truckloads of earth dumped daily to raise the level of the bottom and to grade the sides of the ravine to the angle of repose. On top of the fill, a watercourse was built, lined with huge stones, each block as big as a gabion. Below the stones lies a layer of filter blanket. Deeding ten of my thirteen acres to the Metro Conservation Authority was a small price to pay for my sense of security. Not only was the erosion halted, but a wooded valley was created, with an

open stream-bed in a setting of grass and trees. A footpath gives public access to the beach. And Fool's Paradise will continue to be a refuge for whoever needs sanctuary, a place for healing, for laughter, for shared tears, for growing.

Chapter 28

As my teaching career ended, I thought with shock and even dismay that the next major event in my life would be dying. There was no imagining then that the best years of my life were still ahead of me.

In 1991, I went off to the Antarctic to see if it could compete with the Canadian north in beauty and interest. I found it different and yet the same, with penguins as a new and piquant note. Shortly after my return I settled into St. Michael's Printshop in St. John's, Newfoundland, learning to make lithographs, with a master printer at my elbow to provide the expertise and the muscle to handle the stones.

Since becoming a full-time artist, much has been given me: a major retrospective exhibition (and worthy catalog) that traveled across the country; a celebration as a "designated artist of honor" by the McMichael Canadian Art Collection; and honorary degrees from several universities. I have had an art gallery named for me, as well as a neo-natal

hospital ward, giving me children to celebrate every day. More than all that, I have a fair number of paintings that I'm quite pleased with.

In the past thirty-some years, I have been true to my beginnings as Thursday's child, traveling often, and often far, with Wendy, Barbara Sutherland, Brenda Brisker and/or Judy Finch. I have been across Canada to paint many times — I stopped counting after twenty — to the Yukon and the Western Arctic, to Newfoundland and the Maritimes, to Alberta and the eastern High Arctic. I have traveled the western coast of the continental United States and painted the New Mexican desert, Hawaii, and Alaska. I have revisited places I love — England, Ireland, France, and Italy — and found new ones to entrance me, among them China, Morocco, Turkey, Tunisia, Hungary, Spain, Portugal, and Ukraine.

When I question myself about this wandering, I believe its roots lie in Haliburton during my earliest days as an artist, when those working holidays with Ethel Curry gave me inspiration, release from the constraints of living with Mother, and the congenial companionship of a fellow painter. For painting demands a concentration and sensibility that grows into an intimacy with the subject. When you are successful, you come to know the land, not just see it. (When you fail to understand it, you cannot tell the story of what you see, and your paintings fail.)

For me, traveling to paint also involved a particular intimacy with my artist companions. It was not only the day-to-day cramped living, often out of a small van or other shared accommodation, which demanded both tolerance and consideration; but also the generous sharing — of laughter

and worry, of the beauty and the challenge of new land-scapes, and of the constructive, kind but insightful critiques at day's end — that are essential to the joy and excitement of creating art.

Two of my later painting trips, however, were like no other. One day in June 2001, I received a phone call from Carol Heppenstall, representing a company called Adven-ture Canada, which ran expeditions to hard-to-get-to places. They were planning an Arctic cruise. Would I be interested in coming along as a resource person? Cruising the Arctic with Doris McCarthy was, apparently, an attractive com-modity. My job would be to give a lecture on art and the Arctic, based on my own work. When not on duty I could do as I pleased — sketch, paint, or do nothing at all. How could I possibly say no? (In fact, I said yes twice, to both the 2002 and 2003 cruise.)

When she explained that there might be amateur paint-ers on board, I went into action. There was something of the teacher in me yet! I worked up a materials list to be sent to prospective artists, and volunteered to give feedback when asked, critique any works the painters wished to submit, and to lead shore sketching trips at various stopping points.

We flew to Iqualuit, then to Resolute, where we were taken to the ship by zodiac, and headed for Beechy Island, speeding past icebergs, shifting shapes of white side-lit in the dark sea. It was the beginning of scenes so thrilling I couldn't wait to get them on paper.

My first sight of Greenland was well worth my ninety-two-year wait: blue shapes that became more exciting the closer they came; icebergs, icebergs everywhere you looked, of every size and shape, in a continuous procession. On

shore, I sketched the little colored homes marching up a massive, looming hill of bare rock, until my hands froze, and I had to resort to photographs to record the images for later paintings.

One day we went out in a flotilla of zodiacs among icebergs of amazingly varied forms and textures. Melting had formed vertical grooves in some of the ice, creating an effect like a comb. The sun was shining, the birds were swirling everywhere or perching on the peaks of the bergs. Bliss.

On the last night of the cruise, the painters held an exhibition of their sketches. (Other nights had been dedicated to singing, dancing, and laughter.) And it was good! I was impressed and delighted. Even the raw beginners had got somewhere and the ensemble was remarkable. I got the same whoop of pleasure that I had felt looking at students' work during my last few years of teaching.

Whatever sadness I felt at the end of the last cruise was mitigated by being able to indulge in my favorite indoor sport — packing, which is a special joy when it means I'm returning to Fool's Paradise.

Not long after the 2003 cruise, my dear friend Lynne Atkinson asked me where I would like her to take me for my ninety-fifth birthday. I think she was hoping for somewhere exotic, but for me the answer was easy: I wanted to go across Canada, one last time. Soon, however, even I realized that while my spirit was willing, my body wasn't going to be able to make the trip. "Well then," said Lynne, "Canada will have to come to you."

Lynne is both creative and determined; still, I had no idea how even she could manage this trick. But manage it she did,

with Lydia Adams, conductor of the Amadeus Choir. Lydia selected music by some of Canada's finest composers, representing the various regions of the country. It was performed by the Amadeus and the Bach Children's Chorus, as photographs of my landscapes, chosen by Lynne, rhythmically appeared on screens above the musicians. The concert ended with a commissioned setting by Eleanor Daley of the *Salutation of the Dawn*, which I have carried in my heart since I was a teenager at Camp Tanamakoon. My heart was full.

The concert was recorded and later broadcast by CBC Radio, and a second performance, including the photos, was held on my ninety-sixth birthday, in the beautiful Festival Performance Hall in Parry Sound, an acoustic marvel of local wood and stone that looks out over my beloved Georgian Bay.

That glorious afternoon revived my ache to travel with the painting friends with whom I had such rich experiences in the past; but, of course, at ninety-six I have outlived most of them and I am certainly in no state to go camping in a van. Yet, what friends I have known — and loved!

Each autumn when I watch the leaves turn scarlet and gold and russet, I feel that my friends are those leaves: their beauty and glorious light dazzle me — and then they fall. So many in recent years: Doug, Nan, Flo, Yvonne, Ginny, Dino, Curry. And Marjorie and the others. Many autumns since, but always with me.

Some years ago, I spent a good deal of time putting things away, tidying my affairs — financial ones, the only kind I have had for some time. I found out from my family and young friends which of my possessions they would like to have, to simplify things for my executors. And I am planning

my own autumn fall. Not a funeral — how can one mourn a life so long and richly lived? — but a celebration. It seems important that death be received graciously, like any other important and interesting guest.

While theology is less important to me now than it was when I was younger, I now consider it possible that there may be life after death. Both are of secondary importance to what I am absolutely sure of: that the word of God is the beauty of the world. Our human place in the world is to see that beauty and to choose actions that will celebrate what is beautiful and, thereby, what is good. As I see it, the best choices we can make are to create some aspects of what we call the "Kingdom of Heaven" here on earth, all of which grow from love.

So here I am, content to enjoy every day as it comes, and wise enough to thank God for his mercies and rejoice in them. My only regrets are my economies (never my extravagances) — particularly those of spirit and love.

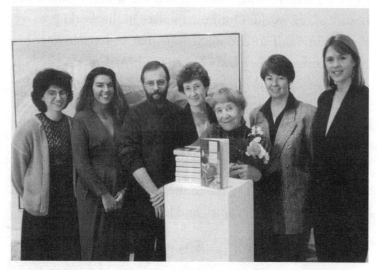

Doris with Lynne Wynick (second from left), David Tuck, Jan Walter (second from right), and staff at the Wynick/Tuck Gallery launch of *A Fool in Paradise,* 1990

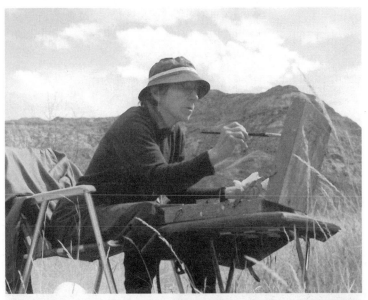

Richard Leiterman filming *Doris McCarthy — Heart of a Painter*

Presented with the Order of Canada from the hands of Governor
General Madame Sauvé, 1987

At work in
Tuscany,
2000

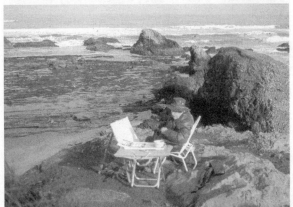

Painting
on the
Oregon
coast,
2000

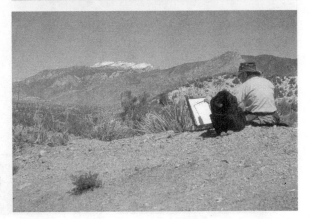

Capturing
the desert,
2001

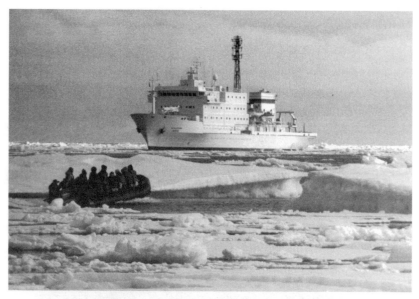

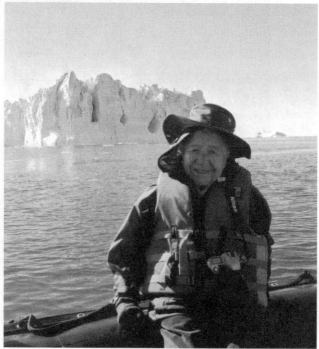

Cruising the Arctic as Resource Staff for Adventure Canada, 2002

Catching a ride on an ATV in the Arctic, 2003

Painting in Baffin, 2004

Discussing her book, *Doris McCarthy: Ninety Years Wise,* with CBC radio host Shelagh Rogers, 2005

Disembarking in Parry Sound, 2004

As a special guest at Wendy Wacko's first exhibition

With Lynne Atkinson at Fool's Paradise, 2005

Hiking the Doris McCarthy Trail with artist
Marlene Hilton-Moore

Receiving an honorary doctorate from the University of Toronto,
accompanied by dear friend and English Professor,
Andrew Patenall, 2001

Presenting a poster of Fool's Paradise to Lincoln Alexander,
Ontario Heritage Chair, 2005

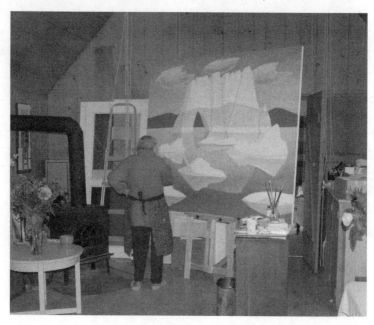

Painting in her studio at Fool's Paradise, 2004

Children gather to watch Doris paint in Greenland, 2003

Painting in Greenland, 2003

With Lynn Atkinson, and friends Woody, Pam, and Val, 2002

On a painting trip in Newfoundland with
Barbara Sutherland, Judy Finch and Brenda Brisker, 2003

Doris's cottage on Georgian Bay

Enjoying cottage life, just after her 94th birthday, 2004

Rollerblading with her great-nephew Duncan